Art Education: Elementary

Andra Johnson, Editor
University of Georgia

National Art Education Association
1916 Association Drive
Reston, VA 22091-1590

1992

About NAEA ...
Founded in 1947, the National Art Education Association is the largest professional art education association in the world. Membership includes elementary and secondary teachers, art administrators, museum educators, arts council staff, and university professors from throughout the United States and 66 foreign countries. NAEA's mission is to advance art education through professional development, service, advancement of knowledge, and leadership.

Cover: Mark Rothko, 1968 (1903-1970). National Gallery of Art, Washington. Gift of the Mark Rothko Foundation.

©1992 The National Art Education Association, 1916 Association Drive, Reston, VA 22091-1590.

ISBN 0-937652-61-X

Table of Contents

Introduction

A period of rapid change has been occurring in the field of art education which has affected the scope and sequence of the curriculum at all levels. This evolution has been especially apparent as the leadership of the field has debated issues related to the development of statewide mandated curricula, the multicultural nature of our school populations, and the evolving perspective supporting the importance of integrating art history, aesthetics, and art criticism into the school art curriculum. The interests of leaders in both higher education and private and corporate agencies have also provided incentives and funding for research on current practices, programs, and institutes for teachers, and the development of new and innovative curricula. These influences have provided the incentive for reexamining the nature and practices which characterize art education.

The range of issues reflected in the current art education literature describes the changing needs and concerns of our society and our educational system as we face the challenges of a rapidly shrinking world. During the last twenty years, developments in communication and information technology have increased possibilities and methods for the exchange of ideas on both local and global levels. These changes, along with an increasingly mobile society, have created many new demands on our schools. They have challenged teachers and administrators to rethink what, why, and how to teach those students who currently populate those schools. It is increasingly important that teachers identify both program content and instructional strategies which are most effective in reaching a school population with a broad range of experiences, interests, and abilities.

The importance of the program at the elementary school level must also be recognized. The quality of our secondary programs is based upon the foundation established and maintained at the secondary level. Without this strong foundation, options for secondary school programs are limited, and art teachers find it difficult or impossible to provide a rich experience beyond the mere basics in art.

The focus of this anthology is based on the identification and discussion of these many issues which affect the nature of elemen-

tary school programs. The content and structure of the school program are often determined by the political and sociological influences which shape our society. The current concern with an expanding agenda for art education that extends curricular content beyond the traditional product orientation has sparked a movement towards an ever broadening curriculum. The goals for quality art instruction adopted by the National Art Education Association call for a sequential program of instruction which is based on the study of (1) aesthetics, (2) art criticism, (3) art history, and (4) art production.

The chapters which have been included in this volume reflect the broad range of *issues* which art educators are facing in the course of determining curricular content. These issues include the need for multicultural approaches in art instruction, the cognitive development of students, integration of students with special needs, advocacy for school art programs, the revision of preparation programs for teachers, appropriate methods and techniques for evaluation of student artwork, determination of who can best teach the content of art, and the process of development of curricular content. Text has been included which addresses these varied topics with the hope that clarification of these issues and suggestions for implementation may be made available to guide the direction of curricular and instructional practices over the coming years.

Illustrations and suggestions for *approaches* to instruction in the elementary classroom are also included in this anthology. These approaches encompass a broad range of strategies which include: improving student thinking, integrating children's literature with art content, utilizing the social context of the student as an approach to instruction in the classroom, play as a context for art instruction, and approaches for teaching aesthetics, art history, art criticism, and art production. Each of these chapters provide various methods and strategies for approaching classroom instruction at the elementary school level.

It is hoped that this anthology will provide support and guidance for the development of elementary art programs during the coming years. The chapters represent the varied range of experiences and interests expressed by each of the authors as they have focused on many of the major issues and concerns of art educators. Each one provides a varied and innovative set of approaches for instruction.

Kay Alexander calls for the development of new curricula and teaching strategies for the field of art education. She supports the opinion that curricula should be developed by those teachers and supervisors who are most directly related to the field. Alexander proposes a step-by-step model for the process. She believes that the training and service of the people on the "front lines" should guide the process since they know the content, methodology, and students best.

Craig Roland provides an extensive overview of the literature on critical thinking and calls for art educators to incorporate strategies for improving student thinking through art instruction. He provides a clear set of principles and applications for the art classroom which may enable the teacher to translate theory into practice.

Doug Blandy calls upon art educators to support the the belief that art education should help to prepare young people to participate in their communities. He extends this argument to promote the integration of elementary-aged children experiencing disabilities into community art settings. Blandy offers a model for an inventory which can be used to assess the environment and necessary skills related to the activity in the community art setting. This model enables the teacher to plan the experience in order to facilitate the students' participation in the community art setting.

Elizabeth Manley Delacruz identifies issues related to the question of the educational theory and politics of educational reform. She traces the history of recent trends toward multiculturalism and calis for the development and dissemination of curriculum resources which reflect interests in the art of diverse populations.

Phillip Dunn describes the importance of the elementary art specialist's role as advocate for the art program. Dunn provides numerous suggestions for ways the art teacher can use to strengthen the position of the art program within the educational system. He calls for art teachers to take leadership roles and to interact with educational decision-makers in building support for art programs at the elementary school level.

Lynn Galbraith suggests that changes are needed in the ways that elementary classroom teachers are prepared to teach art. She cites literature in art education describing the changing trends in curricula and instruction for the art program and encourages

educators in the field to respond to the call to develop a research agenda for art education which will examine the current preparation and course content of art methods courses in preservice education. She suggests that pedagogical practices be fully examined and defined to improve and broaden the scope of procedures and content used to train teachers to teach art. Galbraith maintains that further focus on content and pedagogy is needed because traditional methods of teaching may not be sufficient for teaching the diverse content and concepts being proposed for the art curricula in the current literature of art education.

Wendy Wiebe poses questions concerning whether or not the teaching of art is approached differently by generalists and by art specialists. The question of the degree of influence of the teacher's performance on the child's art experience is also raised. She discusses the findings of a study which was conducted to describe and evaluate the art experiences of students under different staffing arrangements. Finally, she gives recommendations for staffing art programs on the basis of her findings in the study.

Sally Hagaman suggests methods for integrating the content and processes of inquiry from aesthetics into the art curriculum to encourage teachers to talk about art in the elementary classroom. She addresses the need for the elementary art teacher to develop a climate for meaningful dialogue and provides strategies for initiating discussions in the classroom.

Terry Barrett provides the reader with a summary of the theory of teaching art criticism and provides suggestions for the translation of that theory into practice. He describes his experience and involvement in the process of teaching art criticism to elementary school children and suggests activities for teachers to use in having their students talk and write critically about art.

Jennifer Pazienza describes curricular models for teaching art history which are based on methods used by art historians and scholars. She illustrates a method of study which encourages children to become "inquirers" and helps students to discover art at their own level. She involves children in the study of many facets of art history and helps them to think critically about art through the process of enacting the mysterious disappearance of an artwork.

Margaret Hess Johnson offers a model for talking about aesthetic meanings and aesthetic concepts which is designed to assist the student in making a reflective judgment. Her model is designed to direct students through a process of thinking about meaning and expression of their ideas about the aesthetic qualities of the artwork.

George Szekely describes the approach of using play in the elementary art classroom and offers innovative strategies for encouraging students to discover both content and motivation for their artwork through play. The author's own experiences provide a basis for this chapter and may suggest alternative approaches for the art program.

Annette Swann argues that the child's social context should provide the direction and motivation for art learning. The role of the child's actions on the environment, the development of the child's sense of self and the roles of adults in relation to the child must all be carefully considered when planning art instruction. Swann contends that art programs should include social interaction activities and focus on socially relevant issues which are based on real experiences drawn from the "lifeworlds" of the children.

Authors Florence Mitchell and Virginia Nelms support the use of children's literature in the art curriculum and offer examples of books which can be related to both the processes of art production and to exemplars from art history. They suggest appropriate objectives for lessons which focus on perceiving and describing art, making critical judgments, and art production.

Finally, Carole Henry offers techniques for assessing student progress in the elementary classroom. She provides an overview of theory on evaluation, as well as practical solutions for the process of evaluating the students in the areas of art production, art criticism, art history, and aesthetics.

Appreciation is extended to Kellene Champlin for her efforts in beginning this volume and the influence that her contribution made in guiding the direction of this anthology. The contributions of Kellene Champlin, Pat Taylor, Lori Resler, and Carole Henry during the review process were also extremely valuable. Appreciation is also extended to the editorial assistance which was provided by Lori Resler and the keyboarding assistance which was provided by Sheri Klein. Their many hours of work will be long appreciated.

Art Curricula by and for Art Educators

Kay Alexander
Art Education Consultant
Los Altos, California

Curriculum development by teachers and supervisors and others directly involved in the field seems like the most obvious and most practical solution to the question of what should be taught in the schools. And yet, over the years, the lessons, units, and textbooks available to help teachers instruct students in any area of the curriculum have been, for the most part, prepared by publishers or by university professors, with, as a polite gesture, several teachers' names listed as an "advisory committee." This author believes that art education curricula can best be designed and developed by persons active and experienced in the field for which they write: art teachers and supervisors who work in the front lines of the nation's schools. They have had the training and service to make contributions which are based on the real world and are practical. With assistance from knowledgeable specialists in collateral fields to authenticate the content from art history, art criticism, aesthetics, and the creative production of art, art educators are capable of developing the most effective art curricula. Since they know the subject, methodology, and their students, they can "custom design" curriculum units for the most effective art education.

It is evident that new curriculum content and teaching strategies are needed in art education. For years, teachers have made up their own lessons, created district art guides by cutting-and-pasting guides from other districts, or put into practice lessons shared by other teachers at conferences or in magazines. Most of these lessons have been for making art or art objects — the "gimme a gimmick to mimic" approach. Occasionally lessons have had reference to a famous artist or a recognized work of art. Seldom have teacher-developed lessons been organized into units in anything other than a tired recycling of the "elements and principles of art," and seldom were the lessons focused on more than developing skills through media. Thus, the resulting art courses had problems that most teachers of art will recognize: an ad hoc approach that tended to rely on trendy superficialities or eye-catching projects; a constant struggle to keep art in the school schedule as school finances deteriorated; desperate efforts to put on a show of the very best

works, or of every student's work, under pressure for equity; subtle isolation of the art teacher from the rest of the staff, who saw themselves engaged in the "required" subjects; and even a struggle to prepare for another line of work against the day when the art program would be eliminated entirely. Teaching art in American schools has never been an easy assignment. Exactly what to teach as art has likewise been an enduring problem.

With insistent demands from the public for higher standards, greater rigor, and increased accomplishment in American general education, art educators have encountered not only a fundamental change in expectations for their role, but also an exciting opportunity to use this chance to bring art into parity with other school subjects. This goal would be accomplished by keeping art as a subject, not only creative and effective, which it certainly is, but by making it a more integrated and intellectual subject as well. These aims are far from new. The National Art Education Association has, for a quarter of a century, promoted a balanced art program incorporating the historical, critical, and philosophical aspects of art, along with creative, skillful expression. For almost a decade the Getty Center for Education in the Arts has advocated a parallel if not identical set of disciplines. Most state art frameworks and statements of essential elements outline similar goals. The National Endowment for the Arts' publication (1988), *Toward Civilization,* and countless articles in professional journals all underscore this expanded conception of what constitutes quality art education. But to date there are only a couple of commercial resources — textbook series, kits, and teachers' guides — that embody this ideal. Although these published materials are gradually being accepted and adopted, many art teachers have yet to utilize them. Most art teachers, it would seem, would rather join with a group of their colleagues and undertake the task of art curriculum development at the local level. Enthusiastic and ambitious, but often naive, they hope to develop an art curriculum that is peculiarly their own, reflecting very local needs and desires. Such a project involves much time, energy, money, and dedication, but it can ultimately be accomplished. It must necessarily be concerned with both the *what* and the *how.*

The What

Most of what children learn in the elementary grades is in the form of skills-subjects, steps toward proficiency in handling words

and numbers or basic facts about science and social studies. Only recently has there been growing attention to teaching children how to think divergently, to form concepts and generalizations about subject areas whose answers do not usually show up in the back of the book. Critical thinking — a recent catchword — has to do with subtleties, nuances, interpretations, and meanings for which facts are the means, not the ends. No one would denigrate the acquisition of factual knowledge and skills, but to stop at that level is to fail to deliver real education.

Art education can go a long way toward teaching young people how to "think through" problems and make decisions about things that require deliberation and judgment — the myriad shadings that every adult faces daily. Furthermore, art education can provide satisfactions and enjoyment available through no other avenue, the joys of aesthetic experience. Teaching just the skills of art is not enough to satisfy new and pressing demands for excellence; the new vision of a substantive, rigorous, multifaceted sequential art curriculum is. Furthermore, integrating history, criticism, and aesthetics into a program does not mean sacrificing the considerable benefits of making original art. Such a balanced program offers students and their teachers the best of both worlds.

It is this larger conceptualization of art learning that is receiving support today, both locally and nationally. The art curriculum that is valued is one that has structure and substance. It is more than Friday afternoon fun, more than creative play with art materials, more even than the good teaching of drawing, painting, and modeling skills. Art that earns its place with other "solid" subjects in the school schedule contributes something unique to students' intellectual, emotional, physical, and aesthetic development. It is, in effect, what the National Art Education Association and the Getty have stipulated all along: the production of art in balance with art history, criticism, and aesthetics. These components, or disciplines, can be taught from early childhood on, in sequences of lessons and units that recognize child growth and development and the social and ethnic diversity of our student population.

Districts contemplating curriculum design or revision need to look first at what is already available to them, to trigger ideas, to modify or perhaps even adopt, thereby avoiding the costly process of curriculum development. Textbooks, packaged programs, "systems," and supplementary materials for teaching art at all levels

of schooling are increasingly available. The best of these have been created by persons who have first-hand experience with the current problems, as well as profound knowledge of the content of art. They recognize the time constraints of teachers, they reflect the frameworks or essential elements determined by professional art educators, and they attend to the changing ethnic and social populations. They represent with thoughtful concern the multiplicity of parts that must interact to build a sequential, substantive program which will achieve a balance between productive, historical, aesthetic, and critical concerns.

The Production of Art

The making of art is an essential activity for elementary children. They need and want hands-on experiences in this "other language." Art lessons must include cycles of experiences with basic media and techniques, allowing students to acquire and then build upon skills fundamental to creative expression. In-depth work with a few media and techniques allows for more self-confidence and imagination than a plethora of unrelated experiences with a wide variety of materials and approaches. As in other subject areas, lessons must be designed to fit children's intellectual and physical development and relate to their expanding interests.

But a carefully planned sequence of instruction aimed at skill-building, vital as it is to building the capabilities to enable creativity, is not sufficient to assure that creative expression will occur. A teacher needs to free students' imaginative thinking by using teaching strategies that motivate children to use their abilities in original, inventive ways. Lessons should include suggestions for doing this essential task. Curriculum designers must conceive of the total scope of the program first before tackling individual units or single lessons. It is helpful to think in terms of outcomes: what will the student achieve by the end of a particular sequence or a year's experience? What concepts, insights, and skills are appropriate for which students? How will this learning grow from prior learning and where will it lead? What adaptations can be made for children who are developmentally different? To what extent should learning in art relate to other subjects? What assessment techniques will be needed? What are the implications for staff development? What should be taught? What, realistically, can be taught, given the practical considerations of time, talent and money?

Once these big questions are settled, curriculum writers must identify the content and dimensions of each lesson, and then fit the lesson carefully into a predetermined sequence that recognizes both children's abilities and the totality of the field of art production. Lessons should use readily-available materials and resources and be clearly written, describing procedures for instruction and evaluation. The lessons should offer guidance but permit creative variations for both teachers and students.

Art Criticism

In order to make informed judgments about the visual art that they produce and encounter in their own environments, or discover from learning about the cultures of other times and places, children must be knowledgeable in their use of the elements of art criticism. Art has a vocabulary, and instruction must introduce children to ways of understanding and utilizing it. Timeworn emphasis on learning about the elements and principles of art is not inappropriate, it is simply not enough. Too often it is the only content of art instruction for year after year, stifling students' desires and abilities to move from these fundamental lessons toward more challenging and intriguing content.

An art critic is someone who has learned not merely to look, but to see, comprehend, and respond. It is part of the professional art critic's job to help others to do the same. An art critic describes, analyzes, explains, defines, interprets, and evaluates, using higher-order thinking behaviors to enhance the viewer's understanding. Students can be taught to use these skills and strategies. The art curriculum must include opportunities for them to learn and practice criticism with ever-expanding competence.

Lessons from grade kindergarten on should expose children to the finest art available, through accurate reproductions and, whenever possible, exemplars of original work. Children should be encouraged to discuss artworks using techniques of description, analysis and interpretation, guided by teachers' questions and shared knowledge of pertinent information. Students can be taught to discriminate among styles, periods, and a variety of cultural art forms. They can, as a part of their art classes, visit museums, galleries and artists' studios. They can read and write about art, and they can report their honest feelings and interpretations. They can

be held accountable for their statements by indicating those qualities in the artwork itself which are the basis of their claims, just as the professional critic must, and they can be encouraged to recognize the validity of differing perceptions and opinions. Needless to say, these skills of critical response should be used also to talk about the art which they produce themselves.

Art History

Art history is more than a collection of facts. As any qualified art historian will attest, it is a continuing process of inquiry into the attribution, description, analysis, interpretation, restoration, conservation, and explication of works of art. Recognizing that children's concepts of time and space are still developing in the elementary grades, the curriculum must include ways to relate art history to their level of understanding. Artworks need to be shown in connection with their social and cultural context and interpreted by the teacher as they would have been "then and there," as well as by children "now and here." Incorporating art history into units of social studies and literature strengthens and broadens all of the content areas and integrates children's learning. Visiting art museums and applying historical information in viewing original works of art from a particular period or place is a legitimate social studies experience as well as an exercise in art.

Western art history will continue to dominate the art curriculum in most regions of the United States, but localities with large numbers of non-Western students, especially, will want to include representative examples from their particular populations. This approach is valuable for all students as it recognizes the significant contributions of others to the world of art. In the interest of acculturating newcomers to the prevailing standards, however, it is important to continue to use exemplars from the history of Western art, to provide a core of understanding for all. Western art provides a benchmark for comparing the art of other cultures and for contrasting the unique aesthetic qualities and the particular function of art in the society in which it was created.

Aesthetics

The art program must assist students to respond more fully to

works of art and to derive meaning and enjoyment from the encounter. The place of aesthetics (or aesthetic viewing or aesthetic perception — a variety of terms is in current use) is the most recent and controversial component of the new art curriculum, and for most writers it is the most difficult to incorporate. Think of it in elementary language: knowing what one likes, and why. Aesthetic perception involves the use of the senses, the emotions, and the intellect to discover what is good, ugly, boring, delightful, or beautiful and precedes the formation of personal tastes. Children can use their own growing powers to form their own opinions and then compare them with the opinions of experts. Aesthetic experiences should include responses to everyday objects as well as fine art, architecture, furniture, clothing and the like. Most children require little encouragement to become collectors; they should be assisted in discussing the criteria that they apply in their own collecting and relate those procedures to that used by art collectors. They can consider whether standards of beauty are universal and unchanging, whether functional objects can also be artistic, whether gut reactions or an informed decision is more valid, as well as other similar, stimulating and thought-provoking topics. The teacher's job is to guide, not dictate, and the curriculum must supply a challenging array of themes for discussion.

Time for Art: Rethinking the Art Program

Where does the time come from to permit this more comprehensive kind of art teaching? Something surely has to go to allow for this to happen. Some of the old production lessons may have to be weighed and found wanting, and some of the art room procedures may need to be handled more efficiently. Again, one must think in terms of outcomes: What is it that one wants all students to internalize by the end of their elementary school years? By being selective and choosing the essential skill and knowledge, it is possible to give every child a solid foundation for learning to love art throughout a lifetime of increased and deepened experiences. The teacher must measure possible content against a list of criteria: Is this material essential or shallow? Authentic or merely contrived? Will the experience enrich or simply entertain? How involved will students be? Will they be active learners or passive recipients? How practical will the course of study really be? Cooperation with classroom generalists may provide additional insights and suggest content and strategies not immediately apparent to the art specialist.

Classroom teachers may come to see themselves as part of a team and be more inclined to follow through and extend the time for art. Once due consideration has been given to the question of "what" should be taught, curriculum developers must next deal with a set of problems and procedures related to the "how."

The How

Assuming that the district has approved the idea of art curriculum development or revision, accepted the proposed content, and allocated time and money for the project, this is one way that an interested group of art educators might proceed.

• Meet together to be sure that all agree on a philosophy of art education for the district that reflects new and emerging practices and content. Identify the leadership — one or more persons experienced in curriculum development, skilled in group dynamics, knowledgeable about art education, informed about district policies, politics, and priorities, and aware of resources in the community and state. Determine and designate the responsibilities of the rest of the group.

• Select teams of writers from outstanding art teachers and supervisors who know one another's styles of working and are philosophically compatible as well as experienced in the grade levels to which their writing will be aimed. Three-person teams work best, and each team should have at least one teacher who is currently teaching and can provide a check on practicality of the team's ideas.

• Identify the goals, scope, and timeline of the project and obtain agreements from all participants that they will be able to complete the task as described.

• Establish a clear sequence for teaching the essential concepts within each of the components of art education. Plan to build in objectives and activities for teaching thinking as well as the skills of production. Know and utilize what research has said about children's growth and development. Respond to the need to recognize racial and social diversity in the school population.

• Choose "experts" in the fields of curriculum planning and evaluation, art history, art criticism, aesthetics, and the making of art

to serve as consultants during the discussion and writing periods and to authenticate the materials before they are published. These persons may be local or regional resource people who are familiar and in accord with the goals of the project.

• Identify additional teachers of art who will eventually help to field test the materials. Make sure they understand the philosophical basis for the work and will do a conscientious job of field testing. Plan how best to use their feedback and when to revise the lessons. Determine who will revise the lessons — the writers, the readers, or both.

• Make sure that all team members attend or at least listen to tapes of all the meetings so that everyone hears, understands, and agrees to what is discussed, throughout each step of the way.

• Give on-going recognition and gratitude to the members of the project. Remember how hard it is to give extended hours to a job whose future is unsure and whose present is stressful. Support them with money, career credits, perks, or publicity, or all of the aforementioned.

• Require that each team select a specific topic within an overarching theme, such as the Purposes of Art. Specific topics related to that theme might include: Art and Me, Art in My Community, Making a Career of Art, Art in America, Art of Other Cultures; all serving to illuminate how art documents, celebrates, informs, fantasizes, commemorates, etc. Teams should agree on their commitment early in the timeline so as to obtain necessary resource materials in time to study, formulate, and discuss ideas before writing.

• Arrange for the teams of curriculum writers to hear and question the experts, one consultant at a time in an informal setting conducive to easy discussion. Make sure each expert is well-acquainted with the project's goals so that he or she can provide not only the content of the discipline but also suggest ways of utilizing it.

• Disseminate guidelines, charts, or other aids and be sure everyone understands how (and why) to use them. A grid that ranges the four components (production, criticism, aesthetics, and history) along one axis, and concepts, student activities, teaching strategies, and evaluation on the other will show at a glance what has been outlined and what yet needs to be planned. The same kind of grid can be

used for a single lesson or an entire unit. Balance among the four components need not be equal but should indicate due attention to each area. Require that such grids or outlines accompany drafts of work in progress. Input from peers is especially helpful at this time, before intensive writing begins.

• The curriculum expert and component area consultants need to be available as the teams decide on their topics, as they develop their grids or outlines, and as they complete preliminary drafts of lessons, to verify authenticity; before the material is published it should be "signed off" as correct by the experts.

• Try to arrange a retreat in a relatively isolated, self-contained setting in which the actual writing can be done. If possible, team members should have specified times to meet as an entire group and other opportunities to work uninterruptedly as teams or alone for a minimum of 12-15 working days. Consider applying for a grant of outside funding for this phase, to supplement the district's commitment.

• A resource room with books, journals, catalogs, posters, slides, typewriters, and computers is essential during the writing period. A secretary or word processor should be available in or near the resource room for the last half of the time to facilitate "clean" copy for the final stages of editing. Access to a photocopy machine is very helpful.

• At least one museum art educator should be on hand throughout the writing time to advise on availability of visual resources and how they are best obtained and utilized, as there are unsuspected restrictions in this area that could jeopardize the success of the project.

• Brief morning meetings conducted by the project leader(s) will serve to get everyone on-task early and allow for necessary announcements, discussion of procedures or problems, leaving subsequent unstructured hours in which to work.

• Plan some fun-times. Several recreation breaks should be scheduled to change the pace and build esprit de corps.

• As lessons and units take form, plan a time for peer review, encouraging frank comments and critiques among the teams as they

share their work-in-progress. Candid yet courteous criticism is highly valuable at this point.

• The leader(s) should maintain high visibility, to assist wherever needed, and to read and respond to lessons with helpful suggestions at each stage, well before the writing is "in concrete." The leader(s) must obtain museum permissions and photos for the illustrations and do whatever preliminary editing is needed before the lessons are sent out for field testing. The final, edited copy must be submitted to the writers first, for their information and approval, before it is shared outside of the group.

• Writers will also field test their own units and make modifications before doing the last revisions, which will include the recommendations of the other field testers.

• The leader(s) will be responsible for sending a final, edited version to the publisher or printer, along with all visuals that are to be included. The publisher will further edit the text and put it into final format for printing.

• Some kind of event should be planned for closure to recognize and reward the participants for their dedicated efforts and successful results. As the new art curriculum is introduced to the district's staff, administrators, and school board members, the writers should receive a public, formal thank you for a job well done.

In summary, art curriculum development by teachers and supervisors can be successful when certain conditions and procedures are facilitated: Start with a big idea, a theme worthy of the time that art teachers and students subsequently will spend on it — the nature of art, its purposes, its evidence in the contemporary world, etc. Delimit the scope to something manageable. Be sure that the content is important, involving, and feasible. Consider the significance of each main focus, or theme, in relation to the whole matrix of what needs to be taught about art and where it best fits in context. Make sure that it can be approached through all four components or disciplines of the broader conceptualization of art education.

Think about the teaching and learning strategies that the curriculum package will allow. Give attention to what a teacher will need to know or do in order to use the curriculum. Consider the

availability of materials and resources. Think about evaluation instruments or procedures. Design a prototype set of lessons with the help of consultants and museum people, ask for peer critiques, and try them out with several groups of students. Ask for and use feedback. Revise the lessons, send the work on to the printer; and celebrate the completion of the project as it moves into mainstream education.

The primary purpose of art education is not to develop more and better artists, although that is a worthy, possible bonus. What is more important is to produce better educated citizens who will value and support artistic and cultural achievements in an evolving society. Art is communication, a language for expressing hopes, fears, inquiries, loves, understandings, and imaginings. Art is a central force in human existence, and all students need the opportunity to learn its language in order to comprehend experience and make sense of a bewildering world. A substantive curriculum in art education can promote such cultural literacy and enduring aesthetic values.

Reference

Toward Civilization: A report on arts education. (1988). Washington, D.C.: National Endowment for the Arts.

Improving Student Thinking Through Elementary Art Instruction

Craig Roland
University of Florida

Improving student thinking has long been considered a major goal of education. Yet, there is some indication that schools today have not been very successful in this respect. Many of the national reports on public education released over the past decade have cited deficiencies in students' cognitive performance and have reaffirmed the need for teachers to foster thinking in all areas of the school curriculum.

What is thinking? How can thinking be fostered in elementary art classes? What are some ways that teachers already do it? What insights might art teachers gain from looking at recent research on cognition in learning? The aim of this chapter is to provide some possible answers to these questions. Art education offers rich opportunities for encouraging thinking among elementary students, and teachers have shown a growing interest in using it for this purpose. Traditionally, art has been taught in elementary schools as a productive activity with an emphasis on the procedural or mechanical aspects of art making. Recent efforts to legitimatize art in the school curriculum have called this practice into question and have led to increased attention being paid to the cogent nature of learning in art. This trend has been supported by a expanding body of research and literature in art education related to the role of cognition in the making of and responding to works of art.

It seems, however, that the full potential of art education for fostering thinking among elementary students is yet to be realized. Rather, teaching thinking in elementary art classes, today, frequently means having children view and talk about artistic exemplars (often from the 18th and 19th centuries) following prescribed methods designed to elicit predetermined responses to those particular works of art. While this approach may require students to use certain "critical thinking" skills in the process, it is doubtful whether they transfer those skills on their own to other works of art, or whether they better understand the art they encounter outside the classroom as a result.

In this chapter, an attempt is made to establish a basis for a more "holistic" approach to teaching thinking in the area of art education; one in which the full range of cognitive possibilities of students in art might be explored. In the following pages, a modest proposal is offered for planning elementary art instruction which places student thinking at its very core. After a brief review of some general aspects of thinking and current efforts to promote student thinking in art, several instructional principles will be discussed which cognitive researchers suggest are central to fostering thinking in learners. Each principle is applied to learning in art, and specific recommendations are made regarding possible teaching strategies which will likely lead to thoughtful behaviors among elementary students.

Thinking Defined

Teachers concerned with improving student thinking need to first determine what is meant by "thinking." There are several different ways to conceptualize and define thinking. Many teachers equate thinking with "higher order thinking," "critical thinking," or "creative thinking." It is recommended, however, that thinking be viewed by teachers in its broadest sense — as an umbrella under which various kinds of thinking can occur. This approach prevents focusing on one type of thinking in the classroom to the neglect of others.

Consider, for example, the definition by Edward de Bono (1976): "Thinking is the deliberate exploration of experience for a purpose" (p. 32). In this way, an individual may actively direct his or her thinking towards a subject in order to solve a problem, make a decision, predict an event, plan an action, or create a painting. Another general conception of thinking is offered by Barry Beyer (1987) who defines thinking as "the search for meaning" (p. 16). For example, an individual must think either to find meaning in a work of art which is assumed to exist or to make meaning out of it when it has no readily apparent meaning. Thinking then, according to Beyer's definition, consists of the mental processes used by an individual to make sense of experience.

Both of the authors mentioned above characterize thinking as intentional, purposeful, and goal-oriented. From this perspective, thinking could be viewed as involving controlled processes and conscious attention. The amount of attention required depends upon an

individual's experience with a given task and its degree of novelty. The more novel or unfamiliar a task, the more attention it requires to complete it. Of course, there is also thinking which is automatic and which requires little, if any, conscious control or attention (Anderson, 1984, Glaser, 1988). An individual employs automatic thinking when engaged in activities which are very familiar and well practiced such as walking, reading, or driving a car. It is important for teachers to consider the relationship between controlled and automatic thinking for two reasons.

First, it helps to clarify the type of learning structure that students need in order to actively engage in thinking. Tasks which have a certain degree of novelty but which are not totally outside the students' experiences seem to foster the best results (Kuhn, 1986). Too much novelty in a task renders it ineffective because students have no relevant past experience to draw upon as a frame of reference. On the other hand, tasks which are relatively familiar to students are generally processed automatically without much cognitive energy expended. Hence, learning activities intended to encourage thinking in students should involve some blend of controlled and automatic behaviors. Good teachers know this from experience. The introduction of elements of novelty into a learning situation tends to add to the intellectual excitement among students. Moreover, instruction which highlights relations between unfamiliar concepts presented in class and students' own experiences and understandings results in high interest and involvement among students in the lesson. This general notion is consistent with the theories of such scholars as Dewey (1910), Bruner (1968), Piaget (1976), and Sternberg (1988).

Second, applying this view of thinking to the classroom we can see that if students are to develop proficiency in any newly introduced thinking skill, they must do it often enough for it to become automatic and a part of their cognitive repertoire. A principal goal of teaching thinking is to produce individuals who know when to use a particular thinking operation and who do so on their own to generate knowledge (Beyer, 1987). Such a desired outcome is likely to emerge by providing students with instruction in how to execute a thinking skill or strategy effectively and with multiple opportunities to practice using it — both under the guidance of the teacher and on their own initiative. The issue of practice in fostering student thinking is a crucial one which will be addressed, again, later in this chapter.

Some conceptions of thinking acknowledge a hierarchical structure among the various cognitive operations involved in thinking. However, this should not be taken to mean that some thinking is better to promote than others. On the contrary, experts are developing new insights into the interrelations that exist among different kinds of thinking and the ways in which they depend on one another. For example, Robert Sternberg (1988) recently proposed a triarchic model of intelligence which divides thinking into three interdependent categories: executive or "metacognitive" processes (which are used to plan, monitor, and evaluate one's thinking); performance processes (which are used to actually carry out plans and solve problems); and knowledge-acquisition processes (which are used to learn how to think and solve problems in the first place). Sternberg emphasizes that while the parts of his theory are distinguishable, they work together in an integrated fashion. The metacomponents direct the performance and knowledge-acquisition components, and these latter kinds of components provide feedback to the metacomponents.

Similarly, Barbara Presseisen (1987) suggests that any curricular design for teaching thinking requires a framework that is broad enough to account for the complexity of human thought processes. To this end, Presseisen draws upon Karen Kirchener's three-level model of thinking (Kirchener, 1983) which includes: *cognition* at the first level; *metacognition* at the second level; and *epistemic cognition* at the third level. Cognition refers to the essential mental operations that underlie an individual's thinking when engaged in a cognitive task: for example, skills such as analyzing, classifying, comparing, and interpreting, which are typically involved in thinking about works of art. This level also includes cognitive processes like problem solving, critical thinking, and creative thinking.

Metacognition, as previously defined, refers to the reflective strategies and processes involved in self-monitoring and conscious control of task performance. When an individual reflects upon, makes explicit, and studies the mental processes by which his or her thoughts and learning behaviors operate, that person is thinking at this level. Epistemic cognition refers to the ways in which an individual's knowledge in a discipline determines how that person thinks when engaged in cognitive tasks related to the particular subject context. An individual is thinking at this level when confronting the major problems, questions, assumptions, and

concepts embedded in a discipline and when learning cognitive structures for adapting to new information in that discipline.

In sum, a general view of thinking might be considered unsatisfactory for educational purposes on the basis that it lacks specificity and provides too little guidance for teachers in planning for instruction designed to foster thinking or in judging the outcomes of such instruction. A precise definition of thinking, as well as detailed descriptions of thinking skills, would certainly be more acceptable to the forces of accountability which dictate that teachers be explicit in writing specified objectives for schooling. Moreover, some experts suggest that students can benefit from direct instruction and practice designed to improve specific thinking skills. Nonetheless, we need to consider that effective thinking often engages a variety of mental operations and dispositions which are interdependent and which can not be easily separated in distinct, easily identifiable categories. Consequently, a concern for fostering thinking means that we must address the totality of thinking if the goal of improving student thinking is to become a reality.

Cognition in Art Education

The nature of cognition as it relates to art has been the subject of intense study and debate in the field of art education for many years (Madeja, 1978). Indeed, philosophers, researchers, artists, and educators from the time of Plato have questioned whether art is essentially a "cognitive" or a "noncognitive" activity. At issue is the extent to which thinking or feeling determine how a work of art is made and how it is perceived. Some scholars argue that thinking and feeling are not distinct aspects of aesthetic experience; rather, they are inseparable (see, e.g., Perkins, 1981; Goodman, 1968). This notion is not, however, particularly common in schools where cognition and affect are set apart; and where subjects which are thought to involve the mind are considered more worthy of study than those which are thought to involve the body (Eisner, 1981). The art classroom is often seen as a place where students "express their feelings" or "work with their hands." Thus, art as a subject of study is generally assigned lower intellectual status among the regular school subjects. Perhaps as a way to strengthen their relative position in schools, art educators have widely embraced a *cognitive* view of art in recent years.

The present reform movement in art education, which has its roots in the early 1960's, is clearly an attempt to make the study of art more "intellectually acceptable" in schools. Spurred on by financial and moral support by the Getty Center for Education in the Arts in the 1980's, proponents of this movement advocate that schools develop comprehensive and "academically rigorous" art programs that provide children with increased opportunities to study content from the disciplines of aesthetics, art criticism, art history, and art production (Getty Center for Education in the Arts, 1985). This "new" approach to art education, labelled Discipline-Based Art Education (DBAE), is aimed at developing "...mature students who are comfortable and familiar with major aspects of the disciplines of art and who are able to express ideas with art media, who read about and criticize art, who are aware of art history, and who have a basic understanding of issues in aesthetics" (Clark, Day & Greer, 1987, p. 138).

One of the key principles of DBAE ideology involves the belief that art teachers should draw equally from the four disciplines in planning a sequentially organized course of study for their students. According to DBAE proponents, the methods of inquiry and sets of concepts used by aestheticians, art critics, art historians, and artists serve as sources for shaping students' thinking and learning about art (Clark, Day & Greer, 1987). Art instruction guided by DBAE tenets should foster in students increasing sophistication in using these various "avenues of thought" (Clark, Day & Greer, 1987, p. 138) to construct more meaningful and complete understandings of art.

The idea that art is not only a medium of thought but is also a vehicle for developing it is clearly supported in the rhetoric of our field. While art education has long been considered synonymous with creative thinking, much of the talk today about improving student thinking in art seems to suggest that critical thinking is now a matter of greater concern to art educators. Signs of this new emphasis, nourished by the DBAE reform movement, are everywhere. The contemporary literature of art education is saturated with articles on teaching children "how to" use critical thinking skills in order to study, understand, and judge works of art better. Art teachers pack sessions on aesthetics and art criticism at professional conferences looking for ways to engage their students in critical inquiry about works of art. Textbooks and instructional resources that include lessons in describing, analyzing, interpreting,

and evaluating works of art have become commonplace in many art classrooms.

The current interest in teaching students to think critically about works of art has caused teachers to reexamine their beliefs concerning what it means to know and learn in art. Although some teachers have been reluctant to deemphasize the role of studio production as the sole basis for learning in art, many recognize that they need to teach their students new skills for responding to and valuing works of art. All teachers want to help their students make sense of the subject matters they study together; and at the very least, chopping art knowledge into the disciplinary areas of aesthetics, art criticism, art history, and art production is a convenient way to organize the content of art for the purpose of instruction. However, as Wanda May (1989) cautions, "defining subjects as disciplines with their own inherent structures forces an artificial boundary around ways of knowing" (p. 59).

Preparing students to eventually think like experts in the four art disciplines appears to be an important goal of the discipline-based view of art education (Clark and Zimmerman, 1988). Accordingly, the work of teachers is seen as one of moving their students from naive to mature states of understandings commonly exhibited by professional practitioners in the field. How is this to be accomplished? DBAE proponents call for lessons which help students to develop integrated understandings of art content from the perspectives of the four disciplines of art. For some teachers this means lecturing to their students on the history of art; imparting to them a particular way of looking at and talking about art; and asking them to mimic the style of well-known artists in their own artwork. But such a didactical approach to art content not only violates the very nature of art, it also forces students to be passive receptacles of knowledge that originated in other worlds — the adult worlds of aestheticians, art critics, art historians, artists, and art teachers.

In 1916, John Dewey argued that organized forms of knowledge enter directly into the activities of the expert and the teacher, but not into that of the child — the learner. The adult's attitude and knowledge of subject matter extends far beyond the range of the child's understanding, experience, and interest so that the same content might be viewed by the two in quite different ways. From a Deweyan perspective, it might be said that the average child is not likely to be particularly concerned with art as it is organized for its

own sake by art historians. Introduced to the subject through slides or prints of works of art from the past — all of which have names and styles to be learned —the student will probably respond to the content, at best, as information to be temporarily stored for "school purposes" because the data and abstractions it presents are often totally outside his or her limited knowledge and experience. According to Dewey, content becomes more than information to be remembered for school purposes only when two conditions are met: First, the content must relate to "some question with which the learner is concerned," and secondly, it must "fit into his (or her) more direct acquaintance so as to increase its efficacy and deepen its meaning" (Dewey, 1916, p. 186).

In his landmark book, *The Process of Education,* Jerome Bruner (1963) makes a similar case: "The task of teaching a subject to a child at any particular age is one of representing the structure of that subject in terms of the child's way of viewing things" (p. 33). Likewise, Jeanne Bamberger (1978) sees the challenge of teachers as one of helping individual children connect their own ways of understanding experience which she calls "intuitive knowledge" with the conventional formulas or "formal knowledge" that people need to know in order to succeed in school and society. In agreement, Eleanor Duckworth (1987) puts it this way:

> As teachers, we need to respect the meaning our students are giving to the events that we share. In the interest of making connections between their understanding and ours, we must adopt an insider's view: seek to understand their sense as well as help them understand ours. (p. 112)

More recently, May (1989) urges us to conceive of learners as novices, who, through the educational process "are to be slowly and deliberately inculcated into more sophisticated adult ways of knowing;" but, who also "are active agents and designers of their own knowledge and the knowledge of future generations." Implicit in this conception of learners is the assumption that knowledge is "actively constructed, evolving rather than inert, tacit as well as explicit, culturally contextual, and politically and emotionally contextual" (p. 61).

What this concern for the learner suggests is that we may need to broaden our definition of "discipline" as it relates to teaching and learning in art. Whereas the conception of *discipline* frequently put

forward in DBAE literature emphasizes the study of stored forms of knowledge, the conception of *discipline* from the perspective of the learner stresses the creation of new forms of knowledge. This reconceptualization does not mean abandoning the values of a DBAE approach to art curriculum, nor does it mean returning to the permissive instructional practices of yesteryear. It does mean, particularly at the elementary level, that if teachers are to effectively translate into classroom practice the concern for a broader knowledge base in art they will need to design and select curricular activities which help children bridge the gap between the "psychological" organization of their own worlds and the "logical" organization of content inherent in adult worlds of art. This task requires that teachers maintain a balance between content and process in shaping the art curriculum into instructional practices that actively engage their students in the learning process. Consequently, teachers not only need to be knowledgeable of the content that they expect their students to learn; but, they also need to be aware of the cognitive processes which must be used by learners in order to make meaning from the content being studied.

Much of the emphasis in art education today is on defining the dimensions of collective art knowledge and its relevance in general education for all students. Such epistemic considerations are certainly important. The foregoing discussion suggests, however, that the learner's contribution in the educational enterprise deserves far more attention than it has previously received in the reform literature of art education. This point seems especially relevant if students are expected to acquire the knowledge which has been selected for them, to think critically about it, to use it to interpret new experiences, and to go beyond it in creative ways.

Teaching Content and Thinking in Art

It is possible that in the rush to improve students' learning of certain art content, one might neglect the development of their fundamental mental abilities to use the content that has been selected for them in ways that would deepen its present meaning and ensure its future applicability. If so, what can be done to engage students in the thinking necessary for deep and meaningful learning to take place? The growing body of research in cognitive psychology suggests a number of possibilities.

Cognitive psychology is concerned with the mental activities governing human information processing, problem solving, and learning, and it currently represents the mainstream of thinking in both psychology and education (Shuell, 1986). From a cognitive perspective, teaching children to think is primarily a matter of helping them to master the ways in which symbols (e.g., words, numbers, pictures, and so on) are used to denote, represent, and express material or abstract meanings (Gardner, 1983). In the remainder of this chapter, five basic themes or principles are outlined which have been gleaned from recent studies in this area and which appear to hold great promise for empowering students to think and reason in the course of learning. To provide the appropriate perspective, references are also made to some of the literature in art education and in general education which has relevance to each of the principles discussed. Furthermore, several suggestions are made for planning elementary art instruction intended to foster better thinking among students as they engage in learning about art.

Principle 1: Art instruction should attend to what children already know and believe about art.

Cognitive researchers view learning as an active constructive process that is dependent upon the mental activities of the learner (Shuell, 1986). It is now generally recognized that learners build new knowledge structures using their previously formed ideas and beliefs — they continually try to make sense of the new in terms of what they already know (Glaser, 1988; Anderson, 1984). Not surprisingly, children's ideas about a subject are sometimes quite different from those which the teacher is trying to teach them. An important consequence of recent cognitive research involves the finding that when students' conceptions are at variance with those presented by the teacher, these ideas actually interfere with intended learning outcomes and often persist despite formal instruction (Eaton, Anderson & Smith, 1984; Nussbaum & Novick, 1982). While this work has largely focused on how children's *alternative conceptions* play a crucial role in their understandings of science, the lessons learned by researchers could be applied to other school subjects such as math, reading, and art (Resnick & Klopfer, 1989; Perkins, 1987; Koroscik, 1988).

Just as in science, research shows that children have their own ideas and beliefs about art which influence their thinking and

learning in our art classes. For example, studies by Stokrocki (1986) and Johnson (1982) reveal that children of elementary school age often share similar views about the nature of art. Many children conceive of art as an activity involving drawing, painting or "making stuff." Some think of art as a place "where you draw" such as in the art room. Others think of art as something that happens at a particular time of the day — say, two o'clock on Friday afternoons. Still others associate art with objects such as pictures, paintings, or "some projects." Furthermore, virtually all elementary school children believe that art is "fun" or "nice."

Developmental studies also reveal that distinctive age-related changes occur in children with respect to their conceptions of art (Parsons, 1987; Winner, 1982; Gardner, Winner & Kircher, 1975). For example, up to the age of seven or so, young children show a strong affinity for paintings which include familiar subjects and favorite colors. If a painting includes horses, for instance, children at this age will probably say they like it or think it is good because they like horses. A painting is thus seen by young children as a source of private pleasure. Around the age of eight, however, favoritism gives way to realistic representation, and children tend to focus on how the subject matter is depicted in a painting. Hence, older children often judge realistic paintings as better than abstract paintings. The underlying assumption being that paintings are supposed to represent something, and those that do not are considered to be less meaningful. Some untrained adults also share this view.

An important aspect of children's conceptions of art has to do with their source. The general consensus among researchers and art educators today is that children acquire their understandings of art largely through the socio-cultural context within which their growth, education, and encounters in art occur. Thus, it seems reasonable to conclude that adults are principal determiners in what children come to know and believe about art. Several implications for teaching art to children might evolve from this assertion and the foregoing discussion.

First, in order to construct meaningful views of art, instruction must attend to children's present knowledge and beliefs about the nature of art and the artistic process. This means that teachers need to be knowledgeable of the various understandings that their students have about art in order to devise effective pedagogical

strategies for teaching it. One way teachers could acquire this knowledge is by asking students questions about art that require inferential thinking. One might ask: What do you think the artist is saying in this work? Why do you think that? By carefully listening to the explanations and reasons students give for their responses to works of art shown in class, teachers might gain insight into the assumptions students hold about art, the expectations they have about what it should be like, the qualities they believe it should possess, and the ways in which they think it should be judged (Parsons, 1987). Teachers could also pose contradictions to students' initial conceptions and then ask for responses. For example, a few common household objects might be used to initiate a discussion on the nature of art. One might ask: Is this art? What makes this art? Why isn't this art? When might we consider this art?

The teacher should probe different ideas expressed by students and encourage them to ask questions of each other, but should do so with considerable diplomacy. Ideas should be challenged without attacking a child's whole perspective. When listening to children talk about art, teachers need to keep in mind that students can not always put into words what they think or feel about art. Teachers should also remember that there are different and perhaps equally valid ways of creating meaning from the same art experience.

Second, the recognition that children bring to our art classes certain ideas and beliefs about art, which may be in opposition to those teachers wish to teach them, poses certain obstacles to effective learning that must be overcome by instruction. Studies indicate that students must become aware of their alternative conceptions and in effect *unlearn* them before new learning may occur. Accordingly, the goal of instruction may be seen as one of restructuring an existing body of knowledge rather than one of imparting new knowledge into a vacuum. Research indicates that this goal is best achieved when teachers provide students with opportunities to explore their own knowledge of the subject, to challenge and rethink ideas (most often their own), to analyze and discuss other possible explanations (such as those offered by their peers or outside experts), and to test new ideas in various contexts in order to determine their validity or worth (Eaton, Anderson & Smith, 1984; Nussbaum & Novick, 1982). Underlying the use of these pedagogical strategies is the assumption that changes in thinking occur when students' preconceptions are confronted by

specific challenges and contradictions (Dewey, 1910). While their description comes from science education literature, these methods seem suitable to art education as well — especially in teaching aesthetics and art criticism where students are encouraged to engage in reflective discourse about various alternative conceptions of art including their own (Hagaman, 1990; Lankford, 1990; Ecker, 1973).

Finally, the assumption that children's conceptions of art are derived primarily through adult-mediated experiences implies that teachers need to look closely at what they are presently teaching about art, how they are teaching it, and the meanings that children construct about art as a result. Research suggests that learners may construct meanings from art instruction which are quite different from those which teachers have in mind. It is possible, for example, that when instruction emphasizes the manipulative aspects of art-making children may develop a rather simplistic and mechanical view of art in which thinking has little or no consequence. It is also possible that when instruction focuses solely on artist models, art media, and art knowledge of past centuries, children may develop conceptions of art which might be considered inadequate from a contemporary art perspective; in that, they may lack the knowledge structures necessary to recognize or to judge art forms and concepts which have been advanced for the most part during the present century. However well-meaning our intentions might be, teachers should consider that what they teach children about art may actually cause them to get the wrong ideas about art. If this is indeed so, prevailing school practices deserve our careful scrutiny.

Principle 2: Art instruction should help children build an adequate knowledge base in art.

Another theme that emerges from cognitive research centers around the interdependence of thinking and knowledge. There is considerable evidence to show that the amount of knowledge one possesses in a domain has a substantial impact on how one thinks in that domain. Recent studies involving individuals with varying levels of expertise consistently reveal that experts and novices solve problems in fundamentally different ways (Anderson, 1984; Glaser, 1988, 1984; Kuhn, 1986; Kitchener, 1983). Compared with novices, experts interpret and structure the demands of a problem

more effectively because they bring a well-developed knowledge base to bear on that task. Experts usually encounter familiar problems, and consequently, they often rely on *automized* thinking. This allows them to spend more time dealing with the novel aspects presented by the problem. Along this line, reports on individuals known for their creative achievements show that they are not only great thinkers, they also know a lot about their fields (John-Steiner, 1985). Thus, it seems that as knowledge in a domain develops the context in which effective thinking can function becomes available (Resnick, 1987).

As earlier discussed, preparing students to think like experts in the four disciplines of art appears to be an important mission of art education today. To accomplish this goal, teachers need to consider how to best approach the chasm that exists between what children know about art on the one side and what trained adults know about art on the other. It might be assumed that when working with children, one should begin by ensuring they acquire an adequate knowledge base. But art instruction that is highly didactic in nature will not serve our purpose well. When the emphasis is on giving out information and instructions rather than on discussion and challenge, children have little chance to make sense of it all. Cognitive research suggests, instead, that children be enabled to create knowledge and meaning themselves as they experience new information. "To know something is not just to have received information but also to have interpreted it and related it to other knowledge" (Resnick & Klopfer, 1989, p. 4). Accordingly, a primary challenge facing teachers is to determine how the content of art can be taught in ways that foster and stimulate children's mental elaborations of their own emerging knowledge structures. One thing is certain — thinking takes time.

Cognitive researchers concur that teachers should spend more time having students actively using knowledge and less time having them simply acquiring more facts and concepts. This means that an art curriculum designed to foster thinking will cover a few topics in depth rather than many in a fleeting fashion (Mattil et al., 1961). Such coverage makes it possible for teachers to help students gain access to new information; examine its structure; question it; link it to other ideas; and relate it to their own present knowledge, beliefs, and experience. The underlying assumption being that as teachers provide more time for students to explore a subject more deeply, students will build better knowledge structures which can be used to

interpret new experiences, to solve new problems, to think and to reason, and to learn independently later on (Resnick & Klopfer, 1989).

The importance of children being mentally *engage'* in the process of learning has been brought to our attention before (Bruner, 1963; Dewey, 1910). Recent cognitive research reaffirms the old axiom that children learn best "by doing." Today, cognitive approaches to learning stress that children be viewed as builders of their own knowledge structures and that the act of instruction be seen as a form of "scaffolding" enabling children to internalize external knowledge and higher intellectual functioning that they might not be able to do otherwise if left to their own devices (Wood, Bruner & Ross, 1976). As children reach these new levels of understanding, the scaffolding is removed.

During the current period of redefining the nature of knowledge in the field of art education, it might be prudent to consider what is known about cognition in learning when planning curricular and instructional strategies. The field of cognitive research in still in its infancy; however, its findings to date urge teachers to be judicious about what is selected for children to study in art. Teachers need to find ways to synthesize the various professional role models being advanced in art education today if children are to understand how to relate them to one another within their own emerging knowledge structures. In this respect, an art curriculum organized around conceptual clusters, involving students in the key ideas, problems, questions, and values which illuminate art as a field of inquiry, might greatly facilitate their development as thinkers.

Principle 3: Art instruction should promote intrinsic motivation and autonomy in children.

A third theme that comes out of current cognitive research in education is that a major emphasis must be placed on the motivation of the learner. Many researchers today regard motivation as an integral part of cognition. "Indeed, we believe that a very large fraction of learning to think — and of thinking — is a problem of motivation" (Nickerson, Perkins & Smith, 1985, p. 338). There is considerable evidence to indicate that an individual's perseverance and sense of motivation when engaged in an intellectual task is a determining factor in whether a successful outcome is achieved

(Sternberg, 1988). In this respect, it might be suggested that as important as knowledge is to developing minds, it is just as important to foster in children a desire to put their knowledge and thinking to good use.

Merlin Wittrock (1987) defines motivation as "the process of initiating, sustaining, and directing activity" (p. 304). He also reviews a number of studies that reveal how motivational factors such as attribution and locus of control direct students' thinking and learning in school. *Attribution* refers to students' perception of the causes of their successes and failures as learners. Studies have shown that students are motivated to learn when they attribute success or failure to their own efforts, rather than to uncontrollable factors such as luck, lack of ability, or the difficulty of the task. There is also evidence to indicate that teacher reinforcement and praise may not increase students' motivation or persistence, unless it is directed toward the effort they exert on a task. Nor will success in itself enhance students' learning or future performance. Success must be perceived by the students as connected to their own self-initiated actions.

Closely related to attribution is the concept of *locus of control*, that is, a feeling of being in control rather than being controlled by some outside source. Students with internal or external loci of control differ in their attributions and in their willingness to commit themselves to challenging intellectual tasks (Cohen, 1986). This research suggests that teaching students to exercise self-control over their learning and encouraging them to persist in their efforts are crucial links in developing the dispositions necessary for effective thinking. Thinking can be hard work. Students must be convinced that they can do it and that it's worth the effort.

Another area of motivation that has important implications for fostering thinking in students involves the influence of extrinsic rewards on intrinsic motivation. Amabile (1983) has studied the effects of external surveillance, evaluation, and rewards on artistic and verbal creativity in both adults and children. The results of her work provide clear evidence that external rewards (such as grades or competitions) can lead to diminished interest in an activity that initially is perceived by individuals as intrinsically interesting in itself. In other words, a reward can be counterproductive when seen by individuals as controlling an activity that they would otherwise do without the reward. Gerhart (1986) reports similar

findings in a study involving the effects of evaluative statements on the continuing motivation of fourth-grade students regarding drawing and visual puzzles. He found that the threat of grades or peer comparisons seems to undermine children's willingness to commit themselves to future task participation. Consequently, research suggests very strongly that teachers should refrain from using grades or rewards to elicit students' thinking and actions, and instead, encourage intrinsic motivation — a desire to pursue a task or problem for its own sake.

One way for teachers to promote intrinsic motivation is to select or design learning activities that children will find inherently interesting and enjoyable so that they will engage in these tasks willingly without the need for extrinsic rewards. As previously mentioned, tasks which challenge students to think and use what they know in novel (yet somewhat familiar) situations might foster interest and involvement. For instance, Marjorie and Brent Wilson (1982) suggest a number of drawing games which challenge children to draw as many of something as they can or to draw something in as many ways as they can. Of course, children often find studio art activities to be enjoyable and intrinsically rewarding. For this reason alone, many teachers are reluctant to reduce the time children spend making art in order to increase the time available for classroom discussions about art. Yet, the sharing of one's intellectual processes with others can also be intrinsically rewarding and therefore be motivating to children. The use of collaborative learning strategies involving children in group dialogue about art is clearly supported by the work of the noted Soviet psychologist Lev Vygotsky, who believed that learning involves the internalization of activities originally witnessed and practiced in cooperative social settings (Vygotsky, 1978; Fielding, 1989). That is, children learn by participating in group activities where they are exposed to a variety of models who differ in expertise including their teacher and peers. Drawing upon the work of Vygotsky and others, Sally Hagaman (1990) proposes a pedagogical approach involving a "community of inquiry" within which teacher and students explore various aesthetic issues related to art. If carefully orchestrated by the teacher, such an approach would undoubtedly be intrinsically motivating to all those involved.

This is not meant to suggest that an emphasis be placed on collaborative learning strategies in the art classroom and that less emphasis be placed on strategies involving individual achievement.

Rather, there appears to be a place and a need for both in art education even at the elementary school level. Howard Gardner (1989) recommends that "peri-artistic" activities involving critical, historical, and responsive learning should grow from children's own art productions. "The heart of any arts-educational process must be the capacity to handle, to use, to transform different artistic symbol systems — *to think with and in* the materials of an artistic medium" (Gardner, 1988, p. 163). Younger children, in particular, should have opportunities to work directly with materials and media often and should be introduced to art objects made by others in relation to the art objects they make themselves. Such encounters are likely to interest children more and encourage them to develop their knowledge and skills in art further.

Along these lines, George Szekely (1988) illustrates how children can be introduced to the world of art by "trying on the role" of the contemporary artist. By becoming contemporary artists themselves, children not only make art, but they also engage in a continuous search for what art is. They think about art, look at it, talk about it, and come to understand its importance as a unique form of human activity. In short, they become aestheticians, art critics, art historians, and artists. Teachers will find Szekely's approach to art education especially challenging in that it places a pedagogical emphasis on student autonomy and independent decision-making. This leads to a final point.

If teachers want children to be more thoughtful and understanding about art as adults, they need to provide them with opportunities to act upon their own intellectual initiative as often as possible in their art classes at school. When all of the decisions are made for them, students may fail to see art as a cognitive activity intrinsically valuable to pursue or as something meaningful to their lives in and out of school. In order for students to construct meaningful views of art, teachers need to increase their sense of personal control over their own thinking and learning. This is likely to occur if teachers: (1) permit students, at least occasionally, to formulate their own problems to solve (Eisner, 1983); (2) offer them meaningful choices to make; (3) expect them to monitor and evaluate their own thinking (Costa, 1984); (4) help them to see the value in what they are doing; and (5) encourage them to become actively involved in the learning process.

Principle 4: Art instruction should provide children with opportunities to practice their thinking and to use their existing knowledge.

A fourth theme derived from cognitive research concerns the importance of practice in developing children's knowledge and thinking in art. A review of the literature on teaching thinking reveals a bewildering variety of programs and curricula based on different models and conceptions of thinking (Costa, 1985; Nickerson, Perkins & Smith, 1985). Some emphasize critical thinking, good thinking, formal reasoning, decision making or problem solving, while others focus on moral development, reflective thinking, higher-order thinking, creative thinking, or right-brain thinking. Although approaches to teaching thinking can differ in many ways, they all are based upon a common assumption — that thinking is a form of skilled behavior that one can develop and improve through practice.

The importance of practice in terms of developing children's thinking has been recognized by experts for quite some time (Dewey, 1910). Deanna Kuhn (1986) notes that, even though there is no empirical evidence to support such a belief, there has been unusual consistency among theorists over the years regarding the view that the only effective way to teach students to think better is to engage them in thinking. Implicit in this philosophy is the assumption that the development of students' thinking requires more than teaching them the strategies and principles associated with it. Rather, it requires providing them with repeated opportunities to exercise their minds in the context of learning new subject matter with the thinking skills and knowledge they have at their current level of development. With long-term practice, comes the potential for improvement of thinking; in that the cognitive processes employed become strengthened and a part of students' knowledge structures. This enables students to process information within a domain more effectively and with less mental energy (Kuhn, 1986; Glaser, 1984).

To understand the role of practice in developing children's proficiency in thinking it might be helpful to examine the difference between declarative and procedural knowledge (Bransford & Vye, 1989; Alexander & Judy, 1988; Anderson, 1982). Students acquire *declarative knowledge* when they receive instructions or factual information from a teacher or a textbook. They acquire *procedural*

knowledge by converting memorized facts or instructions into mental acts or actual behaviors. In art, for example, when students learn from their teacher such facts as "rhythm is a principle of design" and "rhythm is produced by repeating compositional elements" they are acquiring declarative knowledge. When students create rhythm in their own artwork or describe how rhythm is achieved in a Jackson Pollack painting, they must activate their memory and transform those declarative facts relevant to the task into procedural form. In order to make this transition from "knowing what" to "knowing how" automatically, students need a great deal of practice and experience.

Practice and experience appear to be especially crucial to children's development in art. From a cognitive point of view, ". . . all artworks contain symbols and are themselves symbols" (Winner, 1982, p. 6). Accordingly, understanding and making art might be seen as involving the acquisition of symbolic competence (i.e., the ability to perceive, to create, and to reflect within a particular symbol system). How is this competence acquired? For many years, developmental researchers assumed that the growth of children's perceptual and motor abilities in art occurred spontaneously, irrespective of cultural influence.

Accordingly, several early attempts at explicating developmental patterns in art sought to attribute age-related differences found among children to regular changes or universal cognitive shifts that occur in children's minds as a result of the natural process of development (see, e.g., Gardner, Winner & Kirchner, 1975 and Machotka, 1966). More recently, however, developmental researchers recognize that while a sophisticated understanding of art requires the pre-existence of certain cognitive structures, it is unlikely that children will acquire these necessary structures of thought through maturation alone. Rather, this new perspective strongly suggests that a child's development in art is highly dependent on specific kinds of external contributions such as those offered by a formal education in art (Gardner 1988; Parsons, 1987; Feldman, 1987). This view is, of course, strongly shared by art educators. For example, Jean Rush (1984) writes:

> Making and comprehending art are skills that must be learned. Children begin to manipulate visual and plastic images at a young age if they find tools and materials at hand in their environments. Children left to their own devices without

being taught art skills, however, develop into nonartistic adults. (p. 13)

How can teachers translate the elementary art curriculum into instructional acts that provide children with extensive practice in using the skills and knowledge they have on the content they want them to learn? Several alternatives are possible. For instance, as already suggested, providing frequent opportunities for class dialogue and debate about various "contingent" matters in art are obviously beneficial when students are able to: (1) relate the topic to their own knowledge and beliefs; (2) rethink their initial ideas and assumptions in light of possible contradictions; (3) explore alternative views and explanations for the same situation; and (4) refute views expressed in class (including their own) by means of available evidence (Eisner, 1983). It is through such planned encounters, that ordinary thinking becomes critical thinking (Kuhn, 1986).

Another strategy that could prove useful for engaging children's minds on a regular basis in art involves presenting new art content in the form of problems to be solved with the use of art materials or resources available in the home, the art room, the school, and the community. Dewey (1910) first promoted the idea that thinking occurs when an individual is faced with a problem that is ambiguous and that proposes alternatives. Likewise, Bruner (1968) recognized the importance of problem-solving as a vehicle for stimulating thinking in the classroom. From a motivational standpoint, children are often willing to devote considerable effort to solving a problem for no reason other than the enjoyment of meeting the intellectual challenge it poses.

Consider, for instance, the problem of: *Using materials found around the home, create a mask that will give you a special power when worn.* Art problems like this one offer rich opportunities for students to exercise a wide range of cognitive skills before, during, and after the art object is made. Teachers might use the mask problem, for example, to have students generate a list of occupations or situations in which masks are worn; explore the universality of masks by comparing masks from different cultures (primitive to modern); speculate on the purposes of various types of masks and categorize them by form and function; interpret how specific masks portray certain feelings and meanings (such as those designed to transform the personality of the wearer); determine criteria for

evaluating the success of masks made by members of the class; and so forth. Of course, such extended learning may require considerable time. As already suggested, if fostering student thinking is desired, teachers must insure that adequate time for thinking is available. (See Rush (1989) for a discussion of the need for "conceptually focused" instruction when presenting students with aesthetic problems to solve in art.)

A third strategy involves trying to infuse opportunities for reflection in virtually every art activity with children. As often as possible, we should ask students to consider how they arrive at their conclusions, decisions and solutions. Reflection, in this case, means thinking about past learning and thinking. Its purpose is to make students more aware of what they know and don't know; what's going on inside their heads; how one mental activity relates to another; and how their thinking relates to their learning. It involves helping students to initiate a dialogue between their metacognitive processes and other cognitive processes through questioning. For example, students might be asked to consider questions such as the following when they are looking at works of art: What do I know about this work of art? What would I like to know? How is this work like those I've seen before? How is it different? What does this work mean to me? How did I arrive at this interpretation of this work? What criteria should I use to make a judgment of this work?

Gardner (Brandt, 1987) suggests that reflection should be linked intrinsically to perception and production in planning arts activities for children. According to Gardner:

> Perception means learning to see better, to hear better, to make finer discriminations, to see connections between things. Reflection means to be able to step back from both your production and your perceptions, and say, "What am I doing? Why am I doing it? What am I learning? What am I trying to achieve? Am I being successful? How can I revise my performance in a desirable way?" (p. 32)

If given enough practice, students will eventually internalize this type of reflective dialogue so that there is no need for the teacher to start the dialogue for them. It becomes automatic.

Besides the three strategies discussed above, there are several other approaches that appear to be equally effective in enhancing

34

thinking through classroom instruction (Resnick, 1987; Costa, 1985; Nickerson et al., 1985). One of these other alternatives combines explicit directions in how to execute a specific thinking skill such as analyzing, comparing, classifying, or inferring with opportunities to practice the skill (Beyer, 1987). Students could certainly benefit from direct instruction that shows them how to analyze or interpret a work of art more skillfully than they otherwise do. For such instruction to be worthwhile it should provide procedural advice and independent practice in applying the skill to other works of art as well. Generalizing the skill in this way increases the likelihood that students will use it in meaningful ways when they encounter works of art on their own.

Principle 5: Art instruction should help children transfer their thinking and knowledge to a variety of contexts.

Finally, one thing that probably all experts concerned with thinking in education agree on is that any organized program designed to foster thinking in students must address the problem of transfer (Glaser, 1988; Nickerson et al., 1985). Studies have shown that skills or knowledge learned in one context do not automatically transfer to contexts that differ from the setting in which they were initially developed. For transfer to happen, research suggests an individual must recognize the wide applicability of a particular skill, principle, or concept and when a particular situation calls for the use of them (Kuhn, 1986).

Researchers refer to this as *conditional* knowledge or "knowing when" and where to access certain facts, apply particular rules, and use specific cognitive strategies (Bransford & Vye, 1989; Alexander & Judy, 1988). There is general concern today that we need to do a better job of helping children to "conditionalize" their knowledge by teaching them how to transfer their learning from one subject area to another and from inside the classroom to outside the school.

The issue of transfer has been a matter of some importance in art education over the years. Some thirty years ago it was widely believed that creativity exhibited and nurtured in art classes would transfer to other subject areas in the school curriculum. It was presumed, for instance, that the development of a child's artistic creativity would influence his or her capacity to think and learn in science. We now know, however, that creativity manifests itself

more often in specific contexts rather than across several disciplines. It is unlikely that children encouraged to think creatively in art class will do so in other classes as well unless teachers in each subject area work toward achieving this goal.

At a 1977 conference entitled "The Arts, Cognition, and Basic Skills," participants generated such questions as: What are the identifiable transformational processes that link thinking, perceiving, knowing and expressing in the arts? Are there relationships, similarities, or connections between artistic skills and other kinds of communicative and expressive skills? Are there ways to describe these relationships so that they will have applicability to the instructional process? In regard to facilitating transfer among the arts, conference participants indicated the need for research to determine the degree to which making the underlying cognitive strategies explicit in one symbol system might influence a student's learning capacity in other domains. It was suggested that skills and knowledge might transfer from one artistic medium or discipline to another when there is an overlapping or sharing of certain "schemata" (i.e., knowledge structures) in the symbol systems involved (Madeja, 1978).

The work that comes closest to addressing the above issues is that done by Howard Gardner and his colleagues at Project Zero (see, e.g., Gardner, 1989; Winner, 1982). In short, this research suggests that similar psychological processes and skills may be called upon in the perception and production of all forms of art, but that the development of these cognitive capacities appears very much tied to the context in which they are initially embedded. Thus, children's cognitive development in each of the arts may be more distinct than previously assumed. Gardner (1988) recently put it this way:

> Development of skills in one artistic symbol system, say music, occurs in a systematic way, but the facts of such development cannot simply be applied to other artistic systems. In fact, each artistic area exhibits its own characteristic developmental paths. (p. 159)

From the foregoing, one may conclude that transfer of learning does not naturally happen. If children are to be able to effectively apply their knowledge in dealing with new information, subjects, and settings, it is clear that teachers are going to have to teach them

"how to" and "when to" do it. In order to maximize the possibility that transfer will occur, a variety of tactics should be employed (Beyer, 1987; Sternberg, 1987; Nickerson et al., 1985).

First, ensure that a high degree of correspondence exists between the context within which students learn and the situations which they will eventually encounter outside of the classroom. This means, in part, that teachers should select content and skills for students to study and practice with an eye toward application outside of school. In this respect, it is questionable how much of the knowledge that students acquire in learning to analyze classical works of art would transfer automatically to analyzing contemporary works of art. Prior experiences with both would possibly exert a more powerful influence on students' thinking.

Second, help students apply their thinking and knowledge to the widest variety of contexts possible. To illustrate, art historians and art critics typically classify (i.e., categorize or group) works of art according to similar characteristics. Classifying things helps us to make sense of a very complex world. It is an important cognitive skill that students could practice doing in a variety of ways in art. For example, small groups of students could be given a pile of art reproductions and asked: *Put works together that you think ought to go together based upon a good reason.* Following the sorting activity, each group could then be given a chance to share the strategies they used and to compare their tactics with those used by other groups. On other occasions, students could practice grouping art reproductions according to various standard classification schemes (e.g., subject matter, style, period, media, and so on) and sorting other kinds of data into categories (e.g., words related to the art elements and principles). In order to generalize this skill beyond the classroom, students could also be asked to identify ways the things they encounter in their daily lives are classified (e.g., names in a telephone book, baseball cards, clothes in a bedroom, sections of a supermarket, and so on).

Third, stress the importance of transfer and offer specific guidance and encouragement with respect to it. In art, for example, students should be shown how the principles of design (e.g., balance, variety, rhythm, and so on) permeate the arts and the world around them. To make this learning more long lasting, students should be encouraged to find these relationships themselves (e.g., in magazine pictures, in natural forms, in architecture, and so on).

One might ask: What else is this like? Can you find an example of this? How it this like something you've seen before? As often as possible, teachers need to help students make connections between what they learn in art class and what they experience in other academic and practical settings.

Lastly, get students to think about their own thinking and how they go about doing it. Experts agree that one of the best ways to facilitate transfer of learning is by increasing students' awareness of their own cognitive processes and of their own performance as thinkers. This points, once again, to the importance of encouraging reflection in art. Asking children to step back and look at what they are doing engages them at a metacognitive level, thereby increasing the chances that they will develop self control of their intellectual processes and recognize when to use them later on.

Summary

In recent years, much attention and debate in art education has been focused on the nature of knowledge in our field. Advocates of discipline-based art education have affirmed that well-chosen content is crucial to the advancement of art programs in our schools. In this chapter, it has been argued that content can not be separated from the way it is taught and learned. *Content must be taught in ways that mentally engage the learner.* Along this line, a review of the literature in cognitive science suggests certain instructional principles underlying improvement of the mental processes involved in thinking and learning. By infusing these principles into an elementary art curriculum, it might be possible to improve the thinking of children as they engage in learning about art. Accordingly, it has been proposed that there are at least five interdependent needs to be addressed by art instruction designed to foster thinking in learners. These are: (1) attending to children's present knowledge and beliefs about art; (2) helping children build an adequate knowledge base in art; (3) promoting intrinsic motivation and autonomy in children; (4) providing children with opportunities to practice their thinking; and (5) helping children to transfer their thinking and knowledge to other contexts. From a cognitive perspective, teaching art content and teaching thinking should not be seen as in opposition to one another. Rather, they should complement one another.

References

Alexander, P.A. & Judy, J.E. (1988). The interaction of domain-specific and strategic knowledge in academic performance. *Review of Educational Research, 58* (4), 375-404.

Amabile, T.M. (1983). *The social psychology of creativity.* New York: Spring-Verlag.

Anderson, J.R. (1982). Acquisition of cognitive skill. *Psychological Review, 89,* 369-406.

Anderson, J.R. (1985). Cognitive psychology and its implications. New York: Freeman and Company.

Anderson, R.C. (1984). Some reflections on the acquisition of knowledge. *Educational Researcher, 13*(9), 5-10.

Bamberger, J. (1978). Intuitive and formal musical knowing: Parables of cognitive dissonance. In S.S. Madeja (Ed.), (1978). *The arts, cognition, and basic skills.* (pp. 173-209). St. Louis: CEMREL, Inc.

Beyer, B.K. (1987). *Practical strategies for the teaching of thinking.* Boston: Allan and Bacon, Inc.

Brandt, R. (1987). On assessment in the arts: A conversation with Howard Gardner. *Educational Leadership, 45* (4), 30-34.

Bransford, J.D. & Vye, N.J. (1989). In L.B. Resnick & L.E. Klopfer (Eds.). (1989). *Toward the thinking curriculum: Current cognitive research.* (pp. 173-205). Yearbook of the Association for Supervision and Curriculum Development. Alexandria, VA: ASCD.

Bruner, J.S. (1963). *The process of education.* New York: Random House.

Bruner, J.S. (1968). *Toward a theory of instruction.* New York: W. W. Norton & Company.

Clark, G.A. & Zimmerman, E. (1988). Professional roles and activities as models for art education. In S.M. Dobbs (Ed.), (1988). *Research readings for discipline-based art education: A journey beyond creating.* (pp. 78-97). Reston, VA: National Art Education Association.

Clark, G.A., Day, M.D. & Greer, D.W. (1987). Discipline-based art education: Becoming students of art. *Journal of Aesthetic Education, 21* (2), 129-193.

Cohen, M.W. (1986). Research on motivation: New content for the teacher education curriculum. *Journal of Teacher Education.* May-June, 24-28.

Costa, A.L. (1984). Meditating the metacognitive. *Educational Leadership, 42* (3), 57-62.

Costa, A.L. (1985). (Ed.) *Developing minds: A resource book for teaching thinking.* Alexandria, VA: Association for Supervision and Curriculum Development.

de Bono, E. (1976). *Teaching thinking.* London: Temple Smith Ltd.

Dewey, J. (1910). *How we think.* Boston: D.C. Heath and Company.

Dewey, J. (1916). *Democracy and education.* New York: The MacMillan Company.

Duckworth, E. (1987). *"The having of wonderful ideas" and other essays on teaching and learning.* New York: Teachers College Press.

Eaton, J.F., Anderson, C.W., & Smith, E.L. (1984). Students' misconceptions

interfere with science learning: Case studies of fifth-grade students. *The Elementary School Journal, 84* (4), 365-379.

Ecker, D.W. (1973). Analyzing children's talk about art. *Journal of Aesthetic Education, 7* (1), 58-73.

Eisner, E.W. (1981). The role of the arts in cognition and curriculum. *Phi Delta Kappan, 63* (1), 48-52.

Eisner, E.W. (1983). The kind of schools we need. *Educational Leadership, 41* (2), 48-55.

Feldman, D.H. (1987). Developmental psychology and art education: Two fields at the crossroads. *Journal of Aesthetic Education, 21*(2), 243-259.

Fielding, R. (1989). Socio-cultural theories of cognitive development: Implications for teaching theory in the visual arts. *Art Education, 42* (4), 44-47.

Gardner, H. (1983). *Frames of mind: The theory of multiple intelligences.* New York: Basic Books.

Gardner, H. (1988). Toward more effective arts instruction. *Journal of Aesthetic Education, 22* (1), 157-167.

Gardner, H. (1989). Zero-based arts education: An introduction to arts propel. *Studies in Art Education, 30* (2), 71-83.

Gardner, H., Winner, E., & Kircher, M. (1975). Children's conceptions of the arts. *Journal of Aesthetic Education, 9* (3), 60-77.

Gerhart, G.L. (1986). Effects of evaluative statements on artistic performance and motivation. *Studies in Art Education, 27* (2) 61-72.

Getty Center for Education in the Arts. (1985). *Beyond creating: The place for art in America's schools.* Los Angeles: J. Paul Getty Trust.

Glaser, R. (1984). Education and thinking: The role of knowledge. *American Psychologist, 39* (2), 93-104.

Glaser, R. (1988). Cognitive science and education. *International Social Science Journal, 40* (1), 22-44.

Goodman, N. (1968). *Languages of art.* Indianapolis: Bobbs-Merrill.

Hagaman, S. (1990). The community of inquiry: An approach to collaborative learning. *Studies in Art Education, 31* (3), 149-157.

Johnson, N.R. (1982). Children's meanings about art. *Studies in Art Education, 23* (3), 61-67.

John-Steiner, V. (1985). *Notebooks of the mind, explorations of thinking.* New York: Harper & Row.

Kirchener, K.S. (1983). Cognition, metacognition, and epistemic cognition: A three-level model of cognitive processing. *Human Development, 26,* 222-232.

Koroscik, J.S. (1988). The formation of art understanding: A theoretical view. In A. Swann (Ed.), *Arts and Learning Research, 6* (1), (pp. 11-21). American Educational Research Association.

Kuhn, D. (1986). Education for thinking. *Teachers College Record, 87* (4), 495-512.

Lankford, L.E. (1990). Preparation and risk in teaching aesthetics. *Art Education, 43* (5), 51-56.

Madeja, S.S. (Ed.). (1978). *The arts, cognition, and basic skills.* St. Louis:

CEMREL, Inc.

Machotka, P. (1966). Aesthetic criteria in children: Justification of preference. *Child Development, 37*, 877-855.

May, W.T. (1989). *Understanding and critical thinking in elementary art and music.* Elementary Subjects Center Series No. 8. East Lansing, MI: Michigan State University, The Center for the Learning and Teaching of Elementary Subjects. (ERIC Document Reproduction Service No. ED 308 982).

Mattil, E.L., et al. (1961). The effect of a depth vs. a breadth method of art instruction at the ninth-grade level. *Studies in Art Education, 3* (1), 75-87.

Nickerson, R.S., Perkins, D.N. & Smith, E.E. (1985). *The teaching of thinking.* Hillsdale, NJ: Lawrence Erlbaum Associates.

Nussbaum, J. & Novick, S. (1982). Alternative frameworks, conceptual conflict and accommodation: Toward a principled teaching strategy. *Instructional Science, 11*, 182-200.

Parsons, M.J. (1987). *How we understand art.* New York: Cambridge University Press.

Perkins, D.N. (1981). *The mind's best work.* Cambridge: Harvard University Press.

Perkins, D.N. (1987). Art as an occasion of intelligence. *Educational Leadership, 45* (4), 36-43.

Piaget, J. (1976). *Judgment and reasoning in the child.* Totowa, NJ: Littlefield, Adams & Co.

Presseisen, B.Z. (1987). *Thinking skills throughout the curriculum.* Bloomington, IN: Pi Lambda Theta, Inc.

Resnick, L.B. (1987). *Education and learning to think.* Washington, D.C.: National Academy Press.

Resnick, L.B. & Klopfer, L.E. (Eds.). (1989). *Toward the thinking curriculum: Current cognitive research.* Yearbook of the Association for Supervision and Curriculum Development. Alexandria, VA: ASCD.

Rush, J.C. (1984). Bridging the gap between developmental psychology and art education: The view from an artist's perspective. *Visual Arts Research, 10* (2), 9-21.

Rush, J.C. (1989). Coaching by conceptual focus: Problems, solutions and tutored images. *Studies in Art Education, 31*(1), 46-57.

Shuell, T.J. (1986). Cognitive conceptions of learning. *Review of Educational Research, 56* (4), 411-436.

Sternberg, R.J. (1987). Questions and answers about the nature and teaching of thinking skills. In J.B. Baron & R.J. Sternberg (Eds.), *Teaching thinking skills: Theory and Practice.* (pp. 251-259). New York: W.H. Freeman and Co.

Sternberg, R.J. (1988). *The triarchic mind, A new theory of human intelligence.* New York: Penguin Books.

Stokrocki, M. (1986). Expanding the artworld of young elementary students. *Art Education, 39* (4), 12-16.

Szekely, G. (1988). *Encouraging creativity in art lessons.* New York: Teachers College Press.

Vygotsky, L. (1978). *Mind in society: The development of higher psychological processes.* Cambridge, MA: Harvard University Press.

Wilson, M. & Wilson, B. (1982). *Teaching children to draw.* Englewood Cliffs, NJ: Prentice-Hall, Inc.

Winner, E. (1982). *Invented worlds: the psychology of the arts.* Cambridge, MA: Harvard University Press.

Wittrock, M.C. (1987). Students' thought processes. In M.C. Wittrock (Ed.), *Handbook of research on teaching* (3rd ed.) (pp. 297-314). New York: Macmillan.

Wood, D., Bruner, J. & Ross, G. (1976). The role of tutoring in problem-solving. *Journal of Child Psychology and Psychiatry, 17,* 89-100.

A Community Art Setting Inventory for Elementary Art and Classroom Teachers: Towards the Community Integration of Students Experiencing Disabilities

Doug Blandy
University of Oregon

Community is defined by the collective participation of all of its members. A primary goal of elementary education is to facilitate the participation by young people in their communities toward the time when they will contribute to the community as adults. Early involvement in the community informs children of their mutual capacities, establishes informal relationships with other community members, connects them with their history through the community's written, oral, and visual traditions, gives cause for celebration, and provides solace in the presence of shared tragedy (McKnight, 1987).

Integral to the life and well-being of the community are those formal and informal institutions that provide, encourage, and maintain visual arts traditions. There are myriad community systems which perform this function and include educational, commercial, ritualistic, environmental, depositional, utilitarian, and other general cultural movements (Kavolis, 1973). Community settings representative of these systems include libraries, commercial galleries, places of worship, public parks, museums of art, industries, and informal artist support groups, respectively.

Art educators have long recognized the importance of involving young people in their communities as a part of the art education curriculum. This recognition influences the goals of art education practice, which include encouraging children's understanding of symbolic communication, social theorizing, shaping community values and discussing definitions, conceptions and issues associated with art in a democratic society. These goals are founded on the belief that young people must be prepared to participate in their communities in a way which considers aesthetic values in

conjunction with the economic, political, historical, cultural, social, psychological, and moral values.

In acknowledgement of these goals, McFee (1966) taught that young people who are cognizant of their experience and symbolic communication will be better informed participants in society. Lanier (1973) envisioned young people hypothesizing about social history and exploring those hypotheses in the community through film making. Chalmers (1974) argued that students can and should be shown how art reinforces community and can be used to shape community. McFee and Degge (1977) stressed that one of the goals that art educators and their students must understand is the relationship between visual quality and social, political, and economic concerns in the community decision making process. They presented a systematic plan for involving students in the analysis of community space and an appreciation of how it is shaped. More recently, it has been argued (Blandy & Congdon, 1987) that conceptions of art in a democracy require that art educators and students engage in community-based dialogue towards reaching mutually defined conceptions of art. Boyer (1987) has assumed community involvement in the processes that students and their teachers will engage in as they become culturally literate in art. M. Huffman (personal communication, June, 1988), an art education curriculum supervisor and elementary art teacher, has routinely taken his students into the Lima, Ohio, metropolitan area to study the city's art systems and to speak with community members on art issues.

Current with this perceived importance of community involvement by art educators and their students is the current trend in special education which emphasizes that one goal of special education is the social integration of children experiencing disabilities through community interaction. Special educators recognize the handicaps associated with visual, auditory, learning, physical, emotional, behavioral, and health-related disabilities. However, newer definitions of disability are concentrating less on the limitations associated with disabilities and more on the failure of the community to adjust to the needs of the disabled person (Hahn, 1985). Special educators, in response to this newer approach, have produced a body of literature which demonstrates the benefits of community involvement by people experiencing disabilities and also makes recommendations on how community settings and programs can be made accessible. Some of this research has been directed to

community settings in which art-related activities can be and are a part. These researchers have found that the integration of persons experiencing disabilities into community environments is most successful when approached with care and by systematically attending to barriers to participation, architectural accessibility, staff training, environmental analysis, and evaluation of the integration process (Ray, Schleien, Larson, Rutten, & Slick, 1986). Integration, if approached in this way, can result in an increase in appropriate behavior by people experiencing the severest of disabilities, such as autism, and can encourage positive attitudinal changes by people not experiencing disabilities (Schleien, Krotee, Mustonen, Kelterborn & Schermer, 1987). Such findings, when applied to an art education program in a community museum, can prove significant. One application revealed that children experiencing moderate to severe cognitive deficits could participate with non-handicapped children in encountering fine art and participating in studio activities. The children experiencing disabilities showed appropriate behavior and increased social interaction. Their non-disabled peers' attitudes towards them changed positively and significantly (Schleien, Soderman-Olson, Ray & McMahon, 1987).

The Education for All Children Act, PL 94-142, requires that all children experiencing disabilities be educated in the least restrictive environment. It can now be assumed and expected that art teachers in the elementary schools and elementary classroom teachers who incorporate art into their curriculum will have one or more students experiencing disabilities in their classes. *Section 504 of the Rehabilitation Act of 1973* prohibits discrimination of people with disabilities in any program or activity receiving federal support. It can now also be assumed and expected that many of the community art settings to which a teacher would take students are at least partially accessible, both architecturally and programmatically, to children experiencing disabilities. Many community art sites now incorporate ramps, audio-visual devices, mapping systems, communication systems, and permanent exhibits designed for visitors experiencing disabilities. However, elementary art and classroom teachers, recognizing the possible sensory, intellectual, behavioral, emotional, and physical handicaps associated with disabilities and the failure of some environments to address the associated needs linked to these disabilities, may be reluctant to venture into the community with their mainstreamed classes. (This reluctance may be founded in concerns regarding the selection of appropriate art activities, selection of community sites, the

adaptability of the activity, architectural accessibility, and transportation.) One way in which an educator can confront these concerns and design a positive community art experience is by completing an inventory for a site under consideration for a visit. This inventory is considerate of the specific needs of elementary art and classroom teachers and their students as they venture into community art settings. It is based on the inventory designed by Certo, Schleien and Hunter (1983) and provides new material specific to the art education school and community setting.

The Community Art Setting Inventory

Inventories are often used by special educators to collect instructional information. The model for the following art setting inventory is an ecological assessment inventory developed by Certo, Schleien and Hunter (1983) for the participation of individuals with severe disabilities in community recreation. These researchers recognized that people experiencing severe disabilities are often excluded from recreation and leisure activities routinely offered to their non-disabled peers. In response, they designed an inventory that can be used by therapeutic recreation specialists and educators for involving their clients in recreation and leisure settings. The value of this inventory to art educators is its attentiveness to skills and environment. It is less helpful in terms of providing specific questions about the skills and environments integral to elementary art education programs.

The completion of this inventory requires teachers to perform an on-site evaluation. This important task will reveal the skills the student will use at the site and the environmental conditions under which those skills will be used. All aspects of this inventory are referenced against what the student's non-disabled peers would experience at the site. This approach promotes a "normalizing" experience for the student experiencing disabilities because it assumes that the student's experience at the site will be equal to the experience of non-disabled students. This inventory assumes that only art education activities and community sites which promote mainstreaming and integration will be selected for analysis. This inventory will accommodate an infinite range of activities; however, it is not prescriptive in this regard. It is assumed in the design of this inventory that elementary students may, but not necessarily will,

encounter studio, historical, socio-cultural, critical, and aesthetic experiences in their art programs.

Table 1

COMMUNITY ART SETTING INVENTORY

I. Art Education Activity and Site Selection

A. Are the art education activity and site appropriate for the student?
B. Describe and analyze the art education activity.
C. Describe the site in terms of its socio-cultural environment: key personnel, rules and regulations, other people likely to be encountered.

II. Art Skills and Adaptions Needed for the Student's Full/Partial Participation

A. What equipment and/or materials will be needed by the student?
B. In what ways is this site accessible to the student?
C. What kinds of visual and auditory discriminations will the student need to make at this site while involved in this art education activity?
D. What interpersonal interactions will the student engage in?
E. What prerequisite academic and nonacademic skills will the student need to have?
F. What decisions and judgments will the student have to make at the site?
G. What adaptions and adjustments will have to be made for the student's full or partial participation?

III. Preparation/Orientation/Transportation

A. How will the student need to be prepared to visit the site?
B. Will parental/guardian permission be needed for the student to visit the site?
C. What transportation options are available to the student?
D. How will the student be oriented to the site upon arrival?

The community art setting inventory is outlined in Table 1. It consists of three sections: Art Education Activity and Site Selection, Art Skills and Adaptions Needed for the Student's Full/Partial Participation, and Preparation/Orientation/Transportation. Each section is designed to reveal specific information which can guide student participation and integration at the site. The questions within each section were designed for students experiencing a broad range of disabilities. Some questions will be applicable to all students, but all questions will not be appropriate to the educational requirements of all students. In addition, teachers may wish to include their own questions.

I: ART EDUCATION ACTIVITY AND SITE SELECTION

This portion of the inventory will identify those activities for which a site is needed and provide information to aid in the selection of an appropriate site. There are three sections which provide questions related to: (A) the appropriateness of the activity and site for the student, (B) a description and analysis of the art education activity,and (C) a description of the community art site's social environment; key personnel, rules and regulations, and other people likely to be encountered.

A. Is the Art Activity and Site Appropriate for the Student?

Answers to the following questions will provide assistance in determining the appropriateness of any given art activity and the site in which it will occur.

(1) What art activity and site is being considered?
(2) Would this art activity and site be appropriate for students not experiencing disabilities of the same age as students with disabilities?
(3) Does the student experiencing disabilities have any of the skills associated with this activity?
(4) Can the art activity be adapted without negating your instructional intent?
(5) To the best of your knowledge is the community site selected for the art activity architecturally accessible to the disabled student?
(6) Do the students in the class have an interest in this art activity?

These are probably the most important questions in the inventory. A negative response to any of these questions would indicate that the site or the activity is not appropriate. If answers are affirmative, the rest of the inventory can be completed at the community art site.

B. Describe and Analyze the Art Education Activity

(1) Identify all skills necessary for the student with disabilities to participate in the art activity at the chosen site. (2) Complete a task analysis of the selected activity through direct observation of a non-disabled peer. Refer to Morreau and Anderson (1986) for an excellent description of completing a task analysis of an art activity.

C. Describe the Site in Terms of Its Socio-Cultural Environment: Key Personnel, Rules and Regulations, Other People Likely To Be Encountered

Answers to the following questions will assist in obtaining information necessary for preparing the student for visiting the community art site. Interviews of site personnel as well as direct observation will be helpful in completing this section of the inventory.

(1) What social interactions are likely to occur and with whom?
(2) What type of supervision will the student with disabilities need?
(3) What clothing is appropriate for the site and art activity?
(4) What social behaviors are considered essential at this site?

II: ART SKILLS AND ADAPTIONS NEEDED FOR STUDENT'S FULL/PARTIAL PARTICIPATION

This section is instrumental in determining the instructional and environmental adaptions that will have to be made at the community art site in order for students with disabilities to participate.

A. What Equipment and/or Materials Will be Needed by the Student?

(1) Will this equipment and these materials have to be adapted in any way?

B. In What Way is this Site Accessible to the Student?

(1) Does it meet the National Endowment for the Arts' *504 Guidelines for Accessible Art Programs?* (These guidelines, titled *The Arts and 504*, are an excellent source of information and are for sale through the Superintendent of Documents, U.S. Government Printing Office, Washington, D.C. 20402).
(2) Is the site suitable for the physical capabilities of the student? (Consider motor ability, body positions, cardiovascular endurance, flexibility, and agility)

C. What Kinds of Visual and Auditory Discriminations Will the Student Need to Make at this Site While Involved in this Activity?

(1) Is a sign language interpreter available to the student?
(2) Are audio tapes descriptive of the site available to the student?
(3) Does the site provide large-print materials?

D. What Interpersonal Interactions Will the Student Engage in?

(1) What are the language requirements of the site and art activity?
(2) What interpersonal interactions is the student likely to engage in (cooperation, turn taking, competition, unstructured, spontaneous)?
(3) How many people will the student encounter, and what are their ages?

E. What Prerequisite Academic and Non-Academic Skills will the Student Need to Have?

(1) Will the student need to be able to read, calculate, or tell time?
(2) What prerequisite art skills and knowledge in the areas of studio, criticism, art history, socio-cultural influences, and aesthetics will the student need to have?

F. What Decisions and Judgments will the Student Have to Make at the Site?

Conversations with the site personnel and observation of participants at the site will reveal this information.

G. What Adaptions and Adjustments Will Have to Be Made for the Student's Full or Partial Participation?

(1) How can art activities be adapted or adjusted so as not to make the student appear abnormal? It is important to remember that adaptations and adjustments will be based on the specific needs of the individual student and should be considered as temporary measures leading to full participation (Wehman & Schleien, & Kierman, 1980). Blandy, Pancsofar and Mockensturm (1988) provide a complete description of adapting art activities towards full participation through the application of the principle of partial participation to the art education setting.

III. PREPARATION/ORIENTATION/TRANSPORTATION

This portion of the inventory will suggest methods for preparing the student experiencing disabilities for participation in the art education activities at the site, orientation upon arrival to the site, and transporting the student to the site.

A. How Will the Student Need to be Prepared to Visit the Site?

(1) Will personnel from the site provide preparatory materials for classroom orientation?
(2) If preparatory materials are available, are they appropriate for the student?

B. Will Parental/Guardian Permission be Needed for the Student to Visit the Site?

C. What Transportation Options are Available to the Student?

(1) Are municipal bus services accessible to the student with physical disabilities?
(2) Can the school system provide transportation?

(3) Is there enough parental/guardian support to provide a car pool?
(4) Is the site within walking distance, and if so, does the student have an understanding of traffic/pedestrian regulations?

D. How will the Student Be Oriented to the Site upon Arrival?

(1) Will the site provide an orientation in a way that is appropriate for the student?
(2) Will the teacher be expected to provide the orientation?
(3) Will peer tutors or parents be available to help the student orient himself or herself to the site?

The goal of this chapter is to promote the integration of elementary-aged children experiencing disabilities into community art settings. A systematic method for the facilitation of this goal is provided in the form of an inventory. Art teachers recognize the importance of taking their students into community art settings for the purpose of encountering art objects, artists, critics, historians, arts administrators, appreciators, and other individuals associated with art. This recognition, and the educational experiences it inspires, can also reinforce those goals of special educators working to integrate students with disabilities into the community. This can be achieved if teachers include children with disabilities when visiting community art settings and is most successful when the selected community art setting is appropriate for all students, including those students experiencing disabilities. Completion of the preceding inventory by the teacher will help to insure that the needs of the student with a disability or disabilities will be considered and met. The result will be art education practice which acknowledges and promotes the active participation by all citizens in those settings and systems which provide, maintain, and encourage a community visual arts tradition.

References

Blandy, D. & Congdon, K.G. (Eds.), (1987). *Art in a democracy*. New York: Teachers College Press.

Blandy, D., Pancsofar, E., & Mockensturm, T. (1988). Guidelines for teaching art to children and youth experiencing significant mental/physical challenges. *Art Education, 39* (1), 60-65.

Boyer, B.A. (1987). Cultural literacy in art: Developing conscious aesthetic choices in art education. In D. Blandy and K.G. Congdon (Eds.) *Art in a democracy* (pp. 91-105). New York: Teachers College Press.

Certo, N.J., Schleien, S.J., & Hunter, D. (1983). An ecological inventory to facilitate community recreation participation by severely disabled individuals. *Therapeutic Recreation Journal.* Third Quarter, 29-38.

Chalmers, F.G. (1974). A cultural foundation for art education in the arts. *Art Education, 27* (1), 20-25.

Hahn, H. (1985). Toward a politics of disability: Definitions, disciplines, and policies. *The Social Science Journal, 22* (4), 87-105.

Kavolis, V. (1973). The institutional structure of cultural services. *Journal of Aesthetic Education, 8,* 63-80.

Lanier, V. (1973). Art and the disadvantaged. In G. Battock (Ed.), *New ideas in art education: A critical anthology* (pp. 181-202). New York: E.P. Dutton & Co., Inc.

McFee, J.K. (1966). Society, art, and education. In E.L. Matill (Ed.), *A seminar for research in art education* (pp. 122-126). University Park, PA: Pennsylvania State University.

McFee, J.K. & Degge, R.M. (1977). *Art, culture, and environment: A catalyst for teaching.* Belmont, CA: Wadsworth Publishing Company, Inc.

McKnight, J.L. (1987). Regenerating community. *Social Policy, 17* (3), 54-58.

Morreau, L. & Anderson, F. (1986). Task analysis in art: Building skills and success for handicapped learners. *Art Education, 39*(1), 52-54.

Ray, T.M., Schleien, S.J., Larson, A., Rutten, T., & Slick, C. (1986). Integrating persons with disabilities into community leisure environments. *Journal of Expanding Horizons in Therapeutic Recreation, 1,* 49-55.

Schleien, S., Krotee, M., Mustonen, T., Kelterborn, B., & Schermer, A. (1987). The effect of integrating children with autism into a physical activity and recreation settings. *Therapeutic Recreation Journal, 21*(4), 52-62.

Schleien, S., Soderman-Olson, M.C., Ray, M.T., & McMahon, K.T. (1987). Integrating children with moderate to severe cognitive deficits into a community museum program. *Education and Training in Mental Retardation, 22,* 112-120.

Wehman, P., Schleien, S., & Kierman, J. (1980). Age-appropriate recreation programs for severely handicapped youth and adults. *Journal of the Association for the Severely Handicapped, 7*(2), 17-27.

Reconceptualizing Art Education: The Movement Toward Multiculturalism

Elizabeth Manley Delacruz
University of Illinois
Urbana-Champaign, Illinois

> It is imperative that we reconceptualize the ways in which we view American society and history in the school curriculum. We should teach American history, literature, art, music and culture, from diverse ethnic perspectives rather than primarily or exclusively from the points of view of mainstream historians, writers and artists. (Banks, 1984, p. 15)

Art educators have given considerable attention to the nature and function of the visual arts curriculum, focusing on problematic issues regarding the role of visual arts education within the contingencies of general public education. Central to these issues are varying and seemingly mutually exclusive views of the nature and functions of art itself. As with other fields of education, ideas are used which have been developed in a variety of professionalized practices. This includes not only the often cited art disciplines of studio practice, art history, art criticism, and aesthetics (Barkan, 1966; Clark & Zimmerman, 1978; Clark, Day & Greer, 1987), but other fields such as archaeology, anthropology, psychology, political science, mythology, structural and post-structural linguistics and political science (Beyer, 1987; Chalmers, 1978, 1981, 1987; Jagodzinski, 1982; Lanier, 1987). Noteworthy among these disciplines are those concerned with the sociology of institutions and the dynamics of culture, resulting in a plethora of academic writings that center around the concept of power and voice.

Talk about cultural forces and the ramifications of institutionalized power is of particular interest to certain educational theorists and forms the basis for their proposals for reform (Anyon, 1981; Apple, 1981; Bowers, 1987; Cherryholmes, 1987; Giroux, 1981; Pinar, 1981). This interest is identified as the *reconceptualist* orientation in curricular theory (Giroux, Penna, and Pinar, 1981) and as a reconstructionist approach in general and art education (Chapman, 1985). Chapman (1985) summarizes:

Within the reconstructionist orientation, the acquisition of knowledge about art is viewed as an instrument for the exercise of power; especially in social, civic, and political life. A major goal of art education is to teach students about the role of art in social life, past and present. The relevance of art to the larger context of human experience is a major concern. Because students live in a culturally pluralistic society that is dedicated (at least in principle) to the achievement of equity, the curriculum should reflect the significance of art created by groups not yet well-represented in the disciplines of art — the artistic accomplishments of non-Western cultures, of minority groups, and women; and the import of art forms such as folk art, the crafts, mass-produced objects, and mass-circulated images. (p. 209)

Following are arguments and recommendations for a reconceptualized program of art education which deals with *multiculturalism* as a future area of focus in school arts curricula. Perspectives from a variety of art educators sharing similar views will be presented, highlighting issues central to the field. These issues include questions about values, aesthetic and cultural literacy, cultural pluralism, ethnocentrism, opportunity, power, and art. Underlying these are two fundamental questions: a) *What constitutes an understanding of art and its role in society?*, and b) *What learning experiences best foster or promote this understanding?* Interest in these questions enhances an appreciation of the dynamics of curriculum. Questions stimulated by varying interests bring to our consideration different ways of knowing, and encourage changing conceptions as they complement valued traditions. An eclectic approach is advocated here, as art educators construct and reconstruct curriculum.

Multicultural Perspectives in the 1970's: A Celebration of Cultures

The major goal of multicultural education is to change the total educational environment so that it promotes a respect for a wide range of cultural groups and enables all cultural groups to experience equal educational opportunity. (Banks, 1984, p. 21)

The reconceptualist position in art education was well formulated, albeit peripheral to mainstream views, in the 1970's. Focusing primarily on the inadequacies of art education programs at

that time, a few art educators called for multicultural perspectives in both the treatment of concepts about art and the attitudes toward learners. For Glaeser (1973), multicultural education was a moral responsibility of the profession. He argued for intellectual and aesthetic involvement as well as an understanding of diverse sociocultural variables, which he believed both influenced and are influenced by the arts. Celebrating people from diverse cultural traditions not only implied a "cherishing of cultural integrity and identity" but also realized an "underlying common and shared dimension" of all human experience, so that cultural biases were transcended as alternative conceptions were chosen and new traditions created (Glaeser, 1973, p. 41). Optimistically, Glaeser offered freedom as the product of this approach to art education, freedom defined as the choice among known alternatives including alternatives not yet created.

McFee and Degge (1977) also saw art education as a moral commitment to intercultural understanding. In their conception art education encompassed the ways in which values and meanings in art operate in the lives of people from diverse cultures, with cultures being arenas of both stability and change. They defined culture as a complex of behaviors, ideas, and values shared by a particular group. The visual arts, as defined by cultural anthropologist Clifford Geertz, was an embodiment of cultural ideas and values that transmit and maintain those ideas and values. McFee and Degge recognized that many people are so immersed in their own culture and art that they adhere to both without question. Furthermore, McFee and Degge rejected an idealized or empiricist claim that art is understood simply by looking: "Art is not wholly a universal language. In observing a given work of art, we are limited by our understandings of culture and the degree to which the artist is central or peripheral to the culture" (p. 280). This theme pervades their landmark textbook, *Art, culture, and the environment.* Looking briefly at regional, ethnic, national, and international art, they advocated the study of historical roots and cultural traditions. This meant going beyond appreciating the art of others solely *as art.* Their goal was to get students involved in conceptions about the works of art in terms of the role art plays in human life, and the diversity of information and aesthetic understanding to be gained from studying art. This meant a reevaluation of art in terms of meaning, not in terms of those beliefs held by the dominant culture, but in terms of the beliefs held by many different cultures. For McFee and Degge (1977), then, the role of the teacher was clear:

As teachers, we must help people become more thoughtful about their judgments...We can help people think about what makes beauty in their lives...we can expose them to other choices...The results may be that they will become dissatisfied with their own standards, respond to new ideas about art and beauty and extend their life-style to become more encompassing. (p. 294)

The Question of Value: Taste or Prejudice?

Those elements within a culture to which individuals and groups attach a high worth are called *values.* Within a social system, there are values that influence the group's feelings towards foods, human life, behavior patterns, and attitudes toward people who belong to out-groups. Sociologists have studied the ways in which values develop within societies and how they are inculcated by individuals in a community. Values, like attitudes and beliefs, are learned from groups in which the individual is socialized; we are not born with a set of values and do not derive them independently. Groups use norms and sanctions to assure that individuals inculcate the pervasive values within their culture or microculture. (Banks, 1984, p. 66)

In part, it was the dichtomizing of fine art and popular art (and folk art), and the classification of the fine arts as high art, and the popular arts as mundane, banal, simplistic, and not needing programmed tuition (Broudy, 1972) that led a number of art educators to question the validity of defining the purposes of art education in terms of cultivating good taste and refining aesthetic perception. McFee and Degge recommended expanding students' frames of reference by exposing them to a wide range of cultural artifacts, including functional objects, costumes, ritual objects, architecture, folk arts, and mass-produced objects, noting that each art form could be evaluated by the cultural influences on the artists and the value of the work may have in the lifestyle of the group. As with McFee and Degge, Lanier broke away from the aesthetic education rationale which focused on perceptual skills and which denied the importance of extra-aesthetic considerations such as cultural meaning and social significance. Lanier advocated *aesthetic literacy,* that is, broad social and aesthetic appreciation of diverse art forms as the only purpose for art education (1980). He dismissed rigidly drawn distinctions between the fine and the "unfine" arts (1987).

In Lanier's view, the study of art would move beyond the much touted Fine Arts curriculum (what he referred to as the arts of the middle class) and include, as advocated by McFee and Degge, the folk arts, the popular arts, and the arts of the mass media. Citing Gans, Lanier rejected the assumption that the fine arts are more noble, profound, or worthy of aesthetic consideration. "The majority of our citizens, both young and old, share a rich aesthetic life outside of our own museum and gallery frame of reference" (1980, p. 17). Disdain of the vernacular arts, according to Lanier, merely reflected the prejudices of our own social class and educational background: "It reveals the depth of our misunderstanding of aesthetic functioning and debilitates the impact of our school efforts" (p. 17).

Feldman also noticed the inadequacies of high art-low art distinctions, "Categories and classifications of art have real life consequences: in the present instance they preserve an artificial distinction between the useful and the beautiful or the useful and the expressive" (Feldman, 1987, p. 393). He noted that we are frequently embarrassed by history which has a habit of changing applied art into fine art.

The social agenda for visual arts instruction which was set forth in the 1970's and the 1980's, was in part, a reaction to what was an unfavorable and untenable characterization of the popular arts by some art educators. Rosenblum (1981) argued that rather than imposing a hierarchy of value judgments upon the art forms of popular culture, art educators should promote respect and a broader understanding of art forms that fall outside of the established art world. According to Rosenblum, the popular arts not only facilitate aesthetic experience, but also "aid in the student's understanding of his culture as well as the cultures of other peoples" (1981, p. 11) leading to an art curriculum of greater social relevance. Bersson, rebutting Smith's (1985) assessment of what constitutes the correct content for art education curricula, warned that the popular or "people's arts," which had flourished under the Carter administration, were in danger of being curtailed by "conservative, elitist, and historically reactionary" forces (Bersson, 1981, p. 35). The people's arts included folk, ethnic, applied, social, and political art forms, which Bersson (1981, 1982) and others endorsed as cultural forms worthy of federal support and teaching.

Art Education for a Multi-ethnic Society

> Students should learn that there are many different ethnic cultures in our society, and that these differences are not likely to vanish. Events cause them to emerge in each new generation. This is the antithesis of the melting pot theory. (Banks, 1984, p. 57)

The debate over content in art education is well documented in the literature of the 1970's and the 1980's. This debate centered primarily on the concerns for more broadly based values, values that represented the diversity of cultures which make up the schools. Like Glaeser and McFee and Degge, Feldman recommended that all students study the art of other cultures, and the study of art as a *social phenomenon* became the driving force of his notable work. Observing that our culture is a hybrid of European, African, Latin American, and Asian cultures, Feldman asked, "What is the educational significance of the fact that American culture is exceedingly diverse in its racial and ethnic origins, and that it continues to produce new artistic forms and modes of aesthetic response?" He answered, "At the most general educational level it means that our students need tools to recognize, appreciate and cope with the plethora of cultural forms and expressions that so complex a civilization generates" (Feldman, 1980, p. 8).

For Feldman, the anthropological curriculum (as opposed to the technical curriculum, the psychological curriculum and the aesthetic curriculum) would "shift our attention away from art conceived as a sequence of technical activities or as a type of performance that parallels psychological development...toward the study of *humanity* through art, that is according to the characteristic art created by particular peoples in particular times and places, under particular circumstances" (Feldman, 1980, p. 8). This meant that visual arts curricula must acknowledge the variety of art traditions and ethnic constituencies, and that teachers and students must focus on the arts and artifacts outside the classroom; that is, something other than the students' own artistic expressions. Interestingly, Feldman (1980) rejected the notion of multi-ethnic education as "workshops where children manufacture more or less banal copies of ethnic art" and stereotypical holiday art, although he recognized the potential of holiday art to promote better understanding of meaningful public rituals. He recommended, rather, that teachers engage their students in introductory functional or anthropological discussions coupled

with presentations of actual artifacts seen first hand in museums or in reproductions — in both books and slides. In his conception, teachers and students can "attempt to understand the differences and similarities — functional, technical, and stylistic — between the art of children, the art of preliterate or tribal peoples and the art of urban and literate peoples living in modern, industrial societies" (Feldman, 1980, p. 7).

Lanier also placed art study in the service of promoting greater social, political, and economic understanding, based on his conviction that "all education is ultimately moral education, and that economics and politics are the larger moral equations" (Lanier, 1980, p. 19). Like Glaeser, Lanier set forth the purpose of art education as the enhancement of inter-cultural understanding through art, what Lanier called aesthetic and social literacy. For Lanier the literate citizen is "one who is affectionately knowledgeable about all the visual arts of past and present and of other cultures and our own...our youth should learn to be literate, above all, about those visual documents which explore the conditions of and reasons for their social oppression" (p. 19).

Hamblen argued that "in a pluralistic democracy, the artistic production of all groups needs to be considered a valid expression of significant needs and beliefs" (Hamblen, 1987, p. 22). She acknowledged the importance of studying fine art for its aesthetic value and specifically as a cultural expression, but she noted that this was "one expression among many." Asking why the aesthetic preferences of minorities were held in such low regard, Blandy and Congdon also argued for a broader focus. For them, aesthetic choices must be enhanced by an understanding of the views of more diverse groups representative of our pluralistic society (Blandy & Congdon, 1987).

A New Paradigm for Art Education: Critical Social Theory

Most ethnic groups within a society tend to think that their culture is superior to the culture of other groups. This is especially true of the most powerful and dominant groups. In our society, Anglo-Saxon Protestants are the dominant group. Many of them feel that their culture is superior to the cultures of other groups and define "culture" as those aspects of their culture that they value highly, such as classical music and

paintings by the European masters. *Civilization* is another very ethnocentric term. Americans tend to think that cultures are civilized only when they have social and technological characteristics that are identical or highly similar to their own. However, civilization can best be described as the total culture of a people or nation. (Banks, 1984, p. 66)

The work of McFee and Degge, Lanier, Chapman and Feldman that began in the 1970's reflected an interest in moving the field of art education toward the broader social contexts of art. This interest was carried further in the writings of Bersson, Hamblen, Congdon, and Blandy. By the early 1980's art educators were seriously questioning not only the hierarchical and restrictive conceptions of the aesthetic education movement, with its exclusive emphasis on the fine arts, but also the self-centered studio model on which art curricula were based. Observing the disparity of goals between general education and those emphasized in visual arts education, Johnson (1982) concluded that educational decision makers were correct in questioning the educational benefits stemming from an exclusive emphasis on technical or creative self-expression. She called for an examination of the relationships between the visual arts and contemporary life, noting that historically visual arts education had been, until recent times, concerned with contemporary social goals and problems. Johnson advocated a return to this interest in the interactions between art and society.

In retrospect, the 1980's may now be seen as the first time since the picture study era of the late 1800's that art educators systematically attempted to redefine and structure the visual arts curriculum in terms of appreciation rather than production (Efland, 1987). This effort took two decisive directions, the discipline-based art education movement and the multicultural movement. The discipline-based art education movement, an outgrowth of the aesthetic education movement (Efland, 1987; Smith, 1987), initially embraced the high-art/low-art hierarchy, favoring the high-arts or exemplars as the subject of refined aesthetic appreciation. The multicultural movement initially emphasized the need for intercultural understanding, and promoted all the arts as exemplars, not necessarily or exclusively of superior aesthetic sensibility but of socially-constructed value and meaning. In more recent years, discussions have focused on the manner in which the values of the dominant culture have been institutionalized in art education curricula (Congdon and Blandy, 1987; Hamblen, 1987).

For Bersson, as with Lanier and McFee and Degge, the purpose of art education extended beyond the education of the senses or the cultivation of aesthetic activity. The aesthetic dimension was not the experience of "distance" or "isolation;" rather, it was a transformational return to our humanity. Bersson advocated a socially progressive conception of aesthetic education, one which posits a new role for visual arts curricula of social criticism and social change, the "dialectical antithesis of all-consuming status quo" (p. 39).

Jagodzinski also observed the inadequacies of the aesthetic education movement with its Kantian notions of a historical, non-instrumental aesthetic stance. He rejected Arnheim's and Langer's notion of transcultural expressive universals, citing crosscultural studies that indicated the influence of culture on the perceptions of illusions. He questioned elitist definitions of the aesthetic: "undoubtedly, what are considered to be 'aesthetic' and artistic pursuits are conditioned by the network of social institutions which define 'art' in a particular historical period" (1981, p. 28). Jagodzinski noted the confusion surrounding distinctions about art, aesthetics, and the aesthetic experience and argued, after Gadamer and Gans, for a socio-historical perspective in which each artistic form is seen as a dialectic between the viewer's own "historicity" and the cultural forces under which artworks are founded (Jagodzinski, 1981). This was the critical, reflective stage of understanding which would, according to Jagodzinski, become the impetus for social action.

Building on the work of Aoki and Habermas, Pearse (1983) characterized this critical dimension as *praxiology*, or the reciprocity of thought and action:

> Understanding is considered in terms of reflection, and knowledge is a result of a process of critical thinking that combines reflection and action. Evaluation is considered in terms of discovering underlying assumptions, interests, values, motives, perspectives, root metaphors, and implications for action to improve human conditions. (p. 161)

Praxiology, for art education, would redirect the curriculum toward the political and moral dimensions of the human situation (Jagodzinski, 1979). It would challenge our conceptions of reality, question accepted human social practices and subject both theory and practice to social change. "It attempts to show the alienation of

the human situation and expresses an unacceptable image of it by calling out to our morals for change" (Jagodzinski, 1979, p. 8).

These concerns have been the primary focus of certain National Art Education Association affiliate groups, including the Women's Caucus, the Committee on Minority Concerns, the United States Society for Education Through Art, and the Social Theory Caucus, as well as other art educators with interests in the sociological aspects of public school education. What began as support for the idea that diverse cultural groups make unique contributions to understanding a complex society, contributions worthy of consideration in the visual arts curriculum, has grown over the past two decades into a movement toward critical social theory, theory which "probes tacitly held intentions and assumptions" about human endeavors (Pearse, 1983, p. 161) and attempts to liberate individuals from the institutionalized forces of oppression.

The Political Dimension: Concepts of Power

> History and contemporary social science teaches us that in every past and present culture individuals have had, and still have, widely unequal opportunities to share fully in the reward systems and benefits of their society. The basis for unequal distributions of rewards is determined by elitist groups in which power is centered. Almost every decision made by those in power, including economic policy, is made to enhance, legitimize, and reinforce their power. Powerful groups not only make laws, but also determine which traits and characteristics are necessary for full societal participation. They determine necessary traits on the basis of similarity of such traits to their own values, physical characteristics, lifestyles and behavior. (Banks, 1984, p. 73.)

The literature advocating multicultural curricula in art education reflected a greater political dimension in the 1980's. This position was reinforced by the critical-theorists who characterized some of our most central notions, including "excellence in the arts" and the "ahistorical aesthetic attitude," as "institutionalized dominance." Many of the issues raised by multiculturalists were directed at the policies and practices of the Getty Center for Education in the Visual Arts as it promoted its version of discipline-based art education (DBAE) (Getty, 1985; Greer, 1984; Duke, 1984). To the critics,

the Getty Center was promoting the very practices they had questioned in the 1970's and early 1980's.

These criticisms mirrored the reconceptionalist stance in general education theory, which included a call for broader educational contexts, less restrictive definitions of excellence, and more attention to pluralistic social concerns. Hamblen (1987) argued that the DBAE approach, supported by the Getty Center, limited conceptions of art to those valued by certain experts who tended to exclude the artistic and aesthetic accomplishments of non-mainstream cultural groups. Chalmers (1987) maintained that the Getty theorists neglected socio-cultural perspectives, thereby maintaining the ideology of the dominant culture.

Hamblen and Katan questioned the tactics of what they dubbed as "the aesthetic power brokers." Hamblen argued that institutionalized power and control have squelched critical discussion, thereby preventing the art education field from advancing (Hamblen, 1989). Equally alarming, according to Katan (1988) was the role of the federal government in defining the values for art education. The underlying premises of private and public institutions seemed, in Katan's view, to promote an insupportable concept of value. Katan (1988) chided art educators who adhered to a conception of art that ignored nonmainstream interests and values, saying:

> Fine works of art provide us with a deepened sense of self and of humanity — at least they do for those of us who know how to value them, like yourself. However, there are classes and communities for whom this is not true. So you decide to teach them 'cultural literacy' such that we become a nation united behind a single taste and walking a uniform path. Only thus will we resist the increasingly messy encroachment of cultures and races and languages and skin colors. (p. 21)

She criticized not only those institutionalized "power brokers" who achieved their ends through political means and not by virtue of their ideas, but also complacent art teachers and art educators who lacked the fortitude and insight to involve themselves in questions of ideology and politics.

In Congdon's and Blandy's view, art educators cannot escape or ignore these controversies. Challenging E.D. Hirsch's concept of "cultural literacy" as Eurocentric and myopic, Congdon and Blandy

asked, "Do the methods of analysis that we use have the ability to truly illuminate objects made by people who do not subscribe to the European American fine arts tradition?" They redefined cultural literacy, like Lanier, as "a person's ability to actively examine a culture's meanings, values, and behaviors" (Blandy & Congdon, 1989, p. 22).

Banks (1984) offered some compelling analyses of the disenfranchisement of ethnic groups falling outside of the Euro-American traditions. He distinguished cultural assimilation and acculturation, noting how both phenomenon have occurred in the United States. "In cultural assimilation, individuals or groups acquire the culture traits of a different ethnic or cultural group, usually that of the dominant group, which controls the political, economic, and social institutions in a society" (Banks, 1984, p. 59). "Acculturation, on the other hand, occurs when two different ethnic groups exchange cultural elements and complexes" (Banks, 1984, p. 61). Banks observed that too little is heard about the cultural traits that dominant groups have acquired from ethnic minorities, such as the contributions of blacks to American music, and the contributions of Indians to American foods, dress and the selection of sites for cities" (Banks, 1984, p. 61).

McFee's questions, in any analysis of curricula in the visual arts, should be given serious consideration by all art teachers and art educators: "Which qualities of art are universal to everyone? Which are culture specific? What artistic traditions support democratic values? How democratic are the institutions that sponsor, support and maintain art? How well do publicly supported art institutions sustain the art traditions of all the people? Are criticism and dialogue based on hierarchical values or democratic ones? Do they support and encourage freedom of choice?" (McFee, 1987, p. x).

The study of art of any culture is a complex endeavor, and efforts to design and implement curricula should take into account the following observations. Definitions and propositions in the art disciplines are altered by dissenting views as new theories replace those that no longer function adequately (Margolis, 1987). What were once considered the crude artifacts of non-Western cultures are now held to be exemplars of profound aesthetic sensibility (Vogel, 1984; Robbins & Nooter, 1989). Curriculum development is inherently a political venture, as programs of study legitimize and perpetuate certain beliefs and attitudes for future generations.

Interest in this political dimension will continue to grow as art educators realize that the aesthetic, in lived experience, is inseparable from the moral and social experience.

Rethinking Curriculum

> What does the art of an ethnic group reveal about its lifestyles, perceptions, values, history, and culture? (Banks, 1984, p. 51)

A number of books and articles echoing these concerns have been written for art educators in recent years, focusing on the need for broader sociological approaches in defining and structuring visual arts education (Congdon, 1987) and involving the questioning of mainstream values in art establishments (Hamblen, 1984, 1988). These views reflect an historical stance, one which accepts that knowledge, meaning and value are epistemologically bound to their social, historical and political contexts (Margolis, 1987; D'Amico, 1989). This is a post-structural or deconstructionist philosophical position, derived in part from movements in French literary criticism, particularly the writings of Derrida and Foucault (Cherryholmes, 1987). According to Cherryholmes, post-structural critics deny all claims of cognitive certainty, positing instead that truth, knowledge and value are legitimated by those in power. Post-structural critics and educational reconceptualists "deconstruct" dominant paradigms of thought by asking whose interests are being served by the authorities, or experts, as they define and institutionalize certain truths. It is this notion that educational reconceptualists press in their writings. Schools are not seen as institutions which promote a free and democratic society; rather, they reproduce the social and economic casts already in place by legitimizing the forms of knowledge and systems of value held by those groups in power (Apple, 1981). Reconceptualists call for alternative forms of schooling, forms which recognize, validate and emancipate many segments of society which have been marginalized by current educational and societal practices. This is a call for opportunity, empowerment and cultural pluralism.

The implications of this stance for educational theory, particularly art education theory, are profound. As histories of this field reveal (Lanier, 1972; Johnson, 1982; Chapman, 1978), there has been an everchanging set of philosophical justifications, similar

to, as noted by Lanier, a chameleon changing its colors. Efforts to congeal and organize the essentials of visual arts education around a national set of teachable objectives seemed a good idea at one time. Moreover, our lack of a viable theory was considered irrational (Barkan, 1966), and the consequence of changing myths and a lack of concensus on objectives (Efland, 1987) contributed to the low status of art in the school curriculum which emphasized standardization and accountability. Efforts would be presented for public scrutiny in the literature advocating discipline-based art education. Critics were quick to challenge the elitism of the fine art/popular art hierarchy, as well as the lack of attention to the artistic achievements of women, people of different races or different world cultures. The potential of reconceptualizing art education objectives along post-structural lines of reasoning are well-explored in literature: for some art educators a movement toward recognizing and valuing of cultural pluralism suggests a movement away from the current powerful art museum and institution driven practices which ignore the artistic and aesthetic accomplishments of people of differing ethnic and racial backgrounds (Blandy and Congdon, 1987; London, Lederman, & Burton, 1988).

Interestingly, in more recent years, some Discipline-Based Art Education theorists have modified their original ideas, recognizing that there are many possible forms of discipline-based art education, advocating regional differences (Duke, 1987). The Getty Center is now disseminating large scale reproductions of the works of artists from different cultures for school use. This was a welcome and much needed expansion of the interests of the Getty Center, and is an indication of the evolution of DBAE. The concept of a discipline-based education, if it is to be truly based in the art disciplines, will become more broadly and sociologically oriented as the art disciplines move in that direction.

The analyses offered by Banks merit consideration once again in this context. Banks observed that the assumption of what is Anglo-American is deeply ingrained in the curriculum materials as well as in the hearts and minds of many students and teachers. In his view, one cannot significantly change the curriculum by merely adding a unit or lesson here and there about Afro-Americans. For Banks, it is a question of not only emphasis but of focus, with the teacher as the most important variable. Banks, like Glaeser, McFee and Degge, Lanier, Feldman, Hamblen, and a growing number of art

educators, has made integrating ethnic content into courses a moral mandate.

Multiculturalism as Curriculum Content: From Theory to Practice

> Learning opportunities must be provided to children and adults that lead to greater options for individual choice and for thinking beyond one's own learned cultural patterns of thought, while still preserving respect for one's own cultural roots. Thus each student is given the freedom to retain and/or transcend her culture. (McFee, 1987, p. x)

Interest by art educators in the meaning and significance of the art of other cultures presents several conceptual and practical problems. Curricular considerations include questions that center around issues of inclusion and exclusion with respect to content selection, the paradox of historicism with respect to theoretical premises about that content, and the dangers of the new ethnological frameworks which have the potential to oversimplify or misinterpret other cultural arenas (Clifford, 1987). According to Jagodzinski (1982), complex heterogeneous societies consist of overlapping cultures in which defining boundaries are not discernible; and the idea of a shared cultural knowledge is in question. For Jagodzinski, multiple values must be maintained because a unified aesthetic which unites a subgroup is rare. Feldman, on the other hand, observes that "Experience tends to be reflected in art. The art of Mesopotamian farmers and Aztec farmers — peoples very far apart — exhibit certain similarities. We can also see stylistic similarities in the art of Scandinavian and Polynesian seafarers. They have no common racial background: there must be something about sailing that leads to a distinctive perception of space" (1987, p. 69). These considerations merit interest as the pluralistic content in art education programs increases.

The social sciences are a prolific source of ideas about the art and artifacts of other cultures (Feldman, 1985). However, specialists in these disciplines "often approach art as a source of data applicable to their own purposes" and may not adequately serve the interests of art educators (Lanier, 1987, p. 178). On the whole, Lanier endorses the redirection in art education toward sociological perspectives and applauds suggestions such as those made by Chalmers "that we have more politically and culturally aware

concepts of art education" (Lanier, 1987, p. 183). Art educators should note Lanier's warnings that an anthropologist's or sociologist's understanding of art and aesthetic theory may be limited. Art historians remain the most reliable source of information about the art and artifacts of other cultures. The availability of scholarly books with good color reproductions and descriptions of the meanings and importance of the art of non-Western cultures has grown in recent years. Additionally, many museums have collections of the art and artifacts of cultures from around the world. These collections include masks, costumes, carved and constructed figures of humans and animals, commemorative and domestic vessels, funerary objects, ornately designed tools, boxes, pipes, musical instruments, furniture, and architectural embellishments. These collections have become more available to the public through educational programs and materials, including slides and books.

Art educators who are interested in including study of the art of other cultures in their curricula are faced with complex choices. One choice is to decide to select a particular culture of another part of the world and focus on one particular kind of artwork or artifact, such as masks, as produced by various ethnic groups in that culture. This approach would reinforce the idea of cultural and ethnic diversity and would discourage students from assuming a simplistic view of other cultures. Teachers may also decide to provide students with an opportunity to study a particular art form such as masks as they are produced by a wider range of cultures and societies. In either case, attention not only to the formal and expressive qualities of these art forms, but also to their intended symbolic meanings, is crucial to an adequate appreciation of these works. African masks, for example, differ in appearance and purpose according to the beliefs, interests, and needs of individual communities and tribes. They also differ from masks produced in other parts of the world.

When art forms are studied cross-culturally, similarities can be found between diverse cultures. Comparisons of masks or ritual and domestic objects produced by selected cultures from Africa, Oceania, Central and South America, and the Pacific Northwest can provide insights into the relationships between the geographic, religious, political, and technological contexts of cultures and the influence of context on the art forms they produce and cherish. The themes of the art of these cultures often center around their interest

in evoking the powerful forces of nature, placating the gods, honoring their ancestors, and ensuring the general health and growth of the community. The artifacts of daily living for many of these cultures were not originally distinguished for their own sake, yet they exhibit creative, aesthetic, and refined sensibilities. Skillful use of materials, complex and subtle designs, and powerful references to important aspects of human life give these works a powerful *presence*, or effect on the viewer, regardless of cultural or ethnic background. It is this powerful presence that has inspired many twentieth century artists. Study of the work of these artists and the cultures that influenced them may be a good way to introduce multicultural perspectives.

In any approach, it is very difficult for Westerners to understand the art forms of other cultures because these art forms are greatly culturally specific (Robbins & Nooter, 1989). Masks, for example, serve religious, spiritual, ritual, or entertainment purposes, and in many cases their design and construction are intended to contribute to or produce certain psychological effects or social attitudes. Exaggerated animal and human characteristics often symbolize or portray emotions, needs, and mores that are widely understood within their communities. To community members, spiritual forces work through these masks, which are worn during festivals, funerals, initiations, and entertainment. Wearers frequently don elaborate costumes along with these masks as they perform animated liturgies of song and dance. The context, meaning, and aesthetic effect are lost when these masks are seen in books or in museums. The most difficult aspect of the study of the art forms of other cultures is their diversity of form and function. The art of non-western cultures are distinct in form, construction, design, symbolism, meaning, and effect. Efforts to include study of the art of other cultures will require considerable work on the part of teachers and curriculum planners as they access museums and make use of recently published resources.

Specific curricular approaches have been suggested by many leading art educators including McFee and Degge (1977), Chapman (1978, 1985), Lanier (1980) and Feldman (1985, 1987). They have consistently advocated the study of the distinctive artistic achievements of other cultures and ethnic groups both within and beyond the United States. This view is embraced here, not only for the purpose of promoting a greater depth of understanding of diverse forms of art, but also for generating greater intercultural

understanding in general. This second purpose certainly has a timely appeal for the 1990's with a hopeful new "World Without Walls" (the catch-phrase given to recent profound, worldwide political, economic, and social changes). The danger of stating dual purposes in pedagogy is that these goals tend to become unnecessarily dichtomized in discourse. Art educators working within the framework of general liberal education can comfortably and simultaneously teach both the understanding of art through culture and the understanding of culture through art. They can blend sociohistorical (or instrumentalist) approaches with formalistic approaches (Feldman, 1987), always bringing aesthetic and ethical considerations back to the idea of art's impact on the viewer, as suggested by Lanier (1987). They can investigate stylistic traditions and innovations both in terms of their unique historical development and cross-culturally. They can include the study of past and present non-Western artists, and Western artists who derive their inspiration from other cultures. They can integrate concepts about art from other peoples with their own concepts of art, while preserving cultural distinctions, by representing their ideas and art forms without totalizing them. This can be done by accepting that cultures are, as observed by McFee and Degge, arenas of both stability and change, and, as noted by Banks, arenas of great complexity. They can place content within the context of a reconceptualized aesthetic framework, one which places more value on the questions about the nature and function of art than it does on answers, and one which redirects attention to those questions not asked.

Such a framework views art as an interaction rather than an isolated action, and views this interaction from a partnership model rather than as a form of domination (Gablik, 1989). Art education curricula is de-constructed and re-constructed as the disciplines on which the field is based change. This is the process of renewal and growth, as new and reemerging interests compliment cherished notions.

There is a new era in art education theory; one which posits a multi-faceted, multi-ethnic view of artistic excellence rather than a Western-dominated view. This advocacy for an appreciation of multiple cultures grew out of a demand in the late 1960's and early 1970's that schools become more relevant to the individuals they serve. Although slow to germinate, this idea is now generally endorsed by most art educators, and curricular materials are beginning to reflect an interest in the art of diverse populations. The

next and perhaps the most important step is to move beyond justifications and into the development and dissemination of comprehensive curriculum resources. In this way advocacy becomes more than mere arguments for or against particular theories or approaches. The school curriculum is where theory is translated into practice. It is here, in the area of actual curriculum development, that efforts must be directed if theory is to be implemented. And it is here that much work needs to be done.

References

Anyon, (1981). Social class and the hidden curriculum of work. In H.A. Giroux, A.N. Penna, & W.F. Pinar (Eds.), *Curriculum & instruction: Alternatives in education*, (pp. 317-341). Berkeley: McCutchan.

Apple, M. (1981). On analyzing hegemony. In H.A. Giroux, A.N. Penna, & W.F. Pinar (Eds.), *Curriculum & instruction: Alternatives in education*, (pp. 109-123). Berkeley: McCutchan.

Banks, J.A. (1984). *Teaching strategies for ethnic studies* (3rd ed.) Newton Mass: Allyn and Bacon.

Barkan, M. (1966). Curriculum problems in art education. In E.L. Mattil (Ed.), *A seminar in art education for research and curriculum development* (pp. 240-255). University Park: Pennsylvania State University.

Bersson, R. (1982). Against feeling: aesthetic experience in a technocratic society. *Art Education, 35* (4) 34-39.

Bersson, R. (1987) Why art education lacks social relevance: a contextual analysis. *Art Education, 39* (4) 41-45.

Beyer, L.E. (1987). Art and society: toward new directions in aesthetic education. *Journal of Curriculum Theorizing, 7* (2), 72-98.

Blandy, D. & Congdon, K.G. (1987). *Art in a democracy*. New York: Teachers College Press.

Bowers, C.A. (1987). *Elements of a post-liberal theory of education*. New York: Teachers College Press.

Broudy, H.S. (1972). *Enlightened cherishing: an essay on aesthetic education*. Urbana, IL: University of Illinois.

Chalmers, F.G. (1978). Teaching and studying art history: some anthropological and sociological considerations. *Studies in Art Education, 20* (1), 18-25.

Chalmers, F.G. (1981). Art education as ethnology. *Studies in Art Education, 22* (3), 6-14.

Chalmers, F.G. (1987). Beyond current conceptions of discipline-based art education. *Art Education, 40* (5), 58-61.

Chapman, L.H. (1985). Curriculum development as process and product. *Studies in Art Education, 26* (4), 206-211.

Cherryholmes, C.H. (1987). A social project for curriculum: Post-structuralist perspectives. *Journal of Curriculum Studies, 19* (4), 295-316.

Clark, G. & Zimmerman, E. (1978). A walk in the right direction: a model for visual arts education. *Studies in Art Education, 19* (2), 34-39.

Clark, G.A., Day, M.D., & Greer, W.D. (1987). Discipline-based art education: becoming students of art. *Journal of Aesthetic Education, 21* (2), 129-197.

Clifford, J. (1987). Of other peoples: Beyond the "savage" paradigm. In H. Foster (Ed.) *Discussions in Contemporary Culture, 1*, (pp. 121-130) Seattle: Bay Press.

Congdon, K.G. (1987). Toward a theoretical approach to teaching folk art: A definition. *Studies in Art Education, 30* (3), 176-184.

D'Amico, R. (1989). *Historicism and knowledge.* New York: Routeledge.

Duke, L.L. (1984). The Getty Center for Education in the Arts. *Phi Delta Kappan, 65,* (9), 612-614.

Duke, L.L. (1987). Afterword: Closing remarks made at the "Discipline-based art education: What forms will it take?" National invitational conference sponsored by the Getty Institute for Educators in the Visual Arts. January 15-17, 1987. Los Angeles, California.

Efland, A.D. (1987). Curriculum antecedents of discipline-based art education. *Journal of Aesthetic Education, 21,* (2), 57-94.

Feldman, E.B. (1980). Anthropological and historical conceptions of art curricula. *Art Education, 33* (6), 6-9.

Feldman, E.B. (1985). *Thinking about art.* New Jersey: Prentice Hall.

Feldman, E.B. (1987). *Varieties of visual experience,* (3rd ed.). New Jersey: Prentice Hall.

Gablik, S. (1989). Deconstructing aesthetics: Toward a responsible art. *New Art Examiner,* January, 1989, 32-35.

Getty Center for Education in the Arts. (1985). "Beyond creating: The place for art in America's schools." Los Angeles: The J. Paul Getty Trust.

Giroux, H.A. (1981). Toward a new sociology of curriculum. In H.A. Giroux, A.N. Penna, & W.F. Pinar (Eds.), *Curriculum & instruction: Alternatives in education,* (pp. 98-109). Berkeley: McCutchan.

Giroux, H.A., Penna, A.N., & Pinar, W.F. (1981). *Curriculum & instruction: Alternatives in education.* Berkeley: McCutchan.

Glaeser, W. (1973). Art, concepts of reality, and the consequences of "The Celebration of Peoples." *Studies in Art Education, 15* (1), 34-43.

Greer, W.D. (1984) Discipline-based art education: Approaching art as a subject of study. *Studies in Art Education, 25* (4), 212-218.

Hamblen, K.A. (1987). An examination of discipline-based art education issues. *Studies in Art Education, 28* (2), 68-78.

Hamblen, K.A. (1988). What does D.B.A.E. teach? *Art Education, 41* (2), 23-35.

Hamblen, K.A. (1989). An elaboration on meaning and motives. *Art Education, 42* (4), 6-7.

Jagodzinski, J. (1979). Towards a new aesthetic. Occasional paper No. 12, published by the Department of Secondary Education Faculty of Education, The University of Alberta.

Jagodzinski, J. (1981). Art education reconsidered or please don't have an aesthetic experience! *Art Education, 34* (3) 26-29.

Jagodzinski, J. (1982). Art education as ethnology: deceptive democracy or a new panacea? *Studies in Art Education, 23* (3), 5-7.

Johnson, N.R. (1982). Social goals and education in the visual arts. *Art Education, 35* (1), 22-25.

Katan, E. (1988). *NAEA News, 30* (4), 21.

Katan, E. (1988). Have we ever got an attitude problem in art education! *NAEA News, 30* (5), 23.

Lanier, V. (1968). Talking about art: an experimental course in high school art appreciation. *Studies in Art Education, 9* (3), 32-44.

Lanier, V. (1972). The objectives of teaching art. *Art Education, 25* (3), 15-19.

Lanier, V. (1980). Six items on the agenda for the eighties. *Art Education, 33* (5), 16-23.

Lanier, V. (1987). Misdirections and Realignments. In Blandy, D. & Congdon, K.G. (Eds.), *Art in a democracy* (pp. 175-183). New York: Teachers College Press.

London, P., Lederman, A., & Burton, J., (Eds.). (1988) *Beyond DBAE: the case for multiple visions of art education.* Dartmouth, MA: University Council on Art Education.

Margolis, J. (Ed.) (1987). *Philosophy looks at the arts: Contemporary readings in aesthetics.* Philadelphia: Temple University Press.

McFee, J.K. & Degge, R.M. (1977). *Art, culture, and environment.* Dubuque, IA: Kendall-Hunt.

McFee, J.K. (1987). Foreward. In D. Blandy & K.G. Congdon (Eds.) *Art in a democracy* (pp. ix-xii). New York: Teachers College Press.

Pearse, H. (1983). Brother can you spare a paradigm? The theory beneath the practice. *Studies in Art Education, 24* (3), 158-163.

Pinar, W.F. (1981). The reconceptualization of curriculum studies. In H.A. Giroux, A.N. Penna, & W.F. Pinar (Eds.), *Curriculum & instruction: Alternatives in education* (pp. 87-97). Berkeley: McCutchan.

Robbins, W.M. & Nooter, N.I. (1989). *African art in American collections.* Washington: Institutional Press.

Rosenblum, P. (1981). The popular culture and art education. *Art Education, 34* (1), 8-11.

Smith, R.A. (1987). The changing image of art education: theoretical antecedents of a discipline-based art education. *Journal of Aesthetic Education, 21* (2), 3-34.

Smith, R.A. (1985). Right to the best: or once more elitism versus populism in art education. *Art Education, 26* (3), 169-176.

Vogel, S.M. (1986). *African aesthetics.* New York: Center for African Art.

Leadership and the Elementary Art Specialist: Twenty Ways to Improve Your Program's Position in the Educational System

Phillip C. Dunn
University of South Carolina

Teachers from all fields, and particularly those in elementary art, often remain isolated from the day to day problems which confront educational administrators and other educational decisionmakers. The level of empathy for each other as groups is, to put it bluntly, low. This educational isolationism ultimately contributes to the continuing malaise experienced in the visual arts when educational managers seek to identify and implement new directions and goals. Are art specialists adequately trained in how to function as leaders within the school system? Should they be expected to function as leaders in addition to everything else they are expected to do in the performance of their duties?

The issue of educational leadership has largely been overlooked in this field until recently (Hatfield, 1983). Now, however, many of those who are involved with efforts to improve the position the visual arts occupy within the system have begun to investigate the relationship between developing art programs which can document student learning, and then actively promoting the educational benefits of such programs. The National Art Education Association, the Getty Center for Education in the Arts, and the National Endowment for the Arts are currently providing much impetus for our field in this area. But even in light of the tremendous benefits the institutional support provided by these entities creates, they must still turn to individuals for leadership. Those who develop and promote programs of this nature are indeed educational leaders. They provide leadership by example; they serve as benchmarks of professional success and accomplishment. But the issue of seeking and developing leadership in our field remains enigmatic. Teacher training programs generally seem to overlook the issue, and art specialists often seem hesitant to seek advancement to managerial or administrative rank as they pursue graduate study. It appears that

the one single quality that is so crucial in master art teachers, the desire to interact with materials as a means of instructing children about the discipline of art, unwittingly conspires to make teachers feel that they do not possess the qualities necessary to become competent educational administrators. In essence, we have traditionally found it difficult to give up the the pleasures of making art with children in favor of exercising a leadership role within the educational system.

Should teachers, however, view this as an either/or situation, or can they find some common ground to exercise leadership and become indispensable without sacrificing those things which initially drew us to the teaching profession? In doing so, can they also identify some from their ranks who would truly enjoy evolving into art consultants, supervisors, curriculum coordinators, principals, and even district superintendents? Hopefully, the answer to both of these questions is "Yes!"

Since our own educational training has probably not prepared teachers for this task, they must begin slowly, simply and use as much common sense as they can muster as a guide. They should first consider the four premises which retain much relevance for this issue. These premises are: 1) School administrators are basically uninformed and therefore neutral, not negatively biased, toward the visual arts, 2) school administrators are willing and able to promote any part of the educational program that makes their job easier or improves the school's community image, 3) elementary school art specialists are relatively untrained in the operational structure and priorities of schools and school districts, and 4) elementary school art specialists must begin to expend more of their efforts outside of the classroom if they wish to change their position within the educational system (Dunn, 1984; Dunn, Jewell, Luftig-Clifton, Skinner & Sullivan, 1987).

To improve educational worth, art teachers must be trained to interact empathetically with educational decisionmakers. After years of being given inadequate classrooms, funding and status, it is little wonder that many art teachers assume that school administrators are somehow biased against the arts. Because the process of higher education in virtually any subject area is one of learning more and more about less and less, it should come as no surprise that the graduate course work and training that form the background of a school administrator emphasizes subjects such as school law to the

total exclusion of disciplines like the arts. Therefore, instead of assuming that educational decisionmakers possess an ingrained dislike for the arts, the more logical assumption is to accept the premise that most school administrators are basically uninformed about the arts and remain neutral and unbiased toward them. School administrators simply do not have enough information about and experience with the arts to form an opinion one way or the other until they actually begin to deal with the arts as a part of their total educational program.

The second premise really strikes to the heart of how each of the following strategies functions. This premise addresses the need for accomplishment that exists in everyone, including educational decisionmakers. Although we seldom take time to ponder the organizational structure of school systems, it seems intuitively obvious that school administrators, who also have to report to their superiors, will support activities and programs that make their school or school district appear successful or distinguished in the eyes of the community. The elementary art specialist who can assist an administrator in reaching those goals will surely receive the support of that decision maker at a later date.

From the fact that educational decisionmakers receive very little experience with or exposure to the visual arts in their training, it follows that the reverse is also true. Visual art teachers generally know very little about how school districts function and how decisions are made. As long as there are supplies and tools, a room in which to teach, and exotic things, such as hot and cold running water, teachers seem content to leave the day to day functioning of the school to others. This situation, unfortunately, reduces the level of empathy that teachers have for those making educational decisions, as well as the level of empathy decisionmakers have for art teachers. The lack of training and understanding of how schools function makes teachers reactive rather than proactive. They react to problem situations rather than actively seek to institute positive change within the system.

Finally, the fourth premise addresses the development of a pragmatic assessment of what elementary art specialists can and must do to begin to improve their collective position within the educational schema. Possessing a love for the visual arts and being a master teacher who nurtures student growth and creative development are not enough to bring about the desired change in the

status of the visual arts. In order to bring these changes about, teachers must expend more energies outside of the classroom, even if this means our teaching performance must suffer a *slight* decline. In reflecting upon the history of art education in America's public schools, the quality of teaching has seldom been a major problem. As a field, however, teachers have always been hindered more by the inability to communicate visual concepts to children. Frankly, art programs are among the most expensive educational programs in the educational system, and teachers have seldom, if ever, devoted enough effort to justify costs in terms of the educational benefits received from studying the discipline of art.

When these four premises are accepted, a myriad of possibilities for enhancing visual art programs begin to emerge. It becomes not only possible, but necessary for those in higher education to train teachers through in-service and graduate programs to interact more positively with educational decisionmakers at various levels. It also becomes crucial that teachers begin to concentrate on developing leaders not only in higher education but in all levels of public and private instruction.

The key to this training lies in teaching art educators to work smarter — not harder. In other words, teachers must make the system work for them. The following are suggestions on how to interact with educational decisionmakers in such a way that the art specialist provides direct and meaningful support to them as they strive to provide a high-quality educational program. In implementing some of the strategies, two results should be expected: art specialists with both leadership potential and the desire to lead can be more easily identified, and the visual arts program can become a pivotal educational discipline within the school.

• **First, conduct an interview** with an administrator or educational decision maker (such as a superintendent, principal, curriculum coordinator, or school board member). Seek out their concerns by asking questions such as, "What are the biggest problems you face on a continuing basis in your position?" and, "How can the art program help you become more successful in addressing your concerns?"

• **Second**, many local businesses become actively involved in public education. One popular example is the "Adopt a School Program." Seek out area businesses that utilize the visual arts in

some way and encourage them to **adopt the art program** in your school or district.

• **Third,** encourage each art specialist in your school district to **adopt a decisionmaker.** Each art specialist should inform the "adopted" administrator or school board member that they have been selected and will be receiving information about the district's art program periodically from them. Use this initiative to increase personal contact with and informally educate those who make critical decisions about the importance and educational contributions of the art program.

• **Fourth,** become an information collector or **form an information collection team.** Each member of the team should be charged with collecting all information concerning the educational benefits of visual arts programs. This information should be shared among the team members so that they can participate in the previously detailed "Adopt an Administrator" strategy more successfully. (Note: Since the publication of *A nation at risk: The imperative for educational reform* (1983), more than twenty reports on the condition of American education have been published. Many of these reports add critical support to the contention that study in the visual arts provides learning experiences that are not duplicated anywhere else in the school curriculum [Academic Preparation in the Arts, 1984]. While art specialists do not have the time to read and study each and every report that comes out, the members of an information collection team could easily split up these duties and provide copies of important pages, sections, or chapters to team members).

• **Fifth,** identify and **work with the leaders of community arts organizations** (Lynch, Jennings, & Katz, 1988). Generate a series of activities involving the school art program with mutual benefit.

• **Sixth,** make art a permanent part of the school's environment. **Establish a Principal's Permanent Art Collection** in which works of art are framed and placed on permanent display each year.

• **Seventh,** have a class or group of students **create a work of art of monumental proportions** that is donated to the school. Be certain that the media, school board members, parents, and other interested parties are invited for the unveiling.

• **Eighth, recognize those decisionmakers who support the arts.** A plaque or certificate that commemorates their actions can provide the needed reinforcement which ensures continued or even increased support.

• **Ninth,** research and **use the educational goals of the school or district.** Note the specific goals to which the arts relate, and mention them in annual reports and presentations whenever possible.

• **Tenth, create a flyer which describes the art program in the school district.** Include information on the general and specific goals of the district. Take a rough draft of this document to the administration for suggestions and approval. Distribute the flyer at parent-teacher conferences, and make it available to the local chamber of commerce for inclusion in real estate packets and other public relations materials.

• **Eleventh, create an Art Newsletter** which is distributed to every student, teacher, administrator, board member, and parent. This newsletter could either be part of the school paper or a separate entity. Regardless, it should be published and distributed regularly. Use this newsletter to outline the goals of the art program. Use students as reporters and illustrators to illustrate the verbal and visual skills students are gaining in art. The newsletter can also be used to solicit assistance from members of the community who have an interest in art.

• **Twelfth,** use those individuals identified by the newsletter as having an interest in or connection with the real world of art to **create a Visual Arts Speakers Bureau.** Community members who collect art or use art in their professions can be invited to speak on their collections or vocations.

• **Thirteenth,** seek district or county approval **to form a local Art Education Action Group.** This group should address common problems in the schools in a way that is acceptable and nonthreatening to the school administration. Membership in this group should be voluntary so that art teachers who fear reprisals or who are uncomfortable with change can exclude themselves. Invite a member of the school administration or board of education who has a record of supporting the arts to serve as an "ex-officio" member of this group. This person could become a valuable asset in several

ways as a source of information about how and when important decisions will be made, and as a positive influence on those in the group who have a tendency to complain about current conditions rather than look for ways to improve them.

• **Fourteenth, begin a parental support group** for the visual arts similar to those that abound around public school music programs. To get this support group off the ground, find at least two wealthy people with an interest in the arts and lots of spare time. Begin with a combination of fund raising and service activities so that members feel that they are getting something for their membership fees. Hold several activities during the year with guest speakers, awards, or simply a gala exhibition with wine and cheese.

• **Fifteenth, seek assistance from professional associations** at the local, state, and national levels whenever necessary. These organizations are a major source of support for lobbying and dealing with the political aspects of the visual arts' position in the educational schema. Encourage fellow art educators to become members of these organizations, and share public relations efforts as well as other related ideas with them. These organizations can provide valuable services, such as dealing with difficult administrators and initiating changes in a district.

• **Sixteenth, support the establishment of a Statewide Art Education Taskforce** to function as a team of emissaries to the professional organizations of educational decisionmakers. This group would be responsible for making presentations about the visual arts before such organizations as the state associations of elementary school principals, secondary school principals, school superintendents, and school boards.

• **Seventeenth**, request a neutral party, who has expertise in evaluating visual arts programs, to **undertake a program assessment** of the school's or district's art program. State art consultants or art educators from the state's higher education system are usually more than willing to perform this service. Use the expert's written report as ammunition to build support for an art program.

• **Eighteenth, develop an evaluation instrument** to help administrators evaluate art programs. Many of the evaluation techniques administrators normally use do not seem to work well in

evaluating the visual arts. Provide these decisionmakers with the proper information to assess efforts and performance.

• **Nineteenth, provide decisionmakers with suggestions concerning appropriate staff development and in-service activities.** Often the people who plan these functions do not know what their art teachers want or need from these activities, and a tactful suggestion could be highly appreciated.

• **Twentieth**, always **write an Annual or End of the Year Report** which details the successes and shortfalls of the art program during the previous school year. Use this report as a means of getting administrators or school board members to think about the art program when they make improvements in the district's educational program. Complete the report so that it is in the hands of decisionmakers just before they consider how to spend the next year's school budget.

These are just a sampling of successful methods which can be used on a grass roots level to give teachers direction and strategy in art education's continuing quest for educational legitimacy. The issues affecting educational policy and decision making comprise the most crucial area that this profession must address during the remainder of this decade.

Early in this paper two crucial questions were posited: Should elementary art specialists be trained to function as leaders, and, with the knowledge of how many students they serve each week, should they be expected to take on this additional burden? The answers to these questions are, of course, mixed. No, elementary art specialists generally are not trained to even aspire to becoming educational leaders. It is assumed that they are given supervision and leadership by a cadre of elementary art coordinators who bridge the gap between educational management and the art classroom. And, in the best of all worlds, this would be true. Art coordinators should be expected to provide leadership, direction, and continuity to public school art programs by directing the specialists and providing in-service to classroom teachers so that the work of the specialist could be continued and extended by the regular classroom teacher.

Sadly, however, the number of elementary art specialists who become art coordinators has lagged proportionally behind the

number of elementary art specialists in the schools. In the state of South Carolina, which has been in the forefront of art education for the past several years in hiring new art specialists, only twelve of ninety-two school districts currently employ an art or fine arts coordinator. An informal survey conducted among graduate students over several years shows that few art specialists currently aspire to become educational administrators of any sort. The issue of leadership, therefore, falls squarely upon the art specialists. Fortunately, we are in the middle of a period of rekindled public interest in both the arts (Americans and The Arts, 1984) and public education. Much attention is currently paid to upgrading teacher preparation programs in colleges and universities. As this reform movement in the pre-service education of teachers continues to support the exploration of relationships between theory and practice, more time will be devoted to training art specialists for the leadership roles so necessary for continued growth. For survival, art teachers must be trained to help decisionmakers become sensitive to the contributions the visual arts make to the educational system. Art educators who want to become art coordinators, curriculum coordinators, school principals, and even superintendents must be identified.

When an educational decision maker who possesses a strong background in art becomes commonplace rather than a rarity in schools, then there will have been significant gains in our quest for educational legitimacy as an academic discipline. Then, and only then, will the educational benefits of a thorough foundation in the visual arts be understood, and prized for its undeniable worth. In the meantime, teachers must continue to strive for educational parity; we must continue to identify, nurture, and develop leaders from their ranks, and apply the advocacy and marketing strategies outlined in this paper.

Author's note: For more information and detail concerning many of the strategies outlined in this paper see *Promoting School Art: A Practical Approach,* published by the National Art Education Association.

References

A nation at risk: The imperative for educational reform. (1983). Washington, D.C.: U.S. Government Printing Office.

Academic preparation and the arts. (1985). New York: College Board Publications.

Americans and the arts:1984. (1984). New York: American Council for the Arts.

Dunn, P.C. (1984). Public relations and the Visual Arts: Ten ways to improve your program's position in the educational system. *Viewpoints: Dialogue in Art Education.* Spring, 4-6.

Dunn, P.C., Jewell, R., Luftig-Clifton, M., Skinner, C., & Sullivan, D. (1987). *Promoting school art: a practical approach.* National Art Education Association. Reston, VA.

Hatfield, T.A. (1983). *An art teacher in every school?* Columbia, SC: Whitehall Publishers.

Lynch, R.L., Jennings, A.F., & Katz, J. (1988). How to get the most out of state and local arts agencies. In Jonathan Katz (Ed.), *Arts and education handbook: A guide to productive collaborations.* Washington, D.C.: National Assembly of State Arts Agencies.

Pedagogical Practices in Preservice Art Methods Courses for the Classroom Teacher: A Research Agenda

Lynn Galbraith
University of Arizona

The shift beyond the teaching of creative art activities towards the inclusion of aesthetics, art criticism, and art history in school art programs has accelerated the need to examine what teachers need to know in order to teach art successfully. The integration of these additional content areas and the National Art Education Association's call for quality art programs in today's schools have highlighted a growing need to focus on preservice art education programs. Changes will be required in how preservice teachers are educated.

One area of concern to the author is how future elementary classroom teachers (non-art specialists) can be introduced not only to these four art components, but also to ways of implementing this content more innovatively and effectively. How can preservice classroom teachers be encouraged to widen their limited perspectives of art education thereby embracing the teaching of these integrated areas? Despite the call for art specialists for every school which was made by the National Art Education Association, it is a fact that elementary school art is still taught by classroom teachers in 42 percent of the nation's schools (U.S. Department of Education, 1988). These teachers usually have little background knowledge about traditional art practices, let alone a working knowledge of aesthetics, art criticism, and art history.

Preservice classroom teachers enter their teacher education programs having spent much of their lives in classrooms. They often bring with them a set of general observations and assumptions about teaching which is grounded in the experiential nature of their own schooling (Lortie, 1975). Moreover, it has been suggested that some preservice teachers often feel that they will learn little from their teacher education programs, and that they already possess sufficient understanding about the nature of teaching (Feinman-Nemser & Buchmann, 1983). Thus the task of introducing some of

these preservice classroom teachers to a pedagogical repertoire of instructional concepts and skills which transcends previous observations and experiences of their own art schooling is both mandatory and onerous. As Goodlad (1983) states: "Teacher's pedagogical habits are extraordinarily resistant to change, protected by the mystique of professionalism and academic freedom and hidden behind classroom doors" (p. 44). Most preservice classroom teachers may need to be taught how to think about, and teach art differently, in order to change traditional art practices in schools. In general, most classroom teachers are trained within the undergraduate offerings of a college or university; with many of their professional courses being taught in schools of education.

One of the professional components of an elementary preservice teacher education program is the methods course component. Methods courses provide preservice teachers with opportunities to learn about pedagogical knowledge within specific subject areas (Lanier & Little, 1986). This pedagogical knowledge can be defined as the knowledge and skills required for teaching these subject areas, as opposed to knowledge of the subject matter itself. Teaching is a highly complex act that involves continuous negotiations of the simultaneous events that take place during classroom interactions (Doyle, 1986). Thus, successful teachers draw upon a repertoire of skills which enable them to make knowledgeable, sensitive, and flexible pedagogical decisions about appropriate and joyful conditions for learning.

Many institutions offer special methods courses within each of the separate elementary school subjects. Therefore, art educators, competing with educators in other elementary school subject areas, are assigned relatively little contact time in which to provide preservice classroom teachers with a thorough understanding of the curricular and pedagogical content needed for elementary art teaching. Many classroom teachers will graduate from their teacher preparation programs having taken only one or two university or college courses related to art education. A methods course on teaching art to elementary children is only a small segment of a preservice classroom teacher's professional course work.

Preservice teacher education, itself, is not only highly controversial, but it is also the object of much criticism from both within and outside of education (Lanier & Little, 1986). Unfortunately, much of the recent rhetoric has been aimed at methods course in-

struction (Adler & Goodman, 1986). It has been alleged that these courses contribute little to the development of the professional and pedagogical skills necessary for prospective teachers (Katz & Raths, 1982; Sedlack, 1987). These courses are considered to be either too idealistic and removed from the reality of teaching within schools (Koehler, 1985; Lortie, 1975) or are perceived as too simplistic and lacking substance and rigor (Beyer & Zeichner, 1982).

Furthermore, the recent calls for reforms (Carnegie Report, 1986; Holmes Group, 1986) within preservice teacher education have suggested that preservice classroom teachers need more course work in the liberal arts, thereby threatening the place of professional courses within teacher education programs. However, some educators feel that this emphasis on subject matter preparation does not seriously take into account the body of pedagogical knowledge that has been recently accumulated by researchers on teaching (Berliner, 1985). From this latter perspective, teacher education is viewed as a vehicle for disseminating information, not as the means by which prospective teachers learn how to function as teachers.

Nevertheless, such critiques, both positive and negative, have failed to significantly change the actual instructional content of methods courses. Research studies have shown that instructors of many methods courses use a limited repertoire of instructional strategies in their teaching (Shaker & Ulrich, 1987). This simplistic core of teaching strategies — lectures, discussions and student reports — fails to serve as an adequate teaching model for how preservice classroom teachers should instruct future elementary students.

In art education, little documentation has been gathered on the types and quality of preservice training for the classroom teacher. Recent reviews (Jones & McPhee, 1986; Maitland-Gholson, 1986; Sevigny, 1987) of preservice teacher education practices have focused primarily on the issues involved in training art specialists. Lovano-Kerr (1985) has suggested that the content of methods courses for *classroom* teachers must be changed in order to meet the needs of Discipline-Based Art Education as promoted by the Getty Center for the Arts, in order to encourage instruction that goes beyond a sampling of studio experiences. Such changes must also take place if the goal of providing quality art education in all schools is to be met. Preservice teachers must be introduced to concepts that provide for the integration of aesthetics, art criticism, art history, and art production in the elementary classroom curricula. Preservice

teachers will also need to understand which aspects of this integrated content are suitable for elementary school instruction, as well as understanding how this content can actually be taught.

To date, few research studies have been conducted on the actual processes involved in teaching art (Galbraith, 1988a; Koehler, 1979). There are few accounts and exemplars of actual teaching within the four art areas that can serve as models for future class-room teachers. Although a number of published curricular texts are available for elementary classroom use, preservice classroom teachers still need to learn how to teach from these more effectively and innovatively, as well as develop research skills for identifying content within the four art areas.

Art educators who are responsible for instruction in methods courses must reflect upon what is presently being taught or should be taught to preservice classroom teachers. Preservice classroom teachers are frequently unfamiliar with the areas of aesthetics, art criticism, and art history, and this condition is manifested in the definition of art education which is grounded in traditional creative art activities (Galbraith, 1988b). Therefore, how can art educators expose these preservice teachers to the rudiments of art, yet at the same time focus on effective teaching methodology? In effect, preservice teachers are being confronted not only with a new body of knowledge, but are also being asked to translate that content into instructional tasks which are appropriate for elementary schools. These are both complex demands that require a great deal of thought and commitment on behalf of every preservice classroom teacher. Instructors of art education methods courses will have to design ways in which both content knowledge and teaching skills can be merged together and modeled during course assignments. Preservice classroom teachers must be encouraged to inquire into the problematic nature of teaching art within the individual socio-cultural framework of today's schools.

The purpose of this chapter is to propose that those art educators involved in teacher education begin to examine and document instruction in preservice methods courses for classroom teachers more systematically. Art education methods courses can serve as research settings in which the new generation of elementary classroom teachers can be introduced to fresh conceptions of art teaching. For as one teacher educator maintains:

> The most important issue facing us in teacher education is how we can teach skills, attitudes and thought processes for which students do not yet have a perceived need.....We must either develop ways of providing students with a schema in which to place the various techniques and strategies of teaching such that they will be recalled and used in later teaching, or develop a very different conception of the knowledge and skills to be acquired in preservice preparation. (Koehler, 1985, p. 27)

If preservice classroom teachers were to enter their future classrooms with a number of art teaching options and strategies from which to choose, perhaps art could be taught more often, more comfortably, and with more success. Art education methods course instruction could be approached in at least two ways. First, art methods courses could adopt a more diverse pedagogical orientation, since preservice classroom teachers need to be provided with opportunities to address the different pedagogical decisions and skills required to teach the four areas of aesthetics, art criticism, art history, and art production. Second, methods courses should address other pedagogical practices that are based outside the field of art education.

A Different Pedagogical Orientation

It is the author's belief that the four art areas — aesthetics, art criticism, art history, and art production — each require at times, differing and various instructional skills for successful teaching and learning. For example, teaching aesthetics is a very different task from teaching art history, as both are from teaching creative art activities. Furthermore, integrating the four art areas within a single unit of study will require a different set of understandings and teaching skills. Each preservice teacher will need to be given help, not only in understanding the intrinsic concepts inherent in each of the four areas, but also in how to teach them. For example, is it more appropriate to teach certain art historical facts through lecturing or in cooperative learning groups? What kinds of questions should be addressed when discussing aesthetics, and how should they be explored in the classroom? Are there indeed more approaches to examining artworks than those usually advocated? What are the key concepts that derive from each of the four art areas? Which of these concepts relate to elementary school art teaching?.

An art education methods course will often provide many preservice classroom teachers with their first encounter with aspects of the field of aesthetics, art criticism, and art history. The task of the art educator will be to introduce preservice classroom teachers to a new body of knowledge from which they will be asked to select appropriate material for elementary classrooms. An indepth and working knowledge of the four art areas is required before the content can be translated into instructional tasks. Thus, preservice classroom teachers will need guidance in making informed decisions and assumptions about the suitability and value of the content within individual classrooms. Furthermore, art education research must document the kinds of decisions that these preservice classroom teachers make.

It is imperative that methods course instruction focuses on the pedagogical differences and similarities that exist among the four art areas, in order to help preservice classroom teachers successfully choose the most appropriate instructional strategies and skills to facilitate teaching. Exploring a diversity of ways in which to teach art concepts can facilitate one's understanding of them.

Such a focus on content and pedagogy will augment the development and recognition of a variety of teaching strategies in order to expand upon those previously exemplified in art teaching. The introduction of the four art areas will mean that preservice classroom teachers can no longer rely only upon such traditional art teaching methods as discussion and demonstrations. Classroom teachers will need to explore a variety of methods, such as lecture, review, and appropriate questioning, as well as more ingenious models such as synectics, group investigation, role play, simulation, and inductive thinking exercises (Joyce & Weil, 1980). Thus, there may be many pedagogical approaches, analogies, and means for teaching (Goodlad, 1987).

It will be the responsibility of methods course instructors and preservice classroom teachers to model such approaches in the methods classroom. The role of pedagogical modeling is twofold: First, it serves as the means by which content can be introduced to preservice classroom teachers. For example, art historical research can be conducted by preservice teachers using the group investigation teaching model, or case studies of teaching scenarios can be discussed in cooperative learning groups. Secondly, pedagogical modeling provides exemplars for how preservice

classroom teachers can instruct their future students. Preservice classroom teachers and methods instructors can critique and evaluate the benefits of each teaching strategy for use in elementary classrooms and provide preservice classroom teachers with the help they will need in distinguishing the subtleties and nuances inherent in the complexities of art teaching.

Pedagogical Thinking Beyond Art Education

Over the last two decades, a great deal of information has been generated on teaching across a variety of subject areas. Much of this research, documented in the *Handbook of research on teaching* (Wittrock, 1986), has primarily focused on the contextual nature of classroom life. It has inspired those involved in teacher education to begin to ask questions about the nature of teaching (Howey, 1983). This research provides a *reciprocal landscape* upon which both researchers and practitioners from all subject areas can develop a sense of professionalism about, and common ground within, teaching. Therefore, this knowledge about teaching should be reflected in art education methods course instruction for preservice classroom teachers. Shulman (1979) has argued that art educators must develop new pedagogical approaches to teaching art, in that art education must extend its research and teaching interests into other subject areas. Although the philosophical roots of art teaching should be grounded in the nature of artistic expression, it may well be that pedagogical processes in other subject areas can be used to bring about successful student learning in art. Concomitantly, research conducted on teaching in art education may help improve teaching in other subject areas:

> To study properly the teaching of the arts, researchers will have to employ new methods which give proper attention to the manner in which cognitive and effective factors interact in learning and teaching. Since this interaction is important in reading, mathematics, and the sciences, what we learn from teaching in the arts will be valuable for improving studies in other subject areas. (Shulman, 1979, p. 260)

Furthermore, art education may be informed by the knowledge and skills that preservice classroom teachers bring with them to their art methods courses from other professional courses. Discussing the life of an artist, comparing two artworks, or even motivating children for creative painting may be better taught in ways similar to

those of other subject areas. Course instructors should start to inquire into how information is presented in other subject areas, and apply it thoughtfully within art education courses. Preservice classroom teachers may react favorably to comparing and questioning the educational similarities between art and other methods course subjects, and by becoming familiar with a cross section of teaching methods. The use of pedagogical skills from other elementary subject areas can complement those that are derived from, and are more familiar within, art education. In turn, some preservice classroom teachers may become more confident about teaching art if they realize that they can adapt and modify processes that they have learned elsewhere in their professional education programs.

The research agenda for art education must include documentation of art methods courses for the preservice classroom. Instructors of methods courses in art education must be concerned with providing a nonthreatening environment, thereby enabling the development of a broader concept of what art education can become in schools. These courses must serve as research settings in which preservice teachers are taught how to make sense of the complexities of teaching art.

References

Adler, S., & Goodman. J. (1986). Critical theory as a foundation for methods courses. *Journal of Teacher Education, 37* (4), 2-8.

Berliner, D.C. (1985). Laboratory settings and the study of teacher education. *Journal of Teacher Education, 136* (6), 2-8.

Beyer, L. & Zeichner, K. (1982). Teacher training and educational foundations: A plea for discontent. *Journal of Teacher Education, 33* (6), 2-8.

Carnegie Task Force on Teaching as a Profession. (1986). *A nation prepared: Teachers for the 21st Century.* New York: Carnegie Forum on Education and the Economy, Carnegie Corporation.

Doyle, W. (1986). Classroom organization and management. In M. Wittrock (Ed.) *Handbook of research on teaching,* third edition (pp. 394-431) New York: Macmillan.

Feinman-Nemser, S. & Buchmann, M. (1983). The first year of teacher preparation. *Journal of Curriculum Studies, 18* (3), 239-256.

Galbraith, L. (1988a) Research-orientated art teachers: Implications for art teaching. *Art Education, 41* (5), 50-53.

Galbraith, L. (1988b). *Merging the research on teaching with art content: A qualitative study of a preservice art education course for general elementary teachers.* Unpublished Doctoral Dissertation, Univ. of Nebraska-Lincoln.

Goodlad, J. (1983). The school as workplace. In G.A. Griffin (Ed.) *Staff development*. (Eighty-second yearbook of the National Society for the Study of Education, part II). Chicago: University of Chicago Press.

Goodlad, J. (1987). *Keynote address*. Fourth Annual Nebraska Consortium for the Improvement of Teacher Education, Lincoln, Nebraska.

Holmes Group Executive Board, (1986). *Tomorrow's teachers: A report to the Holmes Group*. East Lansing, MI: Holmes Group.

Howey, K.R. (1983). Teacher education: An overview. In K.R. Howey & W.E. Gardner (Eds.) *The education of teachers: A look ahead* (pp. 6-38). New York: Longman.

Jones, B. & McPhee, J. (1986). Research on teaching arts and aesthetics. In M.C. Wittrock (Ed.), *Handbook of research on teaching* (third edition) (pp. 906-916). New York: Macmillan.

Joyce, B. & Weil, M. (1980). *Models of teaching*. Englewood Cliffs, New Jersey: Prentice Hall.

Katz, L.G. & Raths, J.D. (1985). A framework of research on teacher education programs. *Journal of Teacher Education, 36* (6), 9-15.

Koehler, V. (1979). Research on teaching: Implications for research on teaching of the arts. In G.L. Knieter & J. Stallings (Eds.), *The teaching process & arts and aesthetics*. St. Louis: CEMREL.

Koehler V. (1985). Research on preservice teacher education. *Journal of Teacher Education, 34* (1), 23-30.

Lanier, J.E. & Little, J.W. (1986). Research on teacher education. In M.C. Wittrock (Ed.), *Handbook of research on teaching* (third edition) (pp. 527-569). New York: Macmillan.

Lortie, D. (1975). *Schoolteacher: A sociological study*. Chicago: University of Chicago Press.

Lovano-Kerr, J. (1985). Implications of DBAE for university education of teachers. *Studies in Art Education, 26* (4), 216-223.

Maitland-Gholson, J. (1986). Theory, practice, teacher preparation and discipline-based art education. *Visual Arts Research, 12* (2), 26-33.

Sevigny, M.J. (1987). Discipline-based art education and teacher education. *The Journal of Aesthetic Education, 21* (2), 95-128.

Shaker, P. & Ulrich, W. (1987). Reconceptualizing the debate over the general education of teachers. *Journal of Teacher Education, 37* (1), 11-15.

Shulman, L. (1979). Research on teaching in the arts: Review, analysis, critique. In G.L. Knieter & J. Stallings (Eds.), *The teaching process & arts and aesthetics*. St. Louis: CEMREL.

U.S. Department of Education (1988). *Bulletin CS 88-417*. Washington, D.C.: Center for Education Statistics.

Wittrock, M.C. (1986). *Handbook of research on teaching* (third edition). New York: Macmillan.

Student's Experiences in Art Under Different Staffing Arrangements

Wendy Wiebe
Vancouver, British Columbia

Do elementary school children need an art specialist? Statements which recommend that art specialists be employed in the elementary schools are frequently made in the literature in art education. Physical education and music specialists are frequently found at this level, but art specialists are much more rare. All across Canada, Ministries of Education have been developing new art curriculum and new programs for teaching art in the elementary schools. Can these programs be adequately implemented by generalist classroom teachers? Why are art specialists not hired? Do they really make any difference, or can classroom teachers do an equally effective job of teaching art to children? These are the questions that need to be asked if quality art programs are to be implemented at the elementary school level.

In Quebec, in 1978 and 1979, the Ministry of Education declared in its *Plan of Action* (Government of Quebec, 1979) that the teaching of the arts in elementary schools should be a priority. Funds were made available through school boards to support research and special projects in art education. Before implementing a new arts program, the Ministry wanted to evaluate the need and use of art specialists, and to determine how they might be used most effectively. A study was funded by the Ministry of Education in Quebec and carried out within the South Shore Protestant Regional School Board of greater Montreal.

Definition of Staff

Classroom teachers or generalist teachers are certified professionals who are responsible for most of the children's daily instruction in academic areas of the curriculum. They are not required to have specialized training in any one particular subject of the curriculum.

Art specialists are persons who teach art to classes of children on

a regular basis. They are teachers trained in art (materials and techniques, aesthetics, language, history, etc.) with at least four years of post-secondary education. In addition they have some training, usually four or five courses, in general education, psychology, and methodology.

Art consultants assist classroom teachers with their art lessons and preparations, and occasionally teach demonstration lessons for students and teachers, but do not teach classes on a regular basis. Consultants have at least the same training as art specialists, but perform the jobs of advisor, supervisor, organizer, researcher, demonstrator, public relations person, and general resource person regarding all matters pertaining to art education in a public school setting.

Support from the Literature

A review of the literature revealed descriptive information regarding *how* art specialists and consultants should be used, rather than whether or not they are effective. Many art education texts discuss the role of the art teacher and state that it is desirable to provide art specialists or consultants, especially at upper elementary levels, but do not provide evidence that the students have a better art experience under the tutelage of the specialist or consultant. Some of the literature states that art specialists can cause art to be an isolated rather than an integrated activity. Furthermore, the intervention of a specialist can interfere with Lowenfeld's ideas about personal expression being best nurtured by the classroom teacher since that teacher may know the child best. Some reports revealed that art consultants were not very effective. Teachers who do not place a high value on art never call upon the consultant, or else they ask for a special lesson so they can have a free period. When the consultant's role is scheduled and imposed, the classroom teachers tend to take little interest in art and leave the planning of the program entirely to the expert. Other reports mention the extra costs for specialized personnel in a time of budget constraints. With this kind of negative information available, is it any wonder that school board administrators do not hire more art specialists or art consultants?

The Problem for Research

Many factors influence children's art experience — the physical environment, the materials available, the time allotted, the philosophy of the school, the parents and the teachers — as well as the child's own attitude towards art. The study described in this chapter was primarily concerned with measuring the effect of the teacher's role. To what extent does the teacher's background in art have an effect on the child's experience in art? Should art be taught by the classroom teacher who knows the child best, or by a trained art specialist who knows the materials, techniques, and concepts best? The questions posed here are: How is the role of the art teacher handled differently by generalists than by art specialists? Will the teacher's performance influence the child's art experience? Can this art experience be described and evaluated?

The Study

In order to answer the above questions, an experiment was set up. It began in September 1979 and continued the length of one school year ending in June 1980. The project involved over three hundred children at the fifth grade level and eleven teachers in four elementary schools. The teaching staff included an art specialist, an art consultant, and ten generalist classroom teachers. The children were grouped with different staff members for their art classes, and their experiences were compared. A large collection of children's artwork was gathered during the school year. The evaluation of the art experience was based on an assessment of the quality and quantity of this work. In addition, the teachers' attitudes and behavior were documented and evaluated. From this collection of information, the quality of the art experience of the various groups of children was assessed.

The Groups

Special efforts were made to minimize the effects of factors other than that of the art teacher. The sample groups of children were selected from similar socio-economic backgrounds. They had similarly matched academic scores on standardized tests in spelling, math, and composite language arts. All classes had similar numbers, art facilities, and curriculum. All teachers had similar

years of experience and equal budgets for art supplies. The persons who provided weekly art instruction in the four different staffing arrangements were:

• Their regular classroom teacher* who was also an art specialist Group El
• An art specialist* who was a staff member in the school Group E2
• Their regular classroom teacher* who had access to the services of an art
 consultant for one full day each week Group E3
• Their regular classroom teacher* who did not receive any help or intervention
 from the project personnel (Control group) Group C

* defined as described in text of this chapter

Before the start of the project, all teachers agreed to use a common curriculum for their teaching. This curriculum included visual concepts, vocabulary, and some techniques of drawing and painting. For comparative purposes it was considered important that all teachers have a similar program. They were not prevented from doing additional personal activities.

Table 1
Schedule for the Collection of Data

Item	Pre-Tests	Post-Tests
1. Art Interest Inventory	Sept./Oct.	May
2. Art Concepts Test	Sept./Oct.	May
3. Drawing Test	Sept./Oct.	May
4. Painting Test	Sept./Oct.	May
5. Picture-Composition Test		April
6. Canadian Test of Basic Skills	Sept.	June
7. Questionnaires to Teachers		June
8. Weekly Diary of Art Consultant	Sept. through	June
9. Children's Portfolios	Sept. through	June

Evaluation

Both statistical (objective) and descriptive (subjective) methods were used in this study. The two different methods offered insights that neither one alone could provide. In the objective study pre- and post-tests were used to evaluate several aspects of the children's art experience. The first test was a questionnaire asking students about

their interests, attitudes, and priorities in art. The second test measured the student's knowledge of art concepts and vocabulary. Three more tests were administered to evaluate drawing and painting skills; these were graded by a panel of judges using specified criteria. In the schedule described previously, Items 1 through 6 were the objective tests.

In addition, a descriptive assessment was conducted. Three judges evaluated the children's portfolios containing their total in-school art production for the school year. Teachers were also assessed on the basis of personal questionnaires and the consultant's observations as recorded in a written diary (Items 7 through 9).

Results of the Objective Tests

Instruction by art specialists proved to be more effective than that involving other staffing arrangements. In four out of the five tests (Interest, Concepts, Painting and Picture-Composition), the groups taught by an art specialist (E1 and E2) achieved higher scores than the other groups taught by classroom teachers, either with (E3) or without (C) the aid of an art consultant. Comparisons between the latter groups showed that the art consultant was ineffective.

The most dramatic difference was in the Painting Test Skills where the scores of children who worked with an art specialist were nearly double those of the children who worked with a classroom teacher and a consultant, and four times greater than the scores of the children taught by their classroom teacher alone. The Picture Composition test was a combined drawing and painting or coloring assignment which did not have a time limit. In this test, the art specialists' groups also excelled, and it was evident that more time and effort had been put into the work.

There was very little difference between the groups on the Drawing Test. This finding was in concurrence with those of other studies which suggest that drawings by young children are less likely to be influenced by the teacher than are paintings. The drawings made by children under twelve years of age seem to reflect a natural evolution of skills rather than the effects of intensive instruction.

As a supplementary result, children who were taught by an art

specialist showed greater improvement in Math and Spelling post-tests (Canadian Test of Basic Skills) than the children who were taught by their classroom teachers. This study indicates that the children who spent more time on their art did not do so at the expense of other subjects.

Results of the Descriptive Study

There was a clear correlation between the teacher's attitude and effort, and the artwork in the student portfolios. In School "A," an art specialist taught art to three classes. The art lessons involved serious presentation and art content. Art had a positive and high profile among the activities in the school. Artwork was always displayed around the building, and the students frequently did extra artwork in their own free time. The portfolios from these classes contained the largest number of works. They were described as excellent, exciting, well integrated and were rated highly overall.

In schools "B" and "C" (Group E3), the five classroom teachers had had little or no background in art. All of these teachers had access to a consultant. They gave art a low priority in the week's activities, and they had difficulty teaching the curriculum because they did not fully understand the art concepts themselves. In their opinion, art lessons for elementary school students should simply provide fun and interesting products. Art was not considered to be a serious learning activity. The art consultant reported a lack of positive responses or enthusiasm from these teachers who feigned interest but took little time to plan or prepare art lessons. The portfolios from these classes contained a small number of artworks which were unimaginative and showed a very limited use of materials. These portfolios were rated as poor or weak.

Students from school "D" served as the Control Group (Group C). No interventions occurred in this setting. It was not possible to collect a complete set of descriptive data for this school. Only one of the three teachers maintained portfolios for her class. There was no consultant to record observations. The classroom teachers responded to the questionnaire in a similar way as did the teachers in schools "B" and "C". Indications were that the children's artwork was teacher-directed and product-oriented, and that the children had an art experience similar to the two other schools where the classroom teachers taught the art lessons.

Conclusions

Both research approaches supported the same conclusion. The results indicated that the children had a better art experience from an art specialist than from a classroom teacher. The statistical analysis showed that the children taught by the art specialist acquired more skills, expressed themselves more personally, and learned more art concepts and vocabulary. The descriptive results revealed that the children who had been taught by the art specialists produced a greater number and a greater variety of artworks as revealed in their portfolios. The results of the teachers' questionnaires and the consultant's diary revealed that the art specialist spent more time and effort in the preparation for and in the teaching of art. This is not a surprise, but the results give a clear indication of the superiority of art instruction directed by an art specialist rather than a classroom teacher.

The elementary classroom teachers in this study had difficulty understanding and teaching some of the concepts selected from the curriculum of the Quebec Ministry of Education. It appears that curriculum guides alone are not sufficient for the classroom teacher to provide a good art experience in the schools. Teachers cannot teach concepts which they do not understand themselves.

On a short-term basis, an art consultant is not often effective for providing a good art experience to children who are taught by their classroom teacher. These findings support the conclusions of other studies which show that consultation is difficult and even when consultation occurred over a period up to two years, results may be disappointing. It is difficult to change habits which have become long-ingrained. Perhaps the art consultant might have been effective over a longer period of time.

The question of whether time spent on art would detract from other academic subjects was one which was also considered in this study. The results of the Canadian Test of Basic Skills, given to the children in this study, indicated that the children who spent more time on art also did better in math and language arts. This is certainly not proof that art instruction will improve math and spelling skills, but supports the idea that extra time spent on art did not cause other academic skills to suffer. This does challenge the popular notion that art is a "frill" and a waste of time.

Recommendations

The following recommendations are suggested by the results of this study:

• Upper elementary school children would profit by having their art program taught by an art specialist who has the training and experience necessary to implement art curriculum objectives. Ideally, elementary schools with ten or more teachers should include one art specialist. Two options are suggested: a) have an art specialist teaching all the art classes in the school, or b) have a generalist teacher who has further training as an art specialist, and who functions both as a classroom teacher and an art specialist. This latter arrangement offers the school more flexibility in staffing arrangements and budgeting.

• Classroom teachers need more practical experience in the making and teaching of art and art concepts. This could be accomplished by means of resource persons, long and short-term art courses, workshops, and in-service training.

• Since it is government and school board officials who make the decisions about staff and curriculum priorities in the schools, the results of this study (Wiebe, 1983) and others like it should be brought to their attention so that they might be more aware of the content and the value of art education and the necessity for art specialists in the elementary schools.

• Other school boards should duplicate this research to provide more evidence for the pedagogical literature.

• If good art programs are important in elementary schools, then art specialists are needed to teach them.

References

Government of Quebec. (1979). *Policy Statement and Plan of Action.* Quebec: Ministry of Education.
Wiebe, W. (1983). *Student Experiences in Art Under Different Staffing Arrangements.* Masters Thesis, Concordia University, Montreal. (Author's note: This thesis includes 172 pages of text, with 37 references cited as well as five appendices which provide information on the tests, the criteria for scoring, the use of a jury system for evaluating art, a questionnaire for art teachers and the computer analysis of the project data.)

Aesthetics in Elementary Art Education

Sally Hagaman
Purdue University

The introduction of aesthetics into the elementary art classroom, as advocated by the Getty Center for Education in the Arts and embraced by the NAEA in its *Goals for a Quality Art Education* (1986), is certainly a troublesome prospect. As Hamblen (1987) and others have noted, there is continuing disagreement about whether it is really possible to teach aesthetics to younger students, whether multicultural aesthetic philosophies can be incorporated into preplanned, "packaged" curricula, and most importantly, what is meant by "aesthetics" as advocated by the Getty Center for Education and the National Art Education Association.

There are many varieties of aesthetics including empirical aesthetics, aptly represented by psychological studies, anthropological/sociological approaches to aesthetics, and philosophical aesthetics. Each of these overlaps the other in significant ways; however there are also questions about the relationships between aesthetics and the other three components of a discipline-based approach to art education (DBAE): production, art history, and especially, art criticism. This chapter will attempt to clarify the conceptual confusion and describe approaches for incorporating aesthetics into the elementary curriculum.

Why Aesthetics?

Aesthetics, as a discipline, is a branch of philosophy. Aestheticians analyze the concepts and language that people use in thinking and talking about art: beauty, expression, realism and representation. They explore the "big questions" of art, such as: What is the purpose of art? Can objective criteria be established for judging the worth of various works of art? Is there a significant difference between art and craft? Can a functional or utilitarian object be a work of art? Is there a difference between a copy and an original work of art which draws heavily from past imagery, style, and technique? Does one have to assume a particular attitude to respond to art? Can traditional categories and evaluation of art be

used to respond to works by women or minority artists? How does one decide what is or is not art? Aesthetics is thus essentially a verbal undertaking, but aestheticians often use specific works or styles of art to illustrate their positions on such issues. Although aesthetics is similar to art criticism, the two are different disciplines. The art critic or the youngster in the art class can each respond to individual works of art. Responses can be made as a formalistic four-step process of description, analysis, interpretation, and judgment (Feldman, 1970) or as a personal reflection, as in poetic interpretation. But when the critic does metacriticism, or analyzes the methods and constructs of criticism itself, the response is in the realm of aesthetics or back to issues underlying the definition of art itself.

All of this may sound very complex, and indeed it is. To paraphrase Harry Broudy, aesthetics is no academic person of leisure. Because aesthetics and certain forms of art criticism deal with these somewhat thorny, yet fundamental, issues, it is very important to find ways to include the content of the discipline in the art class. When teachers are asked how often they talk with students about the various big questions in art, like the purposes of art, for example, they admit that they probably should, but rarely do. Is this because they never think of these issues? Of course not. Each time they plan a unit of study, they are thinking of the objectives involved: communicating an idea, expressing a personal response to a theme or event, creating a new symbol, and the like, and all of these are tied to the various purposes that art serves in our lives. Teachers may never think specifically or analytically (philo-sophically, if you will) about their purposes in terms of aesthetics. Nor will their students be likely to think about these issues unless they are prompted to do so by what happens in the classroom.

At the elementary level, the most important reason for integrating the content and processes of inquiry from aesthetics into the art curriculum is so that students *do* think about these things, and they *will* think and talk about them if given the chance and the right motivation. This integration process is crucial because it begins to tie the art curriculum together, to make meaningful connections among all the varied things teachers ask children to do in the name of elementary art education. The elementary art classroom is as much a place for talk about art as it is for making art. Such talk need not be theory-driven, alien, or dull, but must begin with children's own experiences and their craving for meaning.

Ideas for Implementation

Many elementary art teachers must assume that most elementary art teachers never thought they would teach aesthetics to their students or be expected to do so. Indeed, the study conducted by Rand/Getty in 1984 found little attention paid to aesthetics even in those programs which best exemplified a discipline-based approach (Day, Eisner, Stake, Wilson & Wilson, 1984). Among the underlying causes of this situation is the fact that most elementary art teachers have had little or no formal education in aesthetics or general philosophy, and know of few, if any, models or materials for teaching aesthetics to their students.

One method of implementing the content of aesthetics is the development of a graduate course for art teachers which introduces philosophical aesthetic concepts (Hagaman, 1988). This class begins to fulfill the role of aesthetics in art education by broadening the art teacher's education in aesthetics, who in turn plans and implements a classroom program which, while it does not deal directly with aesthetics, is enhanced by the teacher's more sophisticated understanding of the discipline.

This notion is consistent with the following statement made by Madeja and Onuska (1977): "Aesthetics, the philosophy of aesthetic phenomena, is taught primarily in universities as a branch of philosophy, and is not directly related to the education of children" (p. 5). James Gray (1987) has suggested a "75 percent solution, for implementation at the elementary level, wherein teachers study aesthetics and then act as 'transformative agents' in a program which *implicitly* entails the study of aesthetics" (p. 55). This position deems philosophical aesthetics too unwieldy and complex a discipline to be integrated successfully into elementary art programs and advocates student concentration upon the other 75 percent (production, history, criticism) of the prototypical discipline-based curriculum.

It is true as Gray has stated that what teachers do not understand or cannot easily transform into classroom experience is often ignored, or worse, attempted with the resulting failure reinforcing the notion that "it cannot be done." However, in the case of philosophical aesthetics, it can and should be taught, just as other "tough" curriculum areas, such as art history or art criticism, can and should be taught. While it is possible to refer teachers to several

excellent introductory anthologies in aesthetics (Hospers, 1969; Margolis, 1978), there is no simplified and yet dramatic collection of writings which would whet everyone's appetite for more. Perhaps the *Reader's Digest* condensed book subsidiary is missing a gold mine here. However, even if such a source were available, it would still be highly preferable for teachers to complete coursework in aesthetics because it requires and develops *discussion,* which must be nurtured in the classroom, if aesthetics is really to be dealt with successfully.

Finding models for curriculum development and implementation is also difficult. There is no such thing as a teacher-proof curriculum, but models of lessons implementing philosophical aesthetics are needed. These materials are currently being developed and field-tested by a number of researchers in art education.

One source for pedagogical ideas in this area is an educational movement called "Philosophy for Children." Over the past twenty years, it has developed and implemented materials and methodologies for philosophical (aesthetic, ethical, metaphysical, and logical) inquiry with children and young people. Much of this work has been based upon the writing and training sessions of Matthew Lipman and his associates at the Institute for Advancement of Philosophy for Children, Montclair State College, Montclair, NJ. They point out that, like all individuals, children think. The pedagogical problem is to transform the child who is already a thinking child into a child who thinks *well.* The general goal of Philosophy for Children sums up the approach:

> In philosophy we seem to have a case of double purpose: we
> want the students to gain insight into the issue discussed and
> to clarify their thinking about it and, at the same time, we
> want to develop, in a more general way, their critical acumen
> and their competence in argumentation and in the giving and
> evaluating of reasons. (Scolnicov, 1988)

The key to success in philosophy for children is the relationship between thinking and dialogue. Because thinking is often regarded as a private matter, there is also some misunderstanding of how it can be improved. The common assumption may be that reflection generates dialogue, when dialogue actually generates reflection. When people engage in dialogue, they are forced to reflect, to consider alternatives and perform many mental tasks in which they might not have engaged otherwise (Lipman, Sharp & Oscanyan,

1980). Adults must not assume that, because they can write something without discussing it with others or look at a work of art and comprehend it without discussing it with others, such refined end products are proper models for the process itself. Dialogue is one stage of experience which advocates of philosophy for children find indispensable, if raw experience is to be converted into refined expression.

How then do elementary art teachers develop a climate for meaningful dialogue, that "community of inquiry," desired by proponents of philosophy for children? One approach is the "good reasons approach" described by Lipman and his associates. In contrast to rules of formal logic, which many imagine is the sole route for philosophical reasoning, this informal logic has no specific rules. Rather it emphasizes *seeking* reasons for a specific situation or problem and then assessing the reasons given. Thus, employing "good reasons logic" in a classroom community of inquiry requires the use of criteria (how did you arrive at that judgment?), attention to context (what are the specifics that must be considered in this case?), and self-correction (how might one's reasons and opinions change because of the points raised in the dialogue process?) (Hagaman, 1990).

This approach invariably makes strong demands upon the teacher. Encouraging students to listen to themselves requires that the teacher listen carefully and *remember* what they have said. Children sometimes look to the teacher for an evaluation of what has been said by another child; they may ignore what was said if it does not meet with instantaneous approval from the teacher. At other times, children may get the impression that any comment, without regard for the inquiry theme or another class member, is "okay." In both instances, the teacher's memory is the best resource. A teacher can ask how a comment bears on previous remarks, or can recall and restate the points made before the digression began, keeping the discussion and the children focused on the subject. Typical questions which encourage "good reasons logic" and philosophical inquiry are: "Is that consistent with what you said before?" "How do your comments connect with what has been said?" "Why do you say that?"

This process is dependent upon materials which invite dialogue. The most widely used sources in general philosophy for children are novels, narrative books cast with children, their families, teachers,

and friends (Lipman, 1974, 1978, 1981, 1982; Reed, 1989). Accompanied by comprehensive teacher's manuals, complete with specific suggestions for discussions and related activities, the novels are written to offer *models of dialogue* about recurring issues in philosophy, without the use of the jargon or technical language of professional philosophers. In this way, they serve a double purpose. Not only do they provide the ideas for classroom dialogue in an interesting, child-centered manner, but they also provide illustrations of good conversations.

This author is currently writing a series of elementary art texts based upon the Philosophy for Children model. In these texts, a small group of children leave the art class each year, travel through time and space, and actively explore the roles and status of art and artists within the various cultures they visit. This approach allows models for dialogue about the perennial questions of aesthetics, integration of multicultural art history, opportunities for art criticism and related production activities to be integrated into a child-centered story format. The books are divided into short episodes designed to be read by or to students before discussion and other activities. There will also be accompanying teacher's manuals. Although these materials must be field-tested and revised, they may eventually provide assistance for elementary art teachers who are challenged to add aesthetics to their curriculum in a comprehensive manner.

Other researchers and writers in art education suggest other means for initiating discussions about aesthetics at the elementary level. Aesthetician Margaret Battin suggests using "puzzle cases" or problems devised by teachers. The following description relates one of her puzzles: Al Meinbart paints a portrait of art dealer, Daffodil Glurt. The resulting canvas is a single color, chartreuse. Meinbart hangs the canvas in the Museum of Modern Art, labelled, "Portrait of Daffodil Glurt." Daffodil is not amused. But has she actually been insulted? (Battin, 1986, p. 13)

Battin points out that this approach denies the dullness of aesthetics, providing instead the genuine interest which concrete cases can generate. Another clever puzzle case, devised by an excellent elementary art teacher/supervisor, involved a local controversy over the juror's rejection of landscape paintings which were painted on old sawblades for a community-based art fair. The ensuing discussion focused on the possibility of establishing objective criteria for judging art and whether regional and personal

preferences should influence judgment in such a situation. The same teacher led a lengthy discussion with fifth graders about whether or not younger children, such as Kindergartners, should be able to judge artworks for a school exhibit, exploring the same philosophical issues as in the former puzzle case (Banks, 1986).

Many art educators, including Lankford (1989) and Stewart (1989), have advocated the use of media stories, brought in by students and teachers, to stimulate philosophical dialogue. One example is a story about an elephant in the local zoo who enjoys painting pictures. Are her products art? Can animals make art? (Lankford, 1989) Questions about the role of the artist's intention, traditional standards, and the importance of the artworld in designating something as "art" easily could arise in such a discussion.

Burton (1988) has explored the use of aphorisms or truisms with young children as a means of stimulating discussions about aesthetic issues. An example, such as the saying, "Beauty is in the eye of the beholder," can lead to such concerns as relativity in evaluation or judgment, the effects of education or maturation upon preferences, or even something as seemingly simple as having children name what they find beautiful and giving their reasons why.

While dialogue seems the best and most constructive approach to dealing with aesthetics in the elementary art class, it is also possible to construct various learning centers, worksheets, and other individual or small group activities. For example, a teacher can assemble a group of postcard reproductions and ask students to sort them based on ideas from aesthetics: "Find examples of realistic works of art that you consider good or bad. Can you find examples of each? If the artwork is realistic, is it always good?" Such activities serve to clarify the criteria used in determining worth and can enhance understanding of the subtleties which otherwise seem cut and dried. These activities are exactly what aestheticians do: they analyze ideas and assumptions about art that others take for granted.

Just as there is no single best way to teach painting, there is no single best way to introduce philosophical aesthetics into the elementary art curriculum. This paper has described a few of the evolving methods for approaching this goal and has attempted to

clarify just what aesthetics is. As pedagogical materials and methods are developed and improved, it will become easier to integrate the content and inquiry processes of philosophical aesthetics into the art programs of elementary schools. But even now, it is possible for the art teacher who feels confident in the ability to lead a discussion, to ask questions such as these:

- What makes one thing art and something else not art?
- Is something art if it is a very good imitation of something in the world?
- Can something be art that doesn't look similar to anything in the world?
- Does something have to be one-of-a kind to be art?
- Can something be ugly and still be art?

Some delightful discussions can take place with elementary students based on questions such as these. Instead of experiencing the "pulling teeth" phenomenon one might expect, the reverse is very often the case: it is difficult to get students to stop talking about these issues. They are really interested in the not so dreadfully dull questions of aesthetics.

It is the excitement, that moment of discovery when things seem to come together, when meanings are at least temporarily clarified in the mind of a child, that make it worth the effort to add one more essential component to the already overcrowded curriculum. For teachers to do this well, reading and dialogue about aesthetics are fundamental. Teachers must be able to recognize the issues of aesthetics as they arise in the life of the classroom, as they will continually, and grasp the "teachable moments" when they appear. Further, teachers must develop an understanding of aesthetics that is sophisticated enough to enable them to plan age-appropriate and grade-appropriate lessons in aesthetics for students and to evaluate the curriculum suggestions of others working in this area. The essential value of aesthetics to art and art education warrants nothing less.

References

Banks, M. (1986). Personal letter.

Battin, M. (1986). The dreariness of aesthetics (continued), with a remedy. *Journal of Aesthetic Education, 20* (4), 11-14.

Burton, D. Aphorisms and aesthetics. Paper presented at the National Art Education Association National Convention, Los Angeles, CA, 1988.

Day, M., Eisner, E., Stake, R., Wilson, B., & Wilson M. (1984). *Art history, art criticism, and art production.* Santa Monica, CA: Rand Corporation.

Feldman, E. (1970). *Becoming human through art.* Englewood Cliffs, NJ: Prentice-Hall.

Gray, J. (1987). The 75% solution. *Art Education, 41* (1), 53-56.

Hagaman, S. (1988). Philosophical aesthetics in the art class: A look toward implementation. *Art Education, 41*(3), 18-22.

Hagaman, S. (1990). The community of inquiry: A model of collaborative learning. *Studies in Art Education. 31 (3),*149-157.

Hamblen, K. (1987). An examination of discipline-based art education issues. *Studies in Art Education, 28* (2), 68-78.

Hospers, J. (Ed.). (1969). *Introductory readings in aesthetics.* New York: The Free Press.

Lankford, L. (1989). *A preservice course for teaching and learning aesthetics.* Paper presented at the National Art Education Association National Convention, Washington, DC.

Lipman, M. (1974). *Harry Stottlemeier's discovery.* Upper Montclair, NJ: Institute for the Advancement of Philosophy for Children.

Lipman, M. (1978). *Suki.* Upper Montclair, NJ: Institute for the Advancement of Philosophy for Children.

Lipman, M. (1981). *Pixie.* Upper Montclair, NJ: Institute for the Advancement of Philosophy for Children.

Lipman, M. (1982). *Kio and Gus.* Upper Montclair, NJ: Institute for the Advancement of Philosophy for Children.

Lipman, M., Sharp, A., & Oscanyan. F. (1980). *Philosophy in the classroom,* 2nd edition. Philadelphia: Temple University Press.

Madeja, S. & Onuska, S. (1977). *Through the arts to the aesthetic: The CEMREL aesthetic education curriculum.* St. Louis: CEMREL.

Margolis, J. (Ed.). (1978). *Philosophy looks at the arts.* Philadelphia: Temple University Press.

Reed, R. (1989). *Rebecca.* Fort Worth, TX: Analytic Teaching Press.

Scolnicov, S. (1988). Personal letter.

Stewart, M. Philosophical aesthetics in the classroom. Paper presented at the National Art Education Association National Convention, Washington, DC, 1989.

Criticizing Art with Children

Terry Barrett
The Ohio State University

This chapter is about engaging school children in the criticism of art. The first part is based on traditional theoretical research and explains what criticism is; the second part is based on action research and explains how children may be taught to do art criticism. During the past five years the author has served as an art critic-in-education, similar to an artist-in residence, under the sponsorship of the Ohio Arts Council. In his capacity, as critic-in-education, the author has visited over fifty schools in Ohio, including rural, urban, suburban, private, and public schools, and has taught art criticism to classes of children from pre-school, including three-year olds, through high school. The children have included "students at risk" of dropping out, gifted and talented, the cognitively and emotionally challenged, and children experiencing hearing impairments. These sessions with children have been documented with audio tape, video tape, children's writing samples, and the author's observations. This data is the basis of the latter part of this chapter.

The Theory

Art criticism is informed talk and writing about art for increased understanding and appreciation of art. The outcome of doing criticism, or of reading criticism, should be what Harry Broudy (1972) calls "enlightened cherishing," the compound concept that acknowledges feeling as well as thought without dichtomizing the two. Criticism is a complex activity (Geahigan, 1982), but Weitz's (1964) four categories of the activities of criticism — description, interpretation, evaluation, and theory — have proven useful for many years, and are used in modified forms in methods of teaching art criticism, most notably Feldman's (1984). After twenty-five years, the categories also still prove to be current in the practice of contemporary critics (Barrett, in press; Lee & Barrett, in press). These four categories of critical activities are used in this chapter to make the complex act of criticizing art more understandable in itself and more teachable to children.

Describing art (Barrett, 1990, Chapter 2) is pointing out and

listing facts gathered from internal and external sources of information about a work of art. Internal description is based on what can be observed in the work; external information is knowledge not observable in the work, but information pertinent to the art object such as historical facts about the world at the time that the artwork was made and the culture in which the work emerged. Although some methods of criticism in art education (e.g., Feldman, 1984; Hewett and Rush, 1987) request that students limit their descriptions to only what they can observe in the artwork, it is asserted here that a work of art cannot be comprehended adequately without placing it in its larger social context. Further, this is normal procedure for professional critics, and if children are taught to contextualize art, it brings art criticism done in schools closer to art criticism done in the world.

Description is an activity of transposing paint or marble to verbal language. Usual and useful subcategories of descriptive activities are commenting on: subject matter — persons, places, or things depicted in the work; form — how the work is arranged and composed; and medium — the materials of which the work is made and how they have been handled by the artist.

Descriptions are important because they inform viewers about what can be noticed and what might not have been noticed. Descriptions form the basis of interpretations, and if descriptions are inaccurate or insufficient, ensuing interpretations suffer. In principle, descriptions are true or false, accurate or inaccurate, although in practice, it is difficult to be certain about some descriptive observations. The merit of descriptions is based on relevancy; that is, on whether the descriptions further the viewer's understanding and appreciation of the art in question. Descriptive relevancy, however, is based on interpretation, and in fact, description and interpretation cannot be easily separated. In general, however, descriptions are factual and interpretations speculative.

To interpret a work of art is to figure out and tell another what the work is about (Barrett, 1990, Chapter 5). Interpretations are arguments based on descriptive evidence from within the work and from contextual information about the work. Good interpretations are objective in the sense that they refer to the object, the artwork, and have evidence in their support which other people can observe and with which they can agree. There is no one right interpretation for a work of art, but some interpretations are better than others.

Interpretations are judged according to whether they are enlightening, insightful, illuminating, reasonable, relevant, and backed by evidence; conversely, interpretations can be dull, factually wrong, without evidence for their support, and lack insight. Different interpretations arise from different ideologies, such as feminism, for example, or religious beliefs. Different reasonable interpretations of the same work of art are valuable because they can bring many facets of the work to life for viewers.

It is maintained here that interpretation is the most significant aspect of criticism, and educationally the most important. Other art educators (e.g, Feldman, 1973; Feinstein, 1988) agree with this claim. Description is a prelude to interpretation, and a thorough description and thoughtful interpretation render a judgment rather easily. Judgment without interpretation is irresponsive and irresponsible.

A complete judgment of a work of art entails a clear appraisal with reasons for the appraisal based on explicit criteria. In practice, however, critics often offer appraisals and reasons for them but may leave their criteria implicit. Judgments, like interpretations, are arguments put forth by critics. They attempt to persuade others to see an artwork the way they see it, and to value it similarly. Like good interpretations, adequate evaluations are objective in the sense that they clearly relate to the object of art being considered and are shown by the critic to relate. Judgments are provisional and open to challenge and to change. Different judgments of the same work by several critics can expand knowledge and appreciation of the artwork being judged. Critics judging many works of art by different artists face the difficult decision of applying one set of criteria to all, or letting different artworks indicate by what different criteria they are best judged. The first choice provides consistency, but also approaches dogmatism; the second choice is tolerant of diversity, but may lead to wishy-washiness.

In his analysis of criticism, Weitz found that judgment is neither necessary nor sufficient for criticism. That is, some critics do criticism by describing or interpreting, and not by judging, and their work still counts as criticism. Criticism which only renders judgments is insufficient as criticism. This is an important point to remember, especially since so much of criticism in popular media is judgmental, and because so many studio critiques are judgmental (Barrett, 1988). Art teachers and art students may think that

criticism is judgment, or that the goal of criticism is judgment, and that description and interpretation are merely a means to that end.

Critics, in the course of criticizing, formulate theory about such questions as how art should be judged, what art is, and what is its value to society. Under current rubrics of art education, such theorizing has been placed in the realm of the aesthetics rather than criticism (e.g, Clark, Day, & Greer, 1988). Nevertheless, critics do theorize in the course of criticizing art because questions arise which require theorizing — much new art challenges older aesthetic theory, and critics are then faced with theorizing anew about what should count as art. Aesthetic theories, like interpretations and judgments, are based on argument; unlike interpretations and judgments which attend to specific artworks, aesthetic theories account for all of art or several examples, rather than the particular work of art. Aesthetic problems and critical problems overlap in discussions of works of art, and recommendations for dealing with problems of aesthetics in the classroom are made by other authors (e.g. Erickson, 1986; Lankford, 1990; Hagaman, 1990; Stewart, 1990).

Professional critics (Barrett, 1989) usually do not first describe, then interpret, then evaluate, and finally theorize. They may begin with any one of these activities, and they often mix types of statements in the same sentence. Critics write for audiences. They do not usually write for the artist whose work they are criticizing but rather for a much larger group of people, such as the readers of the *New York Times* or *Art in America*. They often write about new art, or old art shown in new contexts, that usually has not been seen by their readers. They consider what their readers may already know and may want to know. Critics attempt to persuade readers to their views by citing evidence and by their literary use of language. Because criticism is persuasive argument, and always open to revision, criticism can and should be criticized.

The learning theory upon which the following experiences with children are based is cognitive developmental theory (e.g., Parsons, 1989). The experiences are guided by the novice to expert paradigm (e.g., Koroscik, 1990). Given what professional critics do, the author sought to find out what children can be taught to do regarding the criticism of art within their elementary years of schooling.

The Practice

Talking About Art

Starting with subject matter when asking young children to describe art is sensible because it is where they most often choose to start. Picasso's *Lobster and Cat*, a 1965 painting by Picasso, available through Shorewood prints, is a favorite choice of the author's for descriptive talk by groups of all ages, even pre-schoolers and kindergartners. The painting is an expressionistic oil of a cat and a lobster fighting. The paint is thickly applied with apparent rapidity. The picture is representational but abstract, and its subject matter is somewhat difficult to recognize. When leading critical discussions about this painting, the author usually starts with the question, "What do you see here?" Most everyone sees that animals are fighting, but from young children he has received such answers as a raccoon and a crab fighting. These answers are descriptively wrong, and the author usually softly responds to such answers with "Yes, they look like they are fighting, but no....it's not a crab and it's not a raccoon." Eventually children in the group will correctly identify the animals as a cat and a lobster.

That descriptions can be wrong is a simple but important theoretical point. It counters a tendency of adults to allow and reinforce any responses that children have when talking about art, even mistaken responses. It counters false beliefs that talk about art is subjective, and that there are no right answers, only irrefutable personal responses. Pedagogically, how one handles incorrect or inappropriate responses to art is another matter — psychological factors come into play, and good teachers are well equipped to appropriately deal with wrong answers from children without hurting their feelings or discouraging them from attempting better answers.

After identifying other aspects of the subject matter, like where they are located, the author asks "Who is going to win?" Most say the lobster. He then asks for reasons why. Then the children's answers are based in the form of the painting, and children are motivated to do a thorough formal analysis. They defend their choice of the lobster by pointing out how Picasso has painted the picture. The lobster is painted with definite long strokes of paint, whereas the cat is painted with squiggly strokes. The lobster looks strong because it is very angular and geometric, metallic and robotic.

Picasso has placed the cat backing off the canvas. The expression on its face is frightened. The lobster takes up more space on the canvas. Its diagonal direction of attack is more forceful than the cat's position of retreat.

One could start with formal questions, such as: What colors do you see? What shapes? What kind of brush strokes? But by starting with what is going on in the painting's narrative, the children are better motivated to discuss the painting's form. Form is not observed in an interpretive vacuum, but in the context of the painting's content.

As descriptions can be wrong, so too can interpretations. Lately, children are seeing "Satanism" in quite a few paintings, to take an extreme example of faulty interpretations. Children often offer inappropriate interpretations with their penchant for associational thinking and storytelling — "My uncle has a cat like that one, and...." Such interpretations are inappropriate because they lead attention away from Picasso's painting toward the child's biography. In these situations, children can be redirected to the painting — "What about Picasso's cat?" or "How is Picasso's cat different than your uncle's?"

Competing interpretations are more interesting to deal with. A class of fifth graders noticed the figures depicted in a painting of hockey players on ice by a German expressionist. The faces of the players are expressionistically painted, but the players look as if they might be wearing makeup, seem to have busts and hips wider than men's, and are in graceful poses not usually associated with ice hockey, a sport known for its roughness and violence. The children came up with different, competing interpretations during the discussion: The painting was German and done in the 1930's; perhaps women played hockey in Germany then. Perhaps the artist thinks that women should play hockey and is depicting what the game might look like if they did. Perhaps the painting is showing the gracefulness of sports and presenting the hockey players as dancers. Their interpretations are different, but each is sensible, and the students offered reasons in their support. The students were comfortable with their varieties of interpretations, and the author let the ambiguity of the painting remain. He did, however, explain that if they wanted more certainty, they could *research* the painting to find out more about the painter and his other works that might provide them with a more accurate and confident interpretation of this

particular painting.

The basic interpretive question (Danto, 1981) is "What is this about?" Variations and permutations of the question are endless when applied to specific artworks: "Why are these hockey players feminine?" "Why is this painting *(Guernica)* so violent?" "Based on these paintings, what is Magritte's view of the world?" "What do Bearden's collages say about being black in America?"

Different Works of Art

In addition to twentieth century American and European paintings, sculptures, photographs, and other works from art museums, especially including art by women and African American artists, the author has also used artifacts selected from children's everyday environments (cf. Chapman, 1978; Lanier, 1982). These have included such things as TV commercials (annual CLIO award winners available on videotape), *Batman*, the movie, ads torn from old issues of magazines in school libraries, "Air Jordan" t-shirts featuring the basketball star Michael Jordan and college sweatshirts that some of the children happened to be wearing, and cereal boxes and teddy bears which young children brought to school.

When using magazine ads, the author randomly passes them out to the members of class. By obtaining the magazines from the school library, he is assured of using magazines developmentally appropriate, to which the children have frequent access, which have ads that are marketed for children. He passes the ads out, pre-torn and pre-selected to save time, but allows children to ask to trade their ad for a different ad so that they are not obligated to the one they receive. He uses the ads, sometimes asking for descriptive statements and then interpretation. As a variation, students are asked to answer two questions about their ads: What is true about it? What is false about it? Another set of questions is: What is being sold? (That is, in addition to the product itself, what values are being promoted?) To whom? How? The children concentrate on how the form of the ads, as well as the language and the subject matter, delivers the messages. The author always asks that they back their assertions with reasons.

On a day when the author visited an eighth grade classroom in a rural section of Ohio close to the Michigan border, two children

were wearing University of Michigan sweatshirts, each with a different design. He asked them to stand in front of the room so that everyone could see and talk about their shirts. He taught the students to separate the denotations of the shirts from their connotations (Barthes, 1971). Denotations of words are ordinary definitions found in dictionaries; connotations are suggested meanings and overtones of meaning. Perrine (1977) provides linguistic examples: "home" denotes the place where one lives but connotes security and comfort; "childlike" and "childish" both denote "characteristic of a child," but "childlike" connotes meekness and innocence, and "childish" suggests pettiness, willfulness, and temper tantrums. In applying the concepts to images, identifying denotations is parallel to description, and identifying connotations, parallel to interpretation.

The group identified all the denotations on the sweatshirts, one by one: the colors yellow (maize) and blue, a football helmet, the words "Michigan," "Wolverines," and "go Blue," some words which they had difficulty reading such as Veritas and "scientia," the number 1878, and a gas lamp. The word "Michigan" appeared in different typefaces, and the students interpreted the different connotations of the style of the letters: one letter style suggested scholarship, another athletic competition. The students were able to decipher the gas lamp and Latin words as part of the official emblem of the university but could not determine the denotations of the Latin words; interestingly enough, however, they easily read their connotative meaning — tradition, antiquity, and academic sophistication. They were interested to note the similarities of the shirts — both of the same university, common colors, same name — and also how radically different were their connotations, one shirt being so scholarly, another so macho, as if they came from two different schools rather than the same.

Fourth graders in a small Ohio town were able to construct the techniques of narrative, Hollywood filmmaking by analyzing selected scenes of the recent "Batman" movie on videotape in their art class. They learned to descriptively identify such formal elements as lengths of shots, cuts, camera angles, camera movements; movement of actors, and actors and cameras moving simultaneously; back, key, and fill lighting; sounds of dialogue, voice-over, ambience, music, and sound effects. While students watched for visual effects, the sound was turned down so that they could better concentrate on technique and momentarily ignore the

story line. They counted the number of shots per minute in a romantic scene and those in an action scene and discussed the different tempos of each. They also timed the length of shots with their digital watches, noting that some were less than a second and some almost a minute in length before a cut was made to another shot. The author and their teacher encouraged them to watch television at home that evening with more critical distance than they would otherwise.

Writing About Art

Challenged by Wilson's (1986) request that children be taught to write about art as well as talk about it, and to reinforce the notion that critics are writers, the author tried some writing experiences with groups of children. To compensate for the lack of time in the art curriculum and the considerable time it takes young children to write, the author has used two different writing activities, one simulated, and the other actual but abbreviated.

When a class of children has gone to an art event, the author has gone into the classroom, announced that he was a critic and that he had to write a review of the event for the daily newspaper, and explained that they were to tell him what to write and how to write it. He provides them with a word count and a certain number of paragraphs, tells them that they will have only one accompanying photograph with their review, and that most of the readers will not have seen the event the children will be criticizing.

For example, the author recently accompanied the children of an urban elementary school in Columbus, Ohio, to see "The American Indian Dance Theater" in an hour-long performance in a downtown theater. Two days later the author visited the school and worked with fourth and fifth grade classes. He asked a fourth grade class first to remember all they could about the performance. When someone said "feathers" he wrote "costumes" on the blackboard and had the group remember all they could about the costuming in the performance. When someone said "bells" he turned that into the larger category of "sound," and they then listed the vocal and instrumental sounds of the concert. They also listed movements, stage sets and lighting, and performers. This was about a ten to fifteen minute descriptive activity.

To engage the children in interpretive thought about the performance, the author asked them to note what they now knew about native Americans that they didn't know before they went to the concert. He also asked them to relate, on the basis of the performance, what was important to native American peoples. The topics they discussed were animals, birds, spirits, gods, prayer, and dance. The children also discussed how the Indians' dancing was different from their own in that it was used to praise gods, request help from gods, and seek healing, as well as provide fun and entertainment. This discussion took about twenty to twenty-five minutes.

In the final ten minutes of the session, referring to the notes all over the blackboard, the group decided how they would organize the review they were pretending to write for the newspaper. The author needed to remind the students that they were writing for people who hadn't and wouldn't see the performance. He also praised the students for offering effective words and phrases, stressing that critics had to be good writers.

In another class at the school, after the students had orally described and interpreted the Indian dances, the author asked the group to transpose their enthusiasm for the event into why they thought it was good. He reminded them that they were pretending to write their review for others who had not seen the performance. They could not simply assert "It was great!"; they had to tell someone why. Two clusters of reasons they offered were that it was very enjoyable to watch and that it taught them things about other cultures that they did not know before. In a fifth grade class, the author skipped the evaluative discussion and, instead, asked each of the children to recall their one favorite moment of the entire performance and to write about it in one paragraph. This writing experience took about eight minutes. The students, if they volunteered, read their paragraphs aloud to their classmates. The following are exact quotes from two of the paragraphs which they wrote; the first by Croix Galipault, the second by Lauren Flemister:

> One of the most fantastic shows are coming to Columbus. It's called "American Indian Dance Theatre." So many different delighting dances will be shown. My favorite dance was the "Hoop Dance." One Indian starts with one hoop and ends up with about twenty at the end. He puts them every witch way around his body to form different animal shapes. At the end he has two 3 demential circles and about five hoops left over.

On Monday morning November 12, '90, at the Ohio Theatre we saw a Indian Dance Company. They have amazingly detailed costumes with a wide variety of colors. They danced with sharp, quick movements. They had neat music. They played drums, bells, and they sang. The lights were also well done. It had a night set with a moon. They had a hoop dance, grass dance, circle dance, and shawl dance, and a couple more. I liked the whole show and I was watching and listening the whole time. The hoop dance was magic and I enjoyed that. But my favorite dance was the one with everyone, the circle dance. Indians really love the earth. You can tell by the dances. If it ever comes back to Columbus I will see it again. I give it a thumbs up!

In different writing exercises involving single paragraphs, the author used large, good quality reproductions of paintings by Rene Magritte from a monthly calendar. He divided the classes into four groups according to the tables they were seated at, and gave one reproduction to each group at the table. He asked the students in their small group to observe for five minutes all they could about their painting, so that they could tell the whole class about it. The children from each table reported their observations to the class, and class members added to the observations of the "table-groups." He presented three more Magritte paintings, one at a time, and led the group in an interpretive discussion. He then asked each child to write one paragraph on "The World of Magritte." Charkeeta, a fourth grader using invented spelling, wrote the following:

I can see that when he makes his painting its like a puzzle. Its like a mystury you have to try and find what he put in. I think that his pitchers are real pure and like pure water. I think that he sees two halves, the first is bright and coliful the second is dreery but ok.

Molly Decamp, a fifth grader, wrote this:

Rene Magritte sees the world in a different way than you and I. He has more than just an ordinary eye. A mountainside to you and I looks like an eagle spreading his wings to him. Only Rene Magritte would draw a painting of a painting of a scene. What other artist would draw a woman in a peach or a man thinking of an apple. Rene Magritte sees the world with a different eye.

Mr. Paul Hammock, Molly's classroom teacher, was enthused about the process of doing criticism, and was moved by the work of Magritte. While his students were writing at their tables, he

wrote this at his desk: Rene Magritte has a curious twentieth century view of the world. He is not painting to describe his world but rather to help the viewer feel his world. While his paintings are fairly bold and simplistic, they also are clearly surrealistic. They have a symmetry that is easy to see, but his subject matter haunts the viewer. Why does the key burn? Why does a large green apple float over a man's head? Magritte's paintings clearly stretch our imagination to try to capture the unreality of our reality. Is our world real or is it illusion? Magritte's rather sober paintings point to the latter.

Using one of Magritte's paintings, in a variation of this writing project in a different class, the author asked one group to write a descriptive paragraph, another an interpretive paragraph, a third an evaluative paragraph, and a fourth, a summary paragraph about Magritte.

Conclusion

Admittedly, the examples of children doing criticism given in this chapter are unique, led by a professor who specializes in criticism, and who, in the schools, enjoys the status of special visitor. In these situations he had advantages that regular classroom teachers and art teachers do not enjoy. He was teaching a relatively light schedule, and did not face the many day to day difficulties teachers face, especially art teachers. Nonetheless, there is evidence here about what children can do regarding criticism in school settings. There is also evidence that they enjoy doing it.

The fourth and fifth grade children who talked and wrote about Magritte and the American Indian Dance Theatre spent, without a break, one hour and twenty minutes doing criticism. This is a record amount of time for the author to have spent doing criticism with children. When he entered the first morning class, he expressed trepidation to the teacher over the length of time he was scheduled and asked her permission to end early if the session proved to be too long. He broke the session into two parts, the first dealing with the Indian dance performance and, the second, with Magritte. The children stayed on task the whole time. At the end of the hour and twenty minutes, the teacher said that she wished *more* time had been scheduled.

All of the other sessions reported here were full class periods,

ranging from forty to fifty minutes depending on the individual schedules of the schools. During that time, the children only engaged in critical activities, not art-making activities. At the end of a full session of talking about twentieth century paintings, Sarah, a fourth grader in a Toledo area public school, longingly sighed to no one in particular, "Oh, I could just do this forever!" It is the author's experience, reinforced many times, that children enjoy doing art criticism.

Classroom teachers as well as art teachers have become excited about the possibility of having their students talk critically about art and write art criticism. Art teachers need to determine how much time they are willing to give to critical activities, and how long their particular classes of students can attentively criticize art. But these sessions by the author have at least shown that in certain situations under certain circumstances, children can thoughtfully talk and write about art for long periods of time.

Author's notes

[1] *An immediate limitation of having children write about art during an art class is the clock time children consume while writing. Art teachers are severely pressed for time in the curriculum and are hesitant to devote their few allotted minutes to the teaching of critical writing. This objection can be eliminated by asking the classroom teacher, rather than the art teacher, to have the children write about works of art in addition to the topics about which they ordinarily write.*

[2] *February and March sales of monthly calendars in bookstores and especially art museum shops are a very economical source of good art reproductions. For plentiful smaller reproductions, weekly appointment calendars provide about fifty reproductions. The Museum of Modern Art, The Art Institute of Chicago, and the Metropolitan Museum, among others, offer mail order catalogues.*

[3] *When working in schools, the author has frequently seen classroom teachers spontaneously raise their hands along with their students to answer critical questions. They enjoy the process and want to participate in criticism.*

References

Barrett, T. (1982). Photographs and contexts. *The Journal of Aesthetic Education, 19* (3), 51-64.

Barrett, T. (1988). A comparison of the goals of studio professors conducting critiques and art education goals for teaching criticism. *Studies in Art Education, 30* (1), 22-27.

Barrett, T. (1989). A consideration of criticism. *The Journal of Aesthetic Education, 23* (4), 23-35.

Barrett, T. (in press). Description in professional art criticism. *Studies in Art Education.*

Barrett, T. (1990). *Criticizing Photographs: An Introduction to Understanding Images.* (Chapter 2). Mountain View, CA: Mayfield.

Barthes, R. (1971). *Image-music-text.* New York: Hill and Wang.

Broudy, H. (1972). *Enlightened cherishing.* University of Illinois Press.

Chapman, L. (1978). *Approaches to art in education.* New York: Harcourt Brace Jovanovich.

Clark, G., Day, M., & Greer, D. (1988). Discipline-based art education: Becoming students of art. *The Journal of Aesthetic Education, 21* (2), 129-193.

Danto, A. (1981). *The transfiguration of the commonplace: A philosophy of art.* Cambridge MA: Harvard University Press.

Erickson, M. (1986). Teaching aesthetics. In S.M. Dobbs (Ed.), *Research Readings for discipline-based art education: A journey beyond creating.* Reston, VA: National Art Education Association.

Feinstein, H. (1989). The art response guide: How to read art for meaning, a primer for art criticism. *Art Education, 42* (3), 43-53.

Feldman, E.B. (1973). The teacher as model critic. *The Journal of Aesthetic Education, 7* (1), 50-57.

Feldman, E.B. (1984). *Thinking about art.* Englewood Cliffs, NJ: Prentice-Hall.

Geahigan, G. (1983). Art criticism: An analysis of the concept. *Visual Arts Research, 9* (1), 10-22.

Hagaman, S. (1990). Philosophical aesthetics in art education: A further look toward implementation. *Journal of Art Education, 43* (4), 22-39.

Hewett, G. & Rush, J. (1987). Finding buried treasure: Aesthetic scanning. *Journal of Art Education, 40* (1), 41-43.

Lankford, E.L. (1990). Preparation and risk in teaching aesthetics. *Journal of Art Education, 43* (5), 51-56.

Koroscik, J. (1990, April). *Novice-expert differences in understanding and misunderstanding art and their implications for student assessment in art education.* Paper presented at the American Educational Research Association Convention, Boston, MA.

Lanier, V. (1982). *The arts we see.* New York: Teachers College Press.

Lee, S-Y. & Barrett, T. (in press). The critical writings of Lawrence Alloway. *Studies in Art Education.*

Perrine, L. (1977). *Sound and sense: An introduction to poetry.* New York: Harcourt Brace Jovanovich.

Parsons, M. (1987). *How we understand art: A cognitive developmental account of aesthetic experience.* New York: Oxford University Press.

Stewart, M. (1990). Teaching aesthetics: Philosophical inquiry in the DBAE classroom. *Inheriting the theory: New voices and multiple perspectives on*

128

DBAE: Seminar proceedings. (pp. 43-44). Los Angeles, CA: The Getty Center for Education in the Arts.

Weitz, M. (1964). *Hamlet and the philosophy of literary criticism.* Chicago: University of Chicago Press.

Wilson, B. (1986). Art criticism as writing as well as talking. In S. M. Dobbs (Ed.), *Research Readings for discipline-based art education: A journey beyond creating.* (pp. 134-147). Reston, VA: National Art Education Association.

The Lost Las Meninas, A who done it and more!: Teaching Art History to Children

Jennifer Pazienza
University of New Brunswick

Critics, scholars, poets, playwrights, and philosophers all have tried to reach its essence, to provide a truly definitive explanation of its meaning, only to find that the picture has eluded the elaborate intellectual traps that they have set for it. In the face of these circumstances, and in the absence of any conclusive documentation, it must be admitted that no single interpretation will ever satisfy every point of view. *Las Meninas*, like every great work of art, is renewed, not depleted, by time and thus remains forever alive...every generation has an obligation to accept the challenge of interpretation as part of this process of perpetual revitalization. (Brown, 1978, p. 87)

Although it may be along way from the world of art history scholars to the world of elementary school children, Jerome Bruner's (1960) notion of the school student as inquirer implies that these worlds meet. One wonders, however, if elementary school students can learn to do what Bruner suggests. When presented with models of historical scholarship, can elementary school students construct art histories in the tradition of Jonathan Brown (1976), Joel Snyder (1985), Michel Foucault (1986), or Svetlana Alpers (1977)? Can children — through historical inquiry — increase their knowledge about art and artists, art history and art historians? Can young students interpret and apply ideals of human and artistic import, embedded in artworks, to a greater understanding of themselves and the world around them? Can these distant and different worlds — the worlds of scholars and children — ever converge? These worlds can and have met, in the mind of a ten year old boy who, in the spirit of contemporary scholars, accepted the challenge of interpretation and produced an account about Diego Velazquez and the painting *Las Meninas*.

How was it possible for this fifth grade student in a rural school in central Pennsylvania to write this account? This is a story about

Las Meninas, Diego Velazquez

the significant events in this student's year long involvement in art historical study, along with nearly one hundred fifty other students from kindergarten to grade five. Looking back to the year spent with students at Glen Richey Elementary School, the kind of thinking which precipitated this study was precisely as Bruner describes. Bruner stated that:

> In contrast to analytic thinking, intuitive thinking characteristically does not advance in careful, well-defined steps. Indeed, it tends to involve maneuvers based seemingly on an implicit perception of the total problem. Usually intuitive thinking rests on familiarity with the domain of knowledge involved and with its structure, which makes it possible for the thinker to leap about, skipping steps and employing short cuts in a manner that requires a later rechecking of conclusions by more analytic means, whether deductive or inductive. (Bruner, 1960, p. 58)

The story which follows, at the time that it occurred, "did not advance in careful, well-defined steps." Yet, as Bruner suggests, to make sense of that year at all, for oneself and for the field of art education, conclusions must be "rechecked by more analytic means." Considering the subject of this study it is only fitting that the mode of analysis invoked be historical narrative. This form of inquiry, writes Michael Stanford (1986), is a common approach in historiography, since young or old, educated or uneducated, most readers find little difficulty in following a story.

The Journey Back

At the time this study occurred, the author had not yet developed a model of art history instruction she wanted to test. Instead, a conception of the discipline of art history — its structures and its content — as it is philosophically and historically informed and practiced by contemporary art historians, was desired. As Svetlana Alpers (1977) suggests, art historians, while in the pursuit of knowledge, sometimes fail to see how they are makers of knowledge. Research into the historical and philosophical underpinnings of the discipline supports the idea that art histories — chronological stylistic progressions of individual accounts about specific artworks — are as much a matter of worldmaking (Goodman, 1978; Pazienza, 1989, in press; Stanford, 1986), or cognitive construction, as artworks are and that the act of

construction is basic to art historical inquiry processes and knowledge. Art historical accounts do not merely result from the historian's discovery and observation of objects and events, but evolve also from other art historical accounts. As contemporary practice suggests that although art historians search for new evidence and new knowledge about an artwork, the histories they produce owe their existence to histories from which they are built. Finally, as initially assumed, historical inquiry into artworks can reveal themes of artistic and humanistic import.

In addition to this general conception of the discipline, it was assumed that if Bruner (1960) was right in presuming that intellectual activity is the same in kind at all ages, then children, to varying degrees, ought to be able to understand *Las Meninas* as scholars do. To what extent then could children model certain art historical inquiry methods to learn about art, humanity, and themselves?

With these theoretical ideas in place, practical problems of choosing an artwork, art historical accounts, and inquiry methods were faced. The decision was made to use Velazquez's *Las Meninas*. Joel Snyder's and Jonathan Brown's written statements about the artwork were selected for analysis. *Las Meninas*, while artistically rich, also contains ideals of humanistic import which might be appropriate for children to think about. Snyder's description involves the double meaning of the reflection or the reflected image of the king and queen — ideas that may relate to the role of art in education, and formulation of one's own values. Brown's description alludes to the role and place of art in society, art as dignified work. Brown also discusses differences between ambition which is self-serving versus ambition that serves greater social or moral ideals.

Of the art historical approaches researched for this project, Erwin Panofsky's (1939) interpretive system and Michael Baxandall's (1985) theory of inferential criticism were found to be two appropriate and fundamental ways in which students can learn to historically study works of art. Erwin Panofsky's (1939, 1955) thesis provided a dominant influence because his iconographic method could provide a basic context for understanding the painting from which alternate historical stances can be assumed.

The Problem of Application

The second week of the school year was about to begin, and the approach to use in teaching had still not been determined. Were the students to be told that they were to pretend to be art historians, and that they were to interpret *Las Meninas*? Hardly. After all, children in kindergarten are just beginning to learn their ABC's. Students in grades one through three are only starting to learn how to read and write. Although fourth and fifth grade students very often can read and write, they usually read books by authors other than Panofsky, Snyder, and Brown. Without these basic tools of reading and writing, how could students in grades K-5, engage in interpretive art historical inquiry?

There was also a matter of the actual painting. Unless the school district would be willing to pay for a field trip to the Prado Museum, the students could not examine the original artwork.

Obviously, seeking a literal application of the theoretical processes from which art historians work would be an exercise in frustration. An analogous translation, however, of the intellectual activity art historians engage in might provide children with the means to successfully interpret works of art. Carlo Ginzburg (1985) equates the work of a historian with that of a detective. Art historians, like detectives, piece together clues and bits of evidence to construct a convincing account. It was with this in mind that the case of "The lost *Las Meninas*: A who done it and more!" was invented. This mysterious scenario which suggested that art historians do more than name, date, and determine stylistic change became an instructional strategy through which the students at Glen Richey Elementary School could learn to interpret meanings in Velazquez's *Las Meninas*.

Hans-Georg Gadamer (1976) explains that the difference between "methodological sterility and genuine understanding is imagination, that is, the capacity to see what is questionable in the subject matter and to formulate questions that question the subject matter further" (p. xxii). It was hoped that these students could, through the application of this scenario, think like some art historians and formulate a range of questions that would make it possible for them to question the subject matter of *Las Meninas* further and enable them to produce a comprehensive account of the painting's meanings.

135

During the study of *Las Meninas*, art histories written by a variety of scholars were found, as well as a play based on the painting, and painted, drawn, and photographed versions, copies, and interpretations which were made by other artists. Each of these ways of art historical worldmaking — writing, drawing, painting, and acting — stood as potential models for the variety of lively ways that these young students could use to form their interpretations of the painting. Eventually, each of these versions of *Las Meninas* became clues that enabled these students to interpret and apply the painting's meanings. After the time that this research was conducted, Nelson Goodman and Catherine Elgin (1988) published *Reconceptions in philosophy and other arts and sciences*. Their writings supported thinking about the educational implications of multiple interpretations of a single work of art. To explain his ideas about the value of studying variations of an artwork, Goodman used Velazquez's *Las Meninas* and Picasso's versions of the same artwork. Goodman (1978) wrote that:

> Variations upon a work, whether in the same or a different medium — and still more, sets of variations — are interpretations of the work; the Picasso variations function as much in this way as does an illuminating essay on *Las Meninas*. Like all other interpretations in paint or music or words, variations are works in their own right, though they may enhance and be enhanced by the theme. Variations and theme reflect each other; *Las Meninas* and the Picassos alike lose when either is deprived of the others. (p. 82)

Goodman's thesis supports art historical inquiry as it has been and is now practiced — specifically the construction of multiple possible accounts about a single artwork. In its application to teaching art history to young students, the notion of variations suggests that art historical worlds, although primarily written, may be drawn, painted, and performed. Finally, the notion of "cross model variations" or interpretations of artworks, crafted in various symbolic forms, has implications for the integration of art history instruction with other art content areas of art production, such as art criticism and aesthetics.

The Lost *Los Meninas*: Setting the Stage

And when you asked, as all history classes ask, What is the point of history? Why history? Why the past? I used to say...But

your "Why?" gives the answer. Your demand for explanation provides an explanation. Isn't this seeking of reasons itself inevitably an historical process, since it must always work backwards from what came after to what came before? And so long as we have this itch or explanations, must we not always carry round with us this cumbersome but precious bag of clues called history? (Swift, 1985, p. 92)

The First Grade

Teacher: Jeremy, please plug in the projector.
Student: Are we going to see more Mona Lisa's today?
Teacher: Someone left a letter for us in my mailbox with instructions for me to open it and read it to all the students here at this school!
Class: Wow! What is it? What does it say? It's probably about doing posters for American Education Week!
Teacher: No, it's not about American Education week.

Half out of their seats, the first grade class hung on every word as they were read: "To the children of Glen Richey. Turn to slide number 31 in the projector." The class projectionist jumped from his seat as he yelled to another student to turn off the lights. Hurriedly, he flipped the slide into place, and there on the screen was a reproduction of a painting.

Class: What is it? Who did it? Is it Leonardo's?
Teacher: Wait a minute. There's more to the letter. It says, "We have taken this painting. When you and every other student in your school can prove to us that you understand all about the different ideas in this painting, we will return it to the museum unharmed. The ability to recite its name and maker, to memorize when it was done, and to recognize what style of painting it is, is only the beginning! We expect you to know and understand what the painting means! Signed, the Thieves!"

The thieves say that we'll have to ask a lot of questions about the painting. Each week the thieves will answer our questions and give us some clues that will help us figure out what the painting means. Before too long, we should be able to tell them a convincing story about the painting's meanings. Did you know, boys and girls, that the fourth graders are using this painting for their Christmas play? They are not using it for a prop. The whole play is to be written and

performed from the meanings in it. Let's get started. What do you want to ask about the painting?

Class: How big is it? What's the name of it? Who did it?
Student: Leonardo did it!
Student: No, he didn't!
Teacher: Why did you say Leonardo didn't do it?
Student: Because he didn't.
Teacher: How do you know?
Student: Because, Leonardo didn't paint like that!
Teacher: Do you think this artist painted at the same time, before, or after Leonardo?
Class: Before! After! At the same time!
Teacher: Is that a question for the thieves?
Student: Yeah! We have to ask when it was painted and who painted it.
Student: I wanted to know who all those people are.
Student: Yeah. Who's that little girl in the middle?
Teacher: Who do you think she is?
Class: We don't know.
Teacher: Who do you think this man is?
Student: He is a painter.
Teacher: Yes, he's a painter. What do you think he's doing?
Class: He's painting.
Teacher: Great! What do you think he's painting?
Class: The people in the room, himself, and the dog.
Teacher: That's another question we'll have to ask the thieves. Who is the artist in the picture painting? Just out of curiosity, do you know what this big thing is (pointing to the canvas in the painting)?
Student: It's a thing! It's like a big thing! I got one at home!

"The lost *Las Meninas*" was as much an unfolding drama for me as it was for these students. Therefore, I decided to write my lesson plans in script form. Although the general idea of the overall scenario was predetermined, the lessons were not taught from a script which had been completely thought out beforehand. At the time, it had been decided that during Act I, the students would be presented with the problem of the theft of *Las Meninas*. During Act II, the longest of the three acts, students in each grade would interpret the ideas in the painting and build a comprehensive account of the painting's meanings. Act III, the conclusion, would address the return of *Las Meninas* to the *Prado Museum* and bring closure to

138

the study. Details in each of the scenes in the three acts were worked out week by week as the students, in dialogue with the painting and the thieves, negotiated the direction of inquiry they wanted to take. The project could be planned in this way because the focus of the educational interests of the students were known beforehand. After studying *Las Meninas*, students in each grade should have: (a) increased their knowledge of art, artists, art histories, and art historians, through learning about *Las Meninas*, Diego Velazquez, Goya, Dali, Vega, and Picasso, and the histories written by art historians, Joel Snyder and Jonathan Brown, (b) gained the intellectual skills, or interpretive methods of art historical inquiry necessary for the acquisition of that knowledge, and (c) received greater understanding of themselves and their world through thoughtful and sensitive application of the ideals contained in *Las Meninas*. While deciding what would be taught next, both the students' questions and these goal areas were kept in mind (Adler, 1982).

The teaching scenario of "The lost *Las Meninas*" was used in grades K-3. Through the application of this method, students were tacitly directed in the use of Panofsky's interpretive system, and clues were introduced that led to the controversial reflected image. The scenario was not used with the fourth and fifth graders. Instead, the research interests for this study were explained to them, specifically the question as to whether or not they could interpret the meanings in *Las Meninas* like art historians do. They also received clues each week, but they knew that these clues had been generated by their teacher. The fourth and fifth graders were also informed that the younger children were also studying the painting and were asked not to give away any of the clues.

Without knowing it, the questions asked related to pre-iconographic description, iconographic analysis, but only rarely to iconological inquiry. Slowly and patiently the students were guided through Panofsky's tripartite scheme through the use of their own questions, and they began to relate their understanding of various parts of the painting to a greater comprehension of the whole painting. As these students asked their questions, ideas taken from Joel Snyder's account were first used to provide answers. As was hoped, this strategy led students to ask questions about parts of the paintings that were inconsistent with Snyder's explanation of the whole painting. The following questions raised by a fifth grade student illustrate this point:

> If the painting is supposed to be about the double meaning of the reflection, the princess, and her relationship to her parents, you know, about how she's supposed to grow up, then why are all those other people in the painting? Why is Jose in the doorway? And why are the maids there? And why is Velazquez and everybody else looking out at us?

This is precisely what art historians do as they try to challenge the account of another. This student was dissatisfied with Joel Snyder's explanation of the painting's overall meaning. To her, Snyder's account did not provide a comprehensive enough explanation of all that she saw in the painting. Because of this student's perceptive questions, Brown's version of *Las Meninas* could be introduced to lead these students to debate the ideas expressed in each account.

The Lost *Las Meninas*: Mirrors, Models, and Magic!

Before the art cart had completely entered into the classroom, the students in the second grade class began asking questions:

Student: Did they leave us another clue? What did they say this time?

Student: What's in the package? On the cart rested the clue that I hoped would move my students from merely recognizing and identifying the characters in the painting.

Student: It's a mirror!

Teacher: Yes, it's a mirror. Why do you suppose the thieves left us a mirror?

Student: Maybe it's some kind of clue to help us get some ideas so we can tell the story about the painting.

Student: Umm. That big thing over there, that painting, it might be the painting of the king and queen. And that mirror, that might be a mirror up there, and it shows, umm, that's what they look like on the big thing.

One third grade student was sure it was mirror in the painting because unlike "the dark, dull Reubens paintings," hanging on the wall above it, "the edges of the mirror are shiny and the faces are bright." A young boy in kindergarten said, "it's a magic mirror" and "maybe the king and queen are invisible and only the mirror can see them." A student in fifth grade argued, "If it's a reflected image, that means that they have to be standing around there somewhere."

140

As they held up their photocopies of the painting, bending the bottom margin to show what they meant, students in the fifth, fourth, and third grades asked, "Couldn't they be standing outside the room looking in? You know, like this. Then they could be seen in the mirror. Yeah, look at how everybody is staring out at something or someone. They're probably looking at the king and queen!" Just as Jonathan Brown and Joel Snyder constructed different accounts of *Las Meninas* as they argued the painting's perspective and the source of the reflection of the king and queen, so did these students.

The Kindergarten

Student: Stand here! No over more! Hold the mirror up a little!
Student: I want to be the queen!
Student: I want to be Diego!

While they took turns posing as the characters in the painting, each kindergarten student had a chance to think about the reflection in the mirror. Is the source of the reflected image of the king and queen, as Joel Snyder suggests, on the canvas depicted in *Las Meninas*? Or, as Brown argues, is the source a corporeal king and queen standing outside the scene? One student thought Diego was painting the king and queen on the canvas which was depicted in the painting. But could he and the other students understand what this had to do with the painting's meaning? Could he agree with Joel Snyder that the reflection had two meanings, one literal and one metaphorical? Snyder believes that Velazquez translated his knowledge of Spanish mirror literature, guide books for the proper education of princes and princesses, into a visual trope. Essential, here, are the ideas that both visual and literary works of art can educate. Learning not only relies on the natural abilities of the child, but also upon the culture.

Teacher: Hold it up.
Student: This is Diego painting on the canvas in the painting. This is the reflection of the king and queen in the mirror.
Teacher: That's great! But what does it mean? Why do you think Diego wanted to paint something like that?
Student: I don't know.
Teacher: Let me try to explain it to you and the rest of the class. The mirror is very important in this painting. What do mirrors do?

Student: We can see ourselves in them!

Teacher: Yes. We can see a reflection of ourselves in them. In this painting, the word reflection has two meanings. First, reflection means what it commonly means. (While pointing to the mirror in the painting, it was explained that the reflection of the king and queen could be coming from the canvas where Diego is painting.)

Student: Yeah, we can see their reflection in the mirror!

Teacher: Exactly. The second meaning of the word reflection has to do with the princess Margarita. Margarita is supposed to reflect the values and beliefs of her parents, the king and queen. In other words, Margarita is supposed to grow up according to the values and ideals taught to her by her mom and dad. Diego painted them in the mirror to remind her. The reflection of her mom and dad in the mirror stands for the way she should behave. She should reflect the teachings of her mom and dad.

As the kindergarten students worked out their understanding of the reflected image through drawing and painting, the fifth, third, second, and first grades were busy making three-dimensional versions of *Las Meninas*. Although art historians typically build their accounts with words, these students built their accounts with cardboard boxes, paper, paint, and dolls. Students in each grade were asked to indicate the source of the reflected king and queen and argue its role in the overall meaning of the painting.

The class discussion of the role of perspective was based on Snyder's account. The fifth graders were shown how Snyder helps convince the reader through several diagrams of the painting's structure. He argues that the point of convergence of the painting's orthogonal lines is located left of Jose. Therefore, the source of the reflected image cannot possibly be a corporeal king and queen who stand outside the picture plane.

These students argued the positions of Snyder and Brown and speculated about alternate possibilities for the locations of the king and queen. Students in grades one and two spun such elaborate tales, sometimes changing the story in the middle of their explanations. The third and fifth grade students prepared their reports in advance. In each case, however, students began to demonstrate their understanding of the relationship between the reflection and the overall meaning of the painting. As did Snyder and Brown, these students eventually asked what the location of the

source of the king's and queen's reflection means to an overall understanding of the painting. Of course they did not ask in those words, but they asked the same question in their own way. Imagine their delight when they were able to tell the thieves that the painting had many different meanings, as illustrated by the following statement that was made by one of the students:

> It's a painting about a princess and how she should behave. Her mom and dad are in the mirror to remind her. In those days princes and princesses had to learn to paint, draw and study art. Velazquez put himself in the painting because he was real good friends with the king. Even though Diego and the king were real good friends, it wasn't right back then to really put the king and himself in the painting, so he did it by putting them in the mirror.

The Lost *Las Meninas*: A Fourth Grade Interpretation

Ms. Blake and the fourth grade students were eager to adopt "The lost *Las Meninas*: A who done it and more!" as the theme and title of their Christmas play. There were about thirteen weeks prior to the first dress rehearsal in which research to the painting, interpret its meanings, write the script, and make the costumes and props. It was decided that the author would instruct the students in interpreting ideas in the painting and transforming those ideas into a play. Ms. Blake chose to cover the historical background of Spain in the seventeenth century and instruct the students in making their own costumes.

The performance deadline of December 15th demanded that the inquiry into *Las Meninas* occur at a much faster pace. Once the fourth grade students had a grasp of the ideas that the reflected image suggests, the writing of the play could begin. Unlike each of the others, this class arrived at the painting's issues in two forty minute class sessions.

The fourth graders were reminded that they had the task of educating as well as entertaining their audience. The students wanted to incorporate both ideas about the reflection. They wanted to show that the reflection could be coming from Diego's canvas, and from the king and queen standing in the room.

Over the weeks that followed, the fourth grade students' play developed as their drawings often do, which supports the theoretical correlation between verbal and graphic narrative development (Wilson and Wilson, 1982). Just as children invest their graphic narratives with rich plots and sub-plots, antagonists and protagonists, these fourth grade students invested their play with good guys, bad guys, heroes, and heroines.

In the play, Jose steals the painting that Velazquez is painting for the king's Christmas present. Later, Jose secretly returns the painting on Christmas Eve. Everyone believes that he is a hero! Then, on Christmas Day, as all gather in Velazquez's studio, the king rewards Jose with 10,000 ducats. As the king stretches out his hand to give him the money, Jose, being the morally right person he really is, refuses the money. Jose confesses he was the culprit, admits his jealousy, and explains that he only wanted the king to notice him as he does Diego! Ashamed and embarrassed, Jose turns to leave. The king, however, filled with the spirit of the season, asks him to stay and celebrate. He says, "I understand. We can work it out. Stay Jose, and celebrate with us. After all, you have always been a true and loyal member of my court."

The fourth grade play became the source of motivation for every lesson in each class. As December grew closer, the entire school was involved in various forms of interpreting *Las Meninas*. The kindergarten students illustrated posters that advertised the play. The third grade class designed and wrote the playbill that was given to every parent who attended the performance. Half of the fifth grade class produced a 7' x 6 1/2' painting of *Las Meninas* that was used in the play, while the other half wrote, designed and mailed a newsletter to every student, teacher, and administrator in each of the schools where the play would be performed.

With actors, props, and costumes in tow, the students boarded the school bus. Students performed for two schools each day on four consecutive days. On the fifth day, the play closed with a final performance for students, teachers, parents, and administrators of Glen Richey Elementary School. Surely the thieves would be satisfied by now!

Will the Real *Las Meninas* Please Stand Up!

While driving through the snow covered mountains between State College and Glen Richey while returning to school after the winter vacation, it was easy to wonder what the students' response would be when they learned that the thieves had yet another package, *Las Meninas*, waiting for them. Did the winter recess break their interest in the painting? When the the school year began, could it have been imagined that the class would finish studying *Las Meninas* in December after the performance of the Christmas play? How could it have been imagined that the study would continue into the spring?

In the weeks that followed, the thieves left some curious clues that prompted the students to continue their interpretation of Velazquez's *Las Meninas*. The manilla envelope, marked *Las Meninas*, was slowly opened. The note inside read: "So, you think you're pretty smart? Well, we have something to show you that will really stump you. You're not finished. Here is a painting named *Las Meninas*: What do you make of it?" The thieves left a slide of Picasso's version of the painting. The thieves had also sent a book on Picasso which explained his interest in *Las Meninas*. The children were fascinated to learn that Picasso interpreted the painting in his own style according to his time and place in history.

In addition to Picasso's version of *Las Meninas*, Goya's copies, Dali's bust of Velazquez, and Peruvian artist Braun Vega's post-modern appropriation were each used to achieve Gadamer's (1976) notion of "effective history." These artworks served as visual illustrations of past worlds, enabling the students to criticize and understand their present world. Each of these artworks or — in Gadamer's terms, successive acts of mediation — can stand as models of his concept of the fusion of horizons. As each of these artists interpreted Velazquez's *Las Meninas* and produced new works, they bridged the gap between the past and their present worlds. It was hoped that these students would learn that they could bridge the gap that separates them from the past and understand, through the application of Gadamer's concept of the fusion of horizons, that they are a part of tradition and history itself. It was hoped that they could construct effective art histories. From an educational standpoint, it is this aspect of history that is most relevant for students.

These students' responses show the high level at which they had grown accustomed to making connections between the clues which the thieves gave and their understanding of *Las Meninas*. Without knowing it, these students had become disciplined inquirers (Bruner, 1962). As the first grade students were introduced to the lesson on visual biographies, every student's hand was anxiously raised in question.

First Grade

Teacher: What is it class?
Kristen: We want to write about the painting like the older kids.
Students: Yeah! The thieves say we have to tell a story, right? Well, we want to write one.
Teacher: Can you write?
Students: Sort of. We're learning to write with our regular teacher.
Teachers: I have an idea. What if you tell your story to me, and I'll write it on this large lined paper?
Students: That's great, but we want to write it too! Yeah! We can copy what you write.

The first grade students were not satisfied merely to dictate their story. They insisted that they write it too. They behaved as though a new world had opened up to them. And it had. These students were no longer restricted from crafting their worlds in words.

Each class session began with the students arguing about the content of the story. To organize their thoughts, the students agreed that there ought to be a beginning, a middle, and an end. Further, the story should tell what the class thinks the painting is about. It was surprising that a lesson of this type would encourage such lively debate over the issue of the reflected king and queen. Without knowing it, these students engaged in an astounding critical debate. In this setting, in the role of mediator, the author listened carefully as the first graders argued their ideas, helped them to combine several of their thoughts and transformed them into sentences as they were repeated to them. Next, the new sentences were read, attached to the portion of the story from the week before. The class decided whether or not to keep each sentence. Once the students had all agreed about the next sentence, it was written on the large lined paper which was fastened to the classroom blackboard. The

students then copied it. It was delightful to see that even the less mature writers in the class maintained interest in the endeavor.

Students who finished copying the story ahead of the others worked on illustrating the story, in the large margin at the top of their paper. The class period closed with the entire group reading, in unison, the latest draft of the story. This, too, was their decision.

The Lost *Las Meninas*: The Return

With only three weeks remaining until summer vacation, the case of "The lost *Las Meninas*: A who done it and more!" needed to be brought to a close. What would satisfy the thieves so they would finally return the painting?

The thieves decided that they wanted the kindergarten, first, second, and fifth grade students to look at a different, but similar painting to *Las Meninas*: Jan Vermeer's *The Art of Painting*. The students were instructed to ask as many questions about the painting as they possibly could within a twenty-five minute period. Possible content of the questions was not discussed although it was wondered just what these students would ask after spending nearly an entire school year modeling the methods of certain art historians. Would these students be able to transfer their knowledge of art and historical inquiry to an unfamiliar painting?

Although it was found that students across grade levels ask similar questions, it was most notable that only a few questions referred to the painting's social, cultural, and historical context. Students in grades K-3 appear to be more interested in asking pre-iconographic and iconographic questions, especially questions that relate to the work's gestural qualities such as "Why are her eyes closed?" and to themes such as "is the painting about art?" rather than asking questions that systematically relate the work to its period. Only in grade five were there questions that might relate to the greater historical context of the work, such as "What country is it from?" This does not mean, however, that children do not ask historical questions. The questions they asked may reveal their view of history as storytelling. The notion of history as storytelling is not new; it is a very old conception of history. History or *historia* is from the Greek, meaning inquiry. The word, *histor*, which means knowing or learned, is similar to the Greek, *eidenai,* to know. A

The Art of Painting, Jan Vermeer

"tale or a story" is the first definition of history entered by Merriam-Webster (1983, p. 573). It can be argued that contextual references should be included in the story told about a work. These students, however, show a preference for understanding the story that the painting tells.

Although children may, during their inquiry, ask questions that relate to the work in context, these questions show that young students are more interested in what the painting is about than what was happening in the world at the time it was produced. Certainly the surrounding world of the painting influences what the painting means and why it looks as it does, but unless the reference to the world outside the painting has direct bearing on understanding of ideas in the work, the reference seems to have little meaning for young students.

Why did these students not ask about themes of human import or life's big issues? The author has written that what is most significant about historical inquiry is its ability to reveal important ideas in works of art that may have meaning for students. Throughout the school year, students were encouraged to think of ways that ideas in *Las Meninas* might have applications to their own lives. One discussion specifically addressed their ideas about the role and place of art in education and led to a more general discussion about who has the power to determine which subjects these students learn. Another discussion questioned whether art could be considered to be dignified work. Reasons were pondered and compared as to why Velazquez was not allowed to paint himself and the king in the same painting. Yet, anyone living today can have his or her picture taken with a lifesize portrait of Queen Elizabeth, Prince Charles, or even the President of the United States. Although time was spent discussing the ideas in *Las Meninas*, this level of discussion only occurred after the ideas were revealed through an explanation of Brown's (1978) and Snyder's (1985) accounts. The point is, big issues embedded in works of art are not self-evident; not to young children nor to uninitiated adults. For example, we cannot learn about Velazquez's moral dilemmas, his ambition for art, and his personal drive to be a great painter or a grand courtier through merely observing the work itself. These ideas are mediated through the art historian's text. In other words, without prior advantage of art historical textual scholarship as models or mediators, it is no wonder that these students did not ask questions regarding the metaphysical concepts or ideas that are not

immediately perceivable in *The art of painting*. This is significant as it is further testimony for the relevance and use of art historical models in children's art instruction and learning.

When the last day of art instruction arrived, so did the last correspondence from the thieves. The package which the thieves sent was addressed to the students in grades K-3.

Teacher: Class, this package contains a note from the thieves that will tell us whether or not they have returned the painting.
Students: Open it up! What does it say? Did they give the painting back?
Teacher: The note reads: "To the boys and girls of Glen Richey Elementary School. Thank you so much for all your hard work studying Diego Velazquez's *Las Meninas*. We have returned *Las Meninas* to the *Prado Museum*. In the package, you should find a picture of the painting hanging on the wall in the museum. We want you to know that we are really not thieves, and that we really did not steal *Las Meninas*. We made up that story so people would listen to us. You see, we believe that works of art are important for everyone to learn about, even young students like yourselves. Because of your hard work we will be able to show and tell people all about the kinds of problems you solved and how you learned to interpret *Las Meninas*. Your work will make it easier for other children, like yourselves, to learn about works of art. Thank you again, The Thieves."
Students: Wow! That sounds really good, but how do we know that they're telling us the truth? Let's have a closer look at that picture. How do we know that they returned the real *Las Meninas*? Yeah! Maybe it's a fake!

Pieces of the Puzzle: Some Implications of the Lost *Las Meninas* for Pre-service and In-service Teacher Preparation

It is important to consider that the year-long application of "The lost *Las Meninas*" to teaching the students at Glen Richey Elementary School should not be viewed as a model. The study was part of a doctoral research project and was an experiment that defined itself as it proceeded. No one specific theory of art history was chosen, rather the author was experimenting with bits and pieces of theoretical ideas. As the year advanced, so did knowledge

about art history and the teaching of art to children. Upon reflection, however, the insights developed over the course of the school year may contribute to the formulation of a theory of art history instruction and learning. Although it is not recommended that teachers choose a single work of art and teach it for an entire year, there are aspects from that year of instruction that have implications for the preparation of art and general classroom teachers.

As the traditional public school approach to the study of art is expanded to include history, criticism, and aesthetics, art education's traditional artist/teacher model for the preparation of art teachers will become inadequate. Can prospective teachers, enrolled in a typical teacher education program, learn to teach the content and structures of art's many disciplines? Hundreds of hours were invested in preparing instruction on a single artwork for six elementary school classes. Can an art program similar to the one at Glenn Richey School be implemented by art teachers and classroom teacher with far more students? Can classroom teachers who have as many or more subjects to teach, with little or no time to plan and organize, implement an art program similar to the one at Glen Richey?

Prospective and practicing teachers need a working philosophy of art and history that reaches beyond the late modernist emphasis on art as formal structure and history as the Darwinian progression of each style successively begetting the next. They need a philosophy that permits artworks and prior art historians to educate about artistic and humanistic ideals such as those found in *Las Meninas*. *Las Meninas* was chosen because of the significant ideas it contains: personal versus greater moral and social ambition, art as dignified work, reality versus illusion, and art in general education. Teachers need to understand that, in works of art, ideas such as these are not self-evident. It is through the mediation of the art historian's text and the artwork that one comes to learn about these ideas.

Finally, as Bruner (1986) suggests, teachers need a theory of development in which the central technical concern will be how to create in the young an appreciation of the fact that many worlds are possible, that meaning and reality are created and not discovered, that negotiation is the art of constructing new meanings. . .it will

not. . .be an image of human development that locates all of the sources of change inside the individual, the solo child (p. 149).

References

Adler, M.J. (1982). *The Paideia proposal.* New York: Macmillan.

Alpers, S. (1977). Is art history?, *Daedalus, 106*, 1-13.

Baxandall, M. (1985). *Patterns of intention: On the historical explanation of pictures.* New Haven, CT: Yale University Press.

Brown, J. (1978). *Images and ideas in seventeenth century Spanish painting.* Princeton: Princeton University Press.

Bruner, J.S. (1960). *The process of education.* Cambridge: Harvard University Press.

Foucault, M. (1986). *Actual minds, possible worlds.* Cambridge: Harvard University Press.

Gadamer, H.G. (1976). *The order of things.* New York: Random House.

Ginzburg, C. (1985). *The enigma of Piero.* Norfolk, Great Britain: The Thetford Press Ltd.

Goodman, N. (1978). *Ways of worldmaking.* Cambridge: Hackett Publishing Company.

Goodman, N., & Elgin, C.Z. (1988). *Reconceptions in philosophy and other arts and sciences.* Indianapolis: Hackett Publishing Company.

Merriam-Webster, A. (1983). *Webster's ninth new collegiate dictionary.* Springfield, MA: Merriam-Webster, Inc.

Panofsky, E. (1939). *Studies in iconology.* New York: Harper and Row.

Panofsky, E. (1955). *Meaning in the visual arts.* Chicago: The University of Chicago Press.

Pazienza, J. (1989). Modes of historical inquiry: Teaching art history to children. *Dissertation Abstracts International, 50A*, 7, 1906.

Pazienza, J. (In press). Re-creating visual and verbal artistic worlds: Teaching art criticism and art history to children. *Art Papers.*

Snyder, J. (1985). *Las Meninas* and the mirror of the prince. *Critical Inquiry,4*, 539-572.

Stanford, M. (1986). *The nature of historical knowledge.* Oxford, Great Britain: Basil Blackwell.

Swift, G. (1985). *Waterland.* New York: Washington Square Press.

Wilson., B. & Wilson, M. (1982). *Teaching children to draw.* Englewood Cliffs, NJ: Prentice-Hall, Inc.

Aesthetic Meanings, Aesthetic Concepts, and Making a Reflective Aesthetic Judgment

Margaret Hess Johnson
Winthrop College
Rock Hill, South Carolina

Aesthetic meanings are derived from an individual's experience with works of art. They are developed through the interaction of aesthetic qualities with perceptions and concepts and are based on insights and significances derived from a range of experience, aesthetic and otherwise. Aesthetic concepts are evolving meanings and significances that develop when an individual experiences a work of art.

But discussion about works of art does not necessarily develop aesthetic understandings. Some art criticism models emphasize language and argument, while others emphasize the experience of the aesthetic encounter for developing perception. This chapter presents a third approach to art criticism: its function in developing aesthetic concepts through the process of making reflective aesthetic judgments.

Among the goals that the NAEA has proposed in *Quality Art Education Goals for Schools: An Interpretation* (Qualley,1986), is one which supports the incorporation of art criticism in art instruction. Through art criticism, the student learns to talk about critical ideas, as well as becoming a producer and appreciator of art. Critical inquiry and dialogue about art are activities which, as Edmund Feldman wrote, are more or less informed, more or less organized, talk about art (Feldman, 1973). This talk allows for the sharing of critical insights about the aesthetic experience. It includes talk about the student's artwork, the teacher's artwork, artworks in galleries or in reproductions. Art criticism as discourse, then, is part of learning the language of art. And yet art criticism, by its very nature, presents problems in the "apprehension" and expression of aesthetic meanings in works of art.

Words that are used to describe Art and works of art represent two different concepts. Not only do a "sensuous" line or a "shifty"

line represent as many meanings as there are readers of the phrases, but saying such and seeing such are two different matters. The arts are forms of thought and feeling which can be inaccessible to communication (Langer, 1957). This semantic problem is described by Woods who wrote, "It is sometimes argued that, unlike the sequential reading of a text, a painting is apprehended simultaneously, all at once" (Woods, 1978, p. 18). Devaluing the significance of pictorial apprehension, Woods maintained that the value of the significant relationship of the sequential steps of Feldman's art criticism method was in learning to read words. And yet, this value pertains only to building language and argument; it has little to do with the experiential aspects of art criticism or the apprehension and expression of aesthetic meanings. In the art class, this value can restrict the growth of aesthetic concepts.

Three related themes are discussed in this paper: (a) evolving aesthetic meanings are related to developing aesthetic concepts because communication about works of art does not necessarily develop aesthetic understandings; (b) procedures for directing art criticism formats are discussed from linguistic and experiential perspectives because established concepts about art may restrict developing perceptions about works of art; and, finally,. (c) a process to develop aesthetic concepts, an approach to art criticism, drawn from writings by Eugene Kaelin, is presented (Kaelin, 1966, 1968, 1986, 1989).

Aesthetic Meanings, Aesthetic Concepts, and the Role of Language

If concepts are the meanings we give particular aspects of our realities, aesthetic concepts are understandings resulting from the interaction of aesthetic experience and language. That is, experience informs language; and conversely, language structures and informs experience. Aesthetic concepts are those evolving meanings that develop when an individual experiences a work of art, either through appreciative or through expressive activities. These meanings form a base of mental associations which can be addressed through art criticism. As people discuss works of art, they draw from aesthetic concepts as they comprehend and express insights. Now language assumes a distinctive role in the development of aesthetic concepts; it performs as an interactive dynamic, a bridge between the art object, the aesthetic experience,

and the individual. Considering the relationship between art criticism and learning as part of critical audience behavior, Madeja wrote, "Language as used in the art program is a device to enable students to describe, analyze and comprehend qualities, and then to make and justify aesthetic judgments about art" (Madeja, 1980, p. 26).

Several methods have been developed that use the critical process for talking about art in the classroom. Some methods (Feldman, 1975; Smith, 1968) emphasize the analytic, others the metaphoric (Feinstein, 1982; Johansen, 1979). Some art criticism methods emphasize phenomenological elements (Lankford, 1984); others emphasize inductive (Ecker, 1972; Clements, 1979) or art-historical elements (Mittler, 1980, 1982). Moreover, strategies which can be referred to as heuristic (Gaitskell & Hurwitz, 1958), dialogic (Johansen, 1982), or interrogative (Douglas & Schwartz, 1967; Armstrong & Armstrong, 1977; Taunton, 1983; Hamblen, 1984) characterize some art criticism approaches, while other formats include a range of perspectives (Chapman, 1978; Eisner, 1979; Hurwitz & Madeja, 1977).

George Geahigan makes two suggestions for using critical methods in the classroom: (a) that the questions be relative to the educational value of the critical activity, rather than to the correspondence of the method to actual critical activity; and (b) that it is a mistake "to assume that there is one, and only one, method of criticizing that is correct and proper" (Geahigan, 1983, p. 21). In other words, art educators should consider the context in which a method can be used. Educational situations differ from one another and change over time; hence, modifications are always a possibility and a necessity for educational growth.

Two Differing Aspects of Art Criticism: Linguistic and Experiential

The common thread in these critical methods is a progression from description, to analysis, to interpretation, to evaluation. This progression can be thought of as particular and linear, or as *linguistic*, or it can be considered in terms of the aesthetic experience, as *experiential,* such as when one perceives the expressive qualities of a work of art. While this sequence from description to evaluation is well-known and commonly accepted, a

focus on art critical language and structure can present an accompanying problem: a focus on language can lead to a misunderstanding of its relationship to visual art criticism in an educative context, as if art criticism were a matter of *reading pictures*. An emphasis on the sequential and literal aspects of art criticism encourages the critic-student to perceive *literal* rather than *aesthetic* meanings in works of art.

In this manner, it is possible to consider classroom art criticism from two different perspectives: the *linguistic* and the *experiential*. A linguistic approach to art criticism uses a sequential, linear format, and emphasizes analytical processing and rhetoric. Linguistic models of art criticism begin in the description phase with a literal inventory of imagery perceived in the work of art. Images are named until they become too abstract; then main shapes, colors, and other formal elements of the work of art are described (see Feldman, 1987, p. 472; Smith, 1973, p. 40; Mittler, 1982; Feinstein, 1982). This process also teaches students to "read" pictures, as if the literal aspects of works of art are the primary carriers of aesthetic meaning.

An experiential approach to art criticism, on the other hand, places an emphasis on the experience in an aesthetic encounter. Rather than endorsing a sequential and linear format, an experiential approach endorses intuitive use of one's senses. The work of art is critiqued through the felt aesthetic experience; rather than "reading" a work of art, one "apprehends" and expresses the meanings and significances of that experience. This approach focuses initially on the *sensory*, not the *literal,* elements of works of art (Broudy, Smith & Burnett, 1966; Broudy, 1986; Johnson, 1989).

Whether linguistic or experiential, criticism is a process of funded perceptions and realizations and is expressed aesthetically. In any lock-step and linear analysis of an artwork, it is possible to lose sight of the beauty, the strength, the simplicity or complexity, and the pervasive quality of the first impression. This is apparent when we consider what happens in an art critique or dialogue with twenty or thirty students. The aesthetic dialogue is a dynamic and often unpredictable dialectic between the teacher, the students, and the artwork. Multiple meanings evolve from the critical inquiry, although rarely as a result in the planned sequence of discussion.

Students usually have an immediate impression of the work of art, even if the artwork is only a reproduction pinned to the bulletin

board. Often they will immediately interpret what they see, making unique and interesting observations, insights, and correlations. But teachers who insist that the aesthetic dialogue follow a linear sequence, in which interpretation is delayed until step three of the critical method, are likely to lose the most valuable tool the students have to understand the meaning of the artwork and the aesthetic experience itself: the initial impression, the pervasive quality of the work. Yet this is what can happen in an atomistic analysis of a work of art; the thrill is gone. When viewers concentrate on the parts rather than experience the whole artwork, the students' talk may be constrained so that the product of the aesthetic inquiry becomes a dissection rather than a synthesis and judgment (Dewey, 1980).

Developing Aesthetic Concepts as a Third Approach to Art Criticism

As a process, art criticism develops aesthetic perception which heightens the aesthetic experience (Broudy, 1986), but as a method, art criticism also develops art language and art argument (Smith, 1968; Feldman, 1967). This distinction between an emphasis on language and argument, contrasted with an emphasis on the aesthetic experience, necessitates a third approach to art criticism: its function in developing aesthetic concepts through making reflective aesthetic judgments (e.g., Kaelin, 1986, 1989). What follows is an approach to art criticism which emphasizes the making of reflective aesthetic judgments.

Reflective Aesthetic Judgment is drawn from Eugene Kaelin's descriptive approach (Kaelin, 1966, 1968, 1968, 1986; and in conversation, 1987, 1988). Emphasizing the experiential and contextual aspects of drawing meaning from an aesthetic encounter, Reflective Aesthetic Judgment was adapted from Kaelin's three aesthetic categories or concepts.

In his article, "Aesthetic education: A role for aesthetics proper," Kaelin presented an approach to art criticism based on three aesthetic concepts. He wrote, "Let us begin, then, by placing brackets around an immediate consciousness and its object; we have an intuition, or direct awareness of quality, and analysis may begin. In the next step, any workable set of aesthetic concepts may be applied" (Kaelin, 1968, p. 59).

The aesthetic concepts Kaelin suggested were "surface" and "depth" (p. 59), and by implication, total expressiveness, in which, "Our experience...deepens and comes to closure in a single act of expressive response in which we perceive the fittingness of this surface...to represent this depth" (p. 60). Kaelin clarified three aesthetic categories later, in conversation (1986, 1987) as follows:

• The first aesthetic category is the *sensuous* surface: The sensuous surface includes colors, lines, textures and their relationships; as they are perceived, they govern a vague feeling.
• The second aesthetic category is *experiential depth:* Experiential depth combines the elements of our past experience with what we perceive in relationship to the surface (e.g. images, ideas and the depth feelings associated with them.
• The third aesthetic category is the *total expressiveness* of the artwork which are the meanings found in the aesthetic context: the context of experience as a locus of interaction between the work of art and the critic.

These three aesthetic categories have also been referred to as "counters," meaning the discernable and describable elements of the surface of the work of art. There are "surface counters" and "depth counters." Surface counters are largely perceptual, while depth counters are conceptual and include psychological imagery. Surface counters combine to create the representations, images, and ideas of depth counters. Surface and depth counters fund the affective (felt) quality of the aesthetic encounter; they are vital in the total expressiveness of the work of art.

In order to promote the development of aesthetic concepts then, avoid an inventory of imagery to begin classroom art criticism. Allow sensory perceptions to be fully explored before literal concepts are applied: the aesthetic is addressed before the linguistic is employed. (Aesthetic meanings evolve from aesthetic concepts as much as they do from an individual's experiences, aesthetic or otherwise.) Beginning with surface counters, and then moving to depth counters, allows more complete aesthetic concepts to develop in classroom art criticism.

Phases of Making a Reflective Aesthetic Judgment: Bracketing and Synthesizing the Aesthetic Experience

The art critical dialogue begins with the phenomenological approach of *bracketing* the qualities of the aesthetic experience. *Bracketing* is the phenomenological strategy of disallowing cognition outside the particular aesthetic experience. We "bracket out" any part of an experience which is not part of the immediate aesthetic encounter. Next, a vague feeling is noted, the three aesthetic categories are considered, and a definite feeling is expressed. This leads to paraphrasing, in which the critic's insights are expressed as hypotheses which are tested, verified or altered in the final phase of re-experience. Paraphrasing can be as simple as younger students assigning their own titles to the work, or as complex as students speculating about symbols or themes perceived. The brackets can then be "opened" and art historical material included in paraphrasing and verification. The phases of making a Reflective Aesthetic Judgment are described in the following guided approach to aesthetic experience.

Reflective Aesthetic Judgment: A Guided Approach to Aesthetic Experiencing

• *Focus:* Bracket the aesthetic experience, focusing directly on the work of art. Spend some time just looking before you begin to think about the experience.

I. *Vague Feeling.* Notice the initial impression the work makes on you. You may sense a certain feeling based on the sensory counters of the surface of the artwork.

II. *Consider the three aesthetic categories: (a) sensuous surface (b) experiential depth and (c) total expressiveness.*

Sensuous surface (surface counters): Note the sensory counters of the sensuous surface and describe their relationships. Refer to counters in the artwork to support the descriptions.
• Describe the surface counters: colors, lines, shapes, textures, the formal qualities seen in the artwork. These are first order counters.

• Describe the relationships between the surface counters: repetition, rhythm, balance, unity, pattern, emphasis. These are second- and higher-order counters.

Experiential depth (depth counters)
See if meanings evolve which modify the vague feeling into a definite feeling; you may verify or alter your original impression. Verification becomes definite feelings which are commonly associated with the objects represented.
• Describe any depth counters (represented objects, ideas, or psychological images). Any description of the depth counter requires descriptions about the surface counters, because surface counters combine to make depth counters.
• Describe the relationships between the depth counters through themes or ideas found in works of art.

Total expressiveness
• The total expressiveness is relating a surface feeling to a depth feeling and is factored into the relationships of surface to depth counters and produces realizations and insights.
• The meanings of the work of art are found in the aesthetic context which is the site of the aesthetic encounter between the artwork and the critic.

III. *Definite feeling.* The vague feeling deepens in the aesthetic context to a definite feeling when the surface and depth counters are described in terms of their interrelationships which produces realizations and insights. The vague feeling becomes a definite feeling when it can be named (this corresponds to Dewey's notion of pervasive quality in an aesthetic context).

IV. *Paraphrase.* This phase involves an expression of insight. Speculate on the possible meanings of the artwork. Draw on personal experience or knowledge to characterize the paraphrase. This paraphrase serves as a hypothesis for interpreting depth significance, moving from image to idea, to be tested in the stage of re-experience.

• The work of art becomes personally significant when the individual's own experiences and concepts enter the aesthetic encounter, by interpreting an aesthetic concept through a storage of concepts.
• Synthesize the aesthetic experience after this preliminary analysis

of the total expressiveness of the artwork. Younger students may simply assign a title to the work.
• Encourage more advanced students to summarize their thoughts about the work of art in the following manner:
1. Start with the dominant impression of the work and state what gives you this impression.
2. Then speculate on what the work symbolizes, in parts and as a whole; move from image to idea. Draw from experience, myths, or themes from either literature or the humanities.
3. Consider that the work of art could be an analogy for experience, and that speculations on meanings are hypotheses for interpreting the artwork's deepest significances.
4. Consider, also, what was learned from this aesthetic encounter.

V. *Re-experience.* This phase verifies the paraphrase. Test the hypothesis against a second aesthetic encounter. Do the meanings hold up when checked against the three aesthetic categories?

•Look again at the way the sensuous surface combines to make certain images and ideas.
• Question the aesthetic experience itself. Has your initial impression changed? Have your ideas changed? How? What did you discover that you had not thought of beforehand?
• Evaluation: Was the experience valuable to you?

A key difference in this approach is that it considers formal, aesthetic qualities *before* considering literal qualities (Feldman, Smith, and Mittler discuss literal before formal qualities). This makes sense because concepts grow out of percepts. Percepts are what are seen as the surface of the artwork and include colors, shapes, and textures. Concepts are then recognized as a result of percepts funded by experiences.

Moreover, this approach is experiential and contextual. It draws the art dialogue out of the individual's experience, allowing interpretations on all levels of artistic experience. This approach also allows individuals to deal with *new* works of art or with unfamiliar territory for which there has not been any art history or criticism written to guide understanding. This approach can be used with the traditional or primitive works of art, as well as more avant garde artwork.

Beyond being experiential and contextual, this approach, known as Reflective Aesthetic Judgment, is empirical in that critical reasons are verified in the artwork during the final phase of the method: re-experience. Moreover, this approach allows *affect* to play a role, acknowledging feeling from the start. Feeling can be used to guide the description, analysis and, ultimately, the judgment, which then becomes reflective.

Finally, the approach is a complement to Broudy's aesthetic scanning, which is called *pre-criticism* (Broudy, 1975, p. 12). Aesthetic scanning does not allow an individual to arrive at an aesthetic judgment, but it is possible to move from aesthetic scanning to judgment through Reflective Aesthetic Judgment. Aesthetic scanning encourages perception of the sensory, formal, expressive, and technical aspects of works of art, but these aspects are not phases in a planned sequence of aesthetic discourse. However, Reflective Aesthetic Judgment maintains the unity of the aesthetic experience during art critical discourse.

Use of the Model of Reflective Aesthetic Judgment allows individuals to derive personal meaning and significance from a work of art. Art specialists, students, general classroom teachers, specialists, and art and education majors have reported that this approach is creative and personal. Finally, this model supports what John Dewey (1980) meant criticism to be, with insight being a creative act.

References

Armstrong, C.L. & Armstrong, N.A. (1977). Art teacher questioning strategy. *Studies in Art Education, 18* (3), 53-64.

Broudy, H. (1975). Arts education as artistic perception. In R. Leight (Ed.), *Philosophers Speak of Aesthetic Experience in Education* (pp. 5-15). Danville: IL: Interstate Printers and Publishers.

Broudy, H. (1986). *Exploring the nature of aesthetic experience* (materials compiled for the Getty Institute for Education in the Visual Arts, 1986). Los Angeles: J. Paul Getty Trust.

Broudy, H., Smith, B.O., & Burnett, J. (1966). The exemplar approach. *Journal of Aesthetic Education,* inaugural issue, Spring, pp. 13-23.

Chapman, L. (1978). *Approaches to art in education.* New York: Harcourt, Brace, Jovanovich.

Clements, R. (1979). The inductive method of teaching visual art criticism. *Journal of Aesthetic Education, 13* (3), 67-78.

Dewey, J. (1980). *Art as experience.* New York: G.F. Putnam.

Douglas, N. & Schwartz, J. (1967). Increasing awareness of art ideas of young children through guided experience with ceramics. *Studies in Art Education, 8* (2), 2-9.

Ecker, D. (1967). Justifying aesthetic judgment. *Art Education, 20,* 5-8.

Eisner, E. (1979). *Educating artistic vision.* New York: Macmillan.

Feinstein, H. (1982). Meaning and visual metaphor. *Studies in Art Education, 23* (2), 45-55.

Feldman, E. (1967). *Varieties of visual experience.* (1st ed.) Englewood Cliffs, NJ: Prentice Hall.

Feldman, E. (1973). The teacher as model critic. *Journal of Aesthetic Education, 78* (1), 50-57.

Feldman, E. (1987). *Varieties of visual experience.* (3rd ed.) Englewood Cliffs, NJ: Prentice Hall.

Gaitskell, C. & Hurwitz, A. (1958). *Children and their art: methods for the elementary school.* New York: Harcourt, Brace, Jovanovich.

Geahigan, G. (1983). Art criticism: analysis of the concept. *Visual Arts Research, 9* (1), 10-22.

Hamblen, K. (1984). An art criticism questioning strategy within the framework of Bloom's Taxonomy. *Studies in Art Education, 26* (1), 41-50.

Hurwitz, A. & Madeja, S. (1977). *The joyous vision: a source book for elementary art appreciation.* Englewood Cliffs, NJ: Prentice-Hall.

Johansen, P. (1979). An art appreciation teaching model for visual aesthetic education. *Studies in Art Education, 20* (3), 4-14.

Johansen, P. (1982). Teaching aesthetic discerning through dialogue. *Studies in Art Education, 23* (2), 6-13.

Johnson, M. (1989). Dialogue and dialectic: developing visual art concepts through classroom art criticism (Doctoral dissertation, Florida State University, 1988) *Dissertation Abstracts International, 50* (1), July, 1989, 56A.

Kaelin, E. (1966). The existential ground for aesthetic education. *Studies in Art Education, 8* (1), 3-12.

Kaelin, E. (1968). Aesthetic education: a role for aesthetics proper. *Journal of Aesthetic Education, 2* (2), 51-66.

Kaelin, E. (1968). *An existential-phenomenological account of aesthetic education* (Penn State Papers in Art Education No. 4) State College, PA: Pennsylvania State University, Department of Art Education.

Kaelin, E. (1989). *An aesthetics for art educators.* New York: Columbia University Teachers College Press.

Langer, S. (1953). *Feeling and form.* New York: Charles Scribner & Sons.

Langer, S. (1957). *Philosophy in a new key: a study in the symbolism of reason, rite, and art.* (3rd ed.) Cambridge, MA: Harvard University Press.

Lankford, E.L. (1984). A phenomenological methodology for art criticism. *Studies in Art Education, 25* (3), 151-158.

Madeja, S. (1980). The art curriculum: sins of omission. *Art Education, 33* (6), 24-26.

Mittler, G. (1980). Learning to look/looking to learn: a proposed approach to art appreciation at the secondary level. *Art Education, 33* (3), 17-21.

Mittler, G. (1982). Teaching art appreciation in the high school. *School Arts, 82* (3), 36-41.

Qualley, C.A. (1986). *Quality art education goals for schools: an interpretation.* Reston,VA: The National Art Education Association.

Smith, R. (1968). Aesthetic criticism: the method of aesthetic education. *Studies in Art Education, 9* (3), 12-31.

Smith, R. (1973). Teaching aesthetic criticism in the schools. *Journal of Aesthetic Education, 7* (1), 38-49.

Taunton, M. (1983). Questioning strategies to encourage young children to talk about art. *Art Education, 36 (*4), 40-43.

Woods, D. (1978). Reading pictures and reading words: a critical review. *Review of Research in Visual Arts Education, 9* (Winter), 11-38.

Play and Art in the Elementary School

George Szekely
University of Kentucky
Lexington, Kentucky

During a demonstration lesson, taught during an interview for a teaching job at a university, students were asked to get down on the floor and move under their tables so they could re-experience the childhood game of "playing house." As the author's own memories of playing under tables were recounted for the students, varieties of forts and vehicles which had been assembled were described.

Soon, these adult students in that university class began excitedly to share their own memories of special and private spaces that they had created as children: memories of clubhouses, protective "forts," built in beds and under desks, or in secret corners in a garage. They recalled dining room chairs that had magically become trains, elegant thrones, or motorcycle sidecars.

It became clear that those play experiences which were most memorable involved combining ordinary household props with one's own imagination. Memories of early hiding places led to recollections of creating one's own displays in special areas. The way that treasured toys and "found objects" were once arranged on a shelf or in a certain corner of one's room, suddenly seemed to have a clear connection to each person's later approaches to art: the way one looks at objects, the way one approaches a surface and changes or rearranges it to please oneself. Thus, a classroom lesson that fueled students' earliest memories of play succeeded in illuminating a vital aspect of adult art production: the role played by childlike inventiveness in the inspiration and will to create something new.

The Art of Play

Before children ever begin to make art, they are already experienced at play, which is creativity at its most fundamental level. At its best, play brings out the individuality of each child, as it does in each adult as well.

As a working artist, the ability to play is an important component of one's ability to create art. The element of playfulness that characterizes all creative investigation helps to generate new ideas and sustain the freedom necessary to plan and execute a work of art to completion. Because a child's imagination thrives on free play, students of all ages should be offered opportunities to play in the classroom. This is the most valuable *teaching* which can be provided.

No special skills are needed for play; there are not any proper techniques to learn. Play is accessible to all children — and to adults, too, with a little encouragement. When play is used to introduce an art lesson, students can draw ideas from their own experiences instead of narrowly following the teacher's lead. The teacher who encourages play in the classroom helps students develop confidence in themselves — in their own ideas and their own inventions. This belief in the self is the most important ingredient in the making of art.

It is most exciting to watch a child at play. In fact, play is the basis of all early childhood learning. Formal education shifts the emphasis from play to the mastering of facts and ideas received from others. The work ethic of most schools and schoolteachers tends to make a distinction between play and what is considered "proper" classroom activity. Children in school quickly learn that they are expected to perform for the teacher, whose job it is to provide instruction. But instead of mimicking academic subjects, art teachers should license and indeed encourage play. Teaching art should never be reduced to the teacher's conception of what is good for children,what they want to learn, and what ideas they should communicate. Art lessons that are sprung upon students at the beginning of each class cannot be expected to generate enthusiastic response, for a planned lesson has already determined what the students should learn about art, instead of involving them directly in the process of art itself. Only when art instruction is planned around the experience of play, do children go beyond the teacher's presentation and learn how to discover and plan for themselves. If children are to develop their own art ideas, they need time to experiment. They need the opportunity to not only absorb each lesson, but also to examine its premise — altering it, restating it, and possibly even rejecting it.

The art class, therefore, must be a place where the art of play is revived and supported. When an art teacher promotes play in the classroom, his students will feel that their explorations are worthwhile. Students also are freed from self-conscious concerns about talent and their fears of failure. It is only through each student's personal exploration that original art will be born.

An artwork begins as an idea first. The idea may vary widely in its degree of clarity for the artist. Drawing a scene from heaven, for example, may require preparation through movement, props, and actions — so that one can act and feel "heavenly." Play provides a means to sort through the possibilities; it is the initial research, the shifting of materials and ideas, the experiencing of movements and images through which most of the important decisions about the artwork are made. The more significant this preliminary activity and the more extensive the decisions made during it, the more clearly and confidently can the artist begin to formulate the direction the work will take. To fully experience the art making process, children — or students of any age — need a chance to actually formulate plans of their own, instead of merely carrying out someone else's plans. They must also learn to select the materials and space for the project and to recognize a variety of possible solutions to an artistic challenge.

Art teachers need to be less concerned with the clarity and simplicity of their own presentations than with giving students the opportunity to express themselves. As the student artists begin to playfully sort through the possibilities, they can become the audience to their own ideas, which can be easily erased or modified. No permanent commitment is required when one is "playing" — with ideas or in any one of a variety of media — but the student artist can solidify his convictions and strengthen his confidence in the work which is in progress. In this way, young artists at play are able to work with real objects and to rehearse their ideas in real space. As students keep track of their play-generated ideas and select from them, they begin to see art making as the generation of possibilities. Just as play allows the mature artist to discover beautiful color, space, or lines before structuring them into an artwork, it also allows young students — particularly children — to see what is interesting about a hose, the curve of a Slinky toy, or the changing lines of an extension cord. Thus, play becomes a means of observing and rehearsing, so that a better, more informed, use of these elements can be made.

The manipulation of almost any object prepares the student artist mentally and physically for the artwork itself. All types of familiar objects can be used to inspire the creation of a variety of lines and forms. These objects are best when reminiscent of the open restructuring of play blocks. Therefore, a box of stickers, straws, paper clips, or rubber bands, can be used as convenient tools for building and displaying ideas that may then be recorded through drawings. Children need to realize that artists can play with anything that is around. Chairs, books, or pencils are as useful as Legos, sand, or pick-up sticks to work through ideas.

Play with such objects can be totally open and student-directed, or guided by the teacher who may design games which explore line qualities, balance, or patterns. Because those materials can also be viewed as useful items for making an artwork itself, students come to understand, through their own experience, the range of "suitable" media for creating a work of art.

Perhaps even more important than such indirect lessons in art concepts and the use of art materials is the atmosphere created in a classroom where students are free to follow their own instinctive direction. A teacher who encourages play is telling students that not all things in school are already known, that there are new things yet to be discovered, that correct answers are not always available from a teacher. This is an inherently optimistic view of the world which implies that change is always a possibility, and that there are numerous solutions to every problem.

In summary, a teacher who creates a playful classroom encourages the young artist to look within himself, to trust and seek his own ideas. Art begins, not with teacher-inspired art projects, but with the individual's deep desire to find and state his own ideas in any media. Play experiences provided in the art class allow this search to begin and to flourish.

Play allows students to gain independence and control over the creative process. It is a personal means of searching, finding out, and — perhaps, most importantly — being surprised by something new. Playing is a means of flying beyond the boundaries of school. It is the best frame of mind for the experimental ventures required by art.

For young children, play and art are inseparable. The longer this relationship can be maintained, the more successfully can individual creativity be pursued.

The Importance of Environment

Each summer, when painting the landscapes around Woodstock, New York, I begin by playing with the trees, rocks, and bushes... by wrapping and dressing them in various materials and fabrics. This is one way of becoming part of the environment, before recording ideas for art on canvas. In the classroom, environments can be set up daily for the students to explore. Children can be encouraged to arrange, build, take apart, and discover — just as they may also be encouraged to play on and explore an art object.

In choosing the objects to be used for play, teachers should consider size, weight, flexibility, and ease of handling to illustrate an art concept. Children soon learn to see everything around them as possible sources for display, selection, or manipulation. After having played with most of the objects in the room, they will perceive the underlying ability to work with the environment, to play with the spaces and objects within it.

The artist who selects and arranges objects for a still life is attempting to gain control over an artwork during these preliminary steps. Similarly, children learn to recognize the possibilities of a floor or a chair as a base, the room as a space, a wall as a background, and the people in the room as forms of movement and change. In addition, they learn to use the floor under the table, the wall, or the ceiling as surfaces to build upon, build from, or on which to attach the objects. They learn to see the room as a *painting* with everything in it as a part of the *canvas*. They are learning to see their environment with fresh eyes.

Students can wrap, hang, tear, roll, stuff, and crush. They may play with hoses, film, tape, pipes, rubber bands, or potato chips. Play may involve building, dismantling, digging, inflating, packaging, or melting. Objects can be reshaped, stacked, tied together, balanced, patterned, or arranged — in a supply closet, on a shelf, or on a clothing rack.

The young players want to use all of their senses; they want to experiment in many different media. The students should be willing to examine any object in their environment, regardless of its intended use. In this way, the young artists learn how to find the possibility of beauty in every source available.

The Role of Movement in the Classroom

Children's art has more to do with moving bodies than it has to do with a "still life." When children leap, jump, and pose in the midst of active play — with the accompanying sound effects — their enthusiastic expression should be the envy of any contemporary choreographer.

Children's explorations of the space around them, and the felt experience of being in the center of space, helps them to understand the notion of space as it functions in art. A young artist playing in a three-dimensional space can learn something about the experience of working with art in a two-dimensional space. Physically crossing a room, climbing up or down, and moving from left to right in actual space helps students to identify the relationship of marks they may leave on an art surface. Students facing a white wall — then feeling it, or even kicking it — are investigating specific art qualities that, in some ways, mirror a canvas or piece of flat drawing paper.

Reaching for the top of a space, walking to its corners, dividing it with barriers are all forms of art play which can lead to a direct understanding of aesthetic qualities. Movement creates its own lines and form in space. Developmental stages in drawing — from the line to the circle — can be examined by a student in the context of his or her movement through space.

Experiments in movement are important because they give children a sense of freedom to mark surfaces or alter forms. A principle tool in such experiments is a flexible body which responds to the environment. Make-believe walks on paper, impersonation of animals, machines, or alien creatures and even marks left by hands, fingers, feet, or the entire body can be properly seen as art, or as a prelude to art.

Encouraging children to move freely in the art classroom is important, not just because of the lessons it provides in form, but

for another equally important reason: Freedom of movement is essential for an artist; it generates the independence of spirit so necessary for creativity to flourish. Movements emanate from one's own personal rhythms: the sounds and music within each person. Children sitting at desks are restricted in their movement. Move an art class from desk top to floor, and watch how quickly students regain the rhythm, joy, and grace of their playful selves. Art rooms must make room for the bouncing of balls, the rolling of marbles, and the improvisation of dance.

Teachers can guide students' explorations of these rhythms through activities which are ancillary to free movement, such as the beat of a metronome, the music of a synthesizer, or the sound of hands clapping together. Incorporating jump ropes, balls, and Slinkys into art teaching encourages students to recapture the movements they have created spontaneously and to expand on them with innovative "art tools."

Performance in Play and Art

In traditional classrooms, children perform *for* a teacher who simply gives them instructions. The teacher in an art classroom, however, should be able to perform *for* as well as *with* his students.

Magic, juggling, the invention of dances — these are all acceptable activities for an art class. Children should be permitted to freely touch objects found all around the room. As much as possible, objects should be movable. Even the teacher should be movable! The teacher who passes freely through space, who jumps in the air or gets down on the floor, demonstrates his or her own ability and willingness to try new things. The teacher who wears a hat, a fake nose or an unusual garment, who performs pantomime — whether staged or richly improvised — shows that he or she is not afraid to play, that the teacher, too, believes in adventure and risk teaching.

The teacher's playfulness can often shock students out of ordinary modes of thinking, allowing them to explore states of mind or actions more conducive to the art task. Teachers should make a special effort to surprise the class, perhaps by varying the voice — a whisper, a cheer, or a well-timed sound effect will do it. The teacher should generate a second glance, inspire the double-take —

for example, by wearing a chef's hat while mixing paint colors in a blender. Teachers who are willing to deviate from normal teaching postures cultivate students who look forward to coming to class — and whose imaginations are stimulated to be creative in their own right.

Many children are expert clowns and enjoy clowning in school. Comic routines, crazy faces, or magic acts are not generally tolerated in a traditional classroom, but in an art class these activities can become an important part of the curriculum. In play, students pass beyond what is considered acceptable classroom behavior. They are motivated to search for the unusual and to preserve their sense of wonder and independence. They maintain their ability to challenge accepted ideas.

The teacher can foster an attitude of playfulness at the beginning of an art lesson by establishing an imaginative or make-believe perspective. The classroom may be set up as a circus, a dance hall, or a cave. Telling children to use their imagination is seldom enough. The experience of play needs to be built into the lesson — including the suggestion of materials. Children can be encouraged to see the relationship of covering a cake with icing to pouring paint over a surface; similarly, they may be inspired to liken their free movement when squeezing sauce out of a "squeeze" bottle onto a pizza to the movement of their hands and arms when they draw on a page. Splashing, digging, and pouring are all pleasurable actions that are already familiar to many children; the teacher helps the student frame a new context for these activities, one which will help them handle art materials creatively and, again, see their environment in new ways.

A teacher's ability to accept the fantastic, say the ridiculous, and think the unbelievable can set the stage for a student's inherent playfulness. Even routine activities such as taking attendance, putting up signs, and distributing messages can be approached in a playful manner. When children observe an adult who is willing to play, they can begin to feel that there is nothing silly or childish in their own playing.

Children love to dress up in their parents' clothes and create their own dance and theater pieces. Through their play, they often bring inanimate objects to life; dolls, soldiers, or a newly-discovered frog. The opportunity to bring inanimate objects to life, giving them

character and personal identity, encourages children to treat them later as subjects of an artwork. The child who truly can make believe that a light bulb can talk will be able to translate this new identity into a strong drawing. Here, play is used to teach a lesson about the importance of pre-visualization.

Children have always creatively located stages anywhere and everywhere — on a stairway or landing, in a doorway or in front of a fireplace. As spaces are partitioned, draped, covered, ordered, and divided, the artworks or "plays" made in the space are being, in fact, visualized and pre-designed. The variety of children's performances may range from stand-up comedy to a parade or art show. It comes as no surprise that children are frequently each other's best audiences.

Children often discover art through these performances as they find new media, movements, and subjects to utilize and imitate. One popular activity — the impersonation of rock stars such as Madonna and Bruce Springsteen — is not generally considered performance art by children or their teachers, but even these activities should be re-examined and re-evaluated by art teachers everywhere.

The Child as Artist: The Artist as Child

In a post-performance conversation, an accomplished saxophone player responded to accolades with the words, "It was fun, man!"

Painters, too — in fact, artists in any media — often feel this way after a period of performing creatively. In addition to feeling tired, satisfied, perhaps self-critical, to some extent — they will, nevertheless, usually feel that "it was fun."

Art teaching should strive to *capture the fun*. Having fun is a prime motivating factor for making art. In order to stay with any creative effort for a long period of time, one must be able to carry out one's work with joy.

Children, in particular, are happy at play. They are free in their movements and in their thoughts. They show themselves to be capable of an unusual amount of patience and self-direction when playing. This is the perfect state of mind for the artist.

Playing — in school or art — is a connection to the freshest source an artist can have, the clearest spring of creativity within each person. The act of playing is less burdened with pretension, traditions, or set ideas than almost any other human activity. In art, play is the experimental part of the process, the part that frames art ideas and rehearses them.

School art today tends to skip over or minimize the child's experiences in favor of the collective experiences of "established" artists, or the art teacher's own experiences. But it often takes a lifetime of formal training to appreciate the beginning of artistic consciousness, the beauty and invention of early creative play.

Play is valuable because it both demonstrates traditional practices in art and calls them into question, simultaneously. Students can be taught the proper way of handling something, but it is better for them if they come to understand the material or technique through play. In any case, the "proper" way may not exist, so students may be encouraged to discover their own options. To find out what a canvas is, it might be suggested that children fly it, stretch it, stuff it, or wear it. They might be asked to look at different clothing, try various drapings, or examine a multitude of surfaces. Well-designed creative games can help young artists not only find out about a material, but also rediscover it with fresh insights. Using games can show them how to conduct their own investigation; it can give them the tools to question and search. It can even help discover alternatives to the standard tools of art. In using a typewriter, sewing machine, or stapler as drawing tools, new applications and new tools for making art can be found. In short, play expands our notion of what art is.

Students might be told that one may not know what art is, but that the challenge of an artistic life is to find out the answer for oneself. Art is not mysterious, not a domain of the gifted to be revealed by a select few and appreciated by a few others. The possibilities of artistic living are everywhere. The artistic life need not be a thing apart from home, from daily life and everyday objects. Loading the refrigerator, cutting the grass, or setting the table can all be done playfully or artistically and become the subject for explanations in an art class.

At present, school art places an emphasis on teaching skills. It is assumed that skills must be learned first, that inspiration will

come later. But it is play that helps students value their own ideas and find pleasure in the search. This is the difference between art being taught and art being found — or rediscovered — by each player.

Resources

Additional information on this topic may be found in the following resources:

Hartley, R.E. (1963). *Children's Play.* New York: Thomas Y. Crowell.

Hurwitz, A. (1972). *Programs of promise: art in the schools.* New York: Harcourt Brace Jovanovich.

King, M. (1974). *Informal learning.* Bloomington, IN: Phi Delta Kappa.

Slade, P. (1954). *Child drama.* London: University of London Press.

Szekely, G. (1988). *Encouraging creativity in art lessons.* New York: Teachers College Press.

Szekely, G. (1991). *From play to art.* Portsmouth, NH: Heinemann Educational Books.

The Social Context Of Art Education: Children's Lifeworlds

Annette C. Swann
University of Northern Iowa

We are builders of "countless worlds made from nothing by use of symbols" (Goodman, 1978, p. 1).

The ability to conceive, produce, and analyze abstract schemata and imaginative scenarios is a hallmark of intelligent behavior in our culture. When children reach beyond themselves to create worlds by sharing experiences, ideas, and opinions, they engage in much of their most intellectually demanding work (Vygotsky, 1978). Children's interactions — infused with social support and energy — can contribute to intellectual development in general and artistic growth in particular. Those interactions reveal lifeworlds, composed of actors, objects and actions, created through experiences with the environment of the school, family, and play.

This chapter examines the development of those worlds in relation to the child's concept of self, the active role of the child in development, and the role of social interaction in the classroom. The child's point of view presented here is significant in the learning equation especially in light of current subject-oriented curriculum reforms. The skills-oriented approach, that is prevalent in education today, may ignore some of children's important needs. Their personal fulfillment can only be obtained when children engage in art as a means of expression and as a way of responding to life.

Origin of Self

The child's self is recognized as being complex. The genesis of the social self is initiated when the child "becomes an object to himself just as other individuals are [viewed as] objects" (Mead, 1934). The child begins to acquire a sense of identity by considering the attitudes of others toward himself or herself within the social context. This process of acquiring (a sense of) self begins when the child steps outside of himself or herself by imitating the actions of others and expands on those actions. This process

reaches completion only when the child is able to assume the organized attitudes of the social group. Important to this view of self is the development of a group identity, which some maintain is carried throughout childhood (Corsaro, 1985; Denzin, 1977).

As Chapman has stated, "authentic expression through art is rarely achieved without active, sympathetic and structured guidance from adults" (Chapman, 1978, p. 13). The socialization of the art student can be viewed as one of the ways in which the child develops a healthy predisposition toward a variety of artworks, acquires the habit of visiting art galleries and museums, and integrates a working knowledge of the basic concepts used when discussing works of art.

Children's Actions on the Environment

The active role of the child is stressed in the constructivist approach to human development described by Harre (1986), and best represented by Piaget (1968) and Vygotsky (1978). Through the child's actions, interpretation, organization, and use of information in the environment, the acquisition or construction of adult skills and knowledge are brought about by forces of equilibrium. Often children's activities in the environment are viewed as including interactions with others. Various interpersonal alignments with adults and peers have been compared and contrasted by other constructivists (Corsaro, 1985; Swann, 1986) to determine how these relationships each specifically affect *individual* development. However, there is (also) a need to examine how these interpersonal relationships are a mirror of cultural systems and how children *collectively* reproduce these features of childhood.

According to Vygotsky, "every function in the child's cultural development appears twice." First, on the social level, and later, on the individual level; first *between* people (inter-psychological), and then *inside* the child (intra-psychological). It is the inter-psychological stage of the theory which is heavily emphasized by developmentalists as representing internalization. Corsaro (1985) considers it a misconception to infer that culture and the resulting social competency of the individual is acquired in this manner. Rather, he advocates for adoption of an interpretive view, in which childhood socialization is defined from an examination of children's collective external productions (play and other social activities). It is

178

primarily through naturalistic research that interpretive studies have been able to implement developmental theory and to make more direct applications toward curriculum development.

The Reproductive View of Child Culture

According to the interpretive approach to socialization, the view of development and acquisition of culture is one which is reproductive rather than linear. Instead of viewing childhood as only a linear period of apprenticeship, children enter into a social network, acquiring interactive skills and reproduce a core of social understanding by which to live their lives. The child's knowledge becomes increasingly dense and is reorganized in accordance with the children's development and changes in the social world.

In art education, this linear view can be equated to learning defined as children's internalization of adult skill and knowledge with an emphasis on modeling and reinforcement as the key mechanisms in human learning and development. In this view, the child is basically passive and is relegated to a unilateral role as art student, shaped and molded by exemplars and art skills that build toward universal ideals in the art world. While the reproductive view does not deny that children imitate adults and that they benefit from reinforcement, it is not believed that these mechanisms can account for the complexity of learning. There are other communicational inputs as well, and children's perspectives are continually changing, as are their lifeworlds. From these sources, children reproduce their culture and actively engage in their own development.

The Role of Adults

The adult role in children's lifeworlds is often one of service as an evaluator. Children look to teachers and parents as those who "know a lot" about society. While adults often stand in a position of judge and authority, children value them for providing a situation in which "particular behaviors are no longer predetermined as right or wrong, or better or worse. Behavior can be tested and submitted to mutual definition." Finally, "unlike the system which children believe adults already know, the one created by collaborating peers has no definite endpoint. It is open to redefinition through a

democratic process founded in methods of reciprocity" (Youniss, 1980, p. 18).

Without clear and finite boundaries, in a world without an endpoint, the child is open to create imaginary worlds and to extend reality as far as can be conceived. Media influences in the world today provide children with models of many possible worlds. Within the schools, there are the sanctioned worlds of children's literature, as well as additional opportunities for creative writing through interactive processes of creating, editing, and audience awareness (DiPardo and Freedman, 1988). Art education, too, is currently searching for ways to structure creative responses into art programs which have long been organized as production-oriented and based upon the individual and competitive modes of achievement.

Social Interaction: The Role of Activity in the Art Classroom

When socialization theory is applied to learning in the classroom, the *role of activity* provides a means for translation of theory into practice. When the child acts upon the environment and acquires higher levels of learning (as in developmental theory), the role of activity can be viewed as that of catalyst. When the structure of activity is used in the classroom, it can be viewed as a scaffold which supports the curriculum and provides a context for learning. This concept pioneered by Bruner (1962) has been further extended by socio-linguists (Ervin-Tripp, 1977) as a way to teach English as a second language to Hispanic children. Even a young child, understanding how an "event structure" functions, is not very different from an adult (Bruner, 1986). Applying this idea to Piaget's concept of equilibrium, it may be seen that when children experience learning as events of activity, there is an intrusion on what they already know which leads to new actions (solutions) in the form of problem-solving and creative behavior.

Activities can be planned which utilize social interaction in guiding elementary students to generate creative responses to their own work and to those works created by other artists. Initially, some students are not prepared to forego the opportunity of producing art at every art class, until they discover that they indeed enjoyed the diversity of these response activities.

Most of the activities which are described in this chapter may relate to the definition of what is currently considered to be *cooperative learning* in that they focus on members of the group working together for a common goal (Johnson & Johnson, 1987). Although this is true, it is intended that elements of peer culture be encouraged and integrated into a response to art. Students are given permission to create their own possible worlds with language and manipulate parts of those worlds with their peers.

In these activities, students are presented with the task of verbally constructing responses to works of art in which they must provide descriptions of works of art, not only with regard for observation skills but also with some attention to analysis and interpretation (Feldman, 1970; Mittler, 1988). Emphasis is placed upon putting cogent ideas together in a shared setting, on fluidity of dialogue and with consideration of social issues. Writing is used as support materials and may consist of sentences, notes, or other visual clues that are deemed necessary for the student's performance. Students work together in a number of various formats which are chosen according to age appropriateness. These formats may include clue searches, panel discussions, or role-playing as art experts. All responses are taped (either audio or video) and played back for evaluation. Frequently, these interview-format performances are completely student directed with students arranging introductions, and then directing questions for tape recording and sign off. Most of the students are eager to perform. Even the shyest ones are interested in participating when they are paired with a close friend and allowed to record their interview in an isolated part of the classroom.

Prior to the experiment which used response activities which is described in this chapter, only fragments of peer interaction were overheard when students chatted about meaningful events in their lives as they worked. Although art students may reflect upon each other's work, especially if the topics are exciting fantasies in their lifeworlds, group projects such as murals drawings do not usually legitimize extensive social interaction. Dyson (1987) has examined the "off task" social interactions of primary students who were writing stories and drawing pictures and found that academic learning occurred and further concluded that peer talk which is encouraged by creative tasks becomes more holistic and may reveal children at their best intellectually.

Presented below are some of the social interaction activities that were developed in a laboratory school. Analyses of evidence of reflective behaviors as well as cooperative efforts toward shared construction and problem-solving which were revealed during the study of each of the activities are also described.

The Use of Socio-Dramatic Roles in Art Response

Students were asked to prepare a dialogue which described and discussed works of art as they acted out the roles of experts — artists, critics, aestheticians, and historians. Groups of two or three students worked together, beginning with questions which asked for essential information but provided opportunities for the students' personal expression. The goals of art criticism were later synthesized from information drawn from the taped interviews.

Two of the boys who are friends have chosen to work together and have decided to take turns interviewing each other about the painting, *Dempsey and Firpo*, by George Bellows. The following is an excerpt of the dialogue from two fourth graders:

Aaron: I am Professor Ding-Dong from the Boston Museum, and I am going to interview Brent Mossberger about the big fight. Take it away Brent. Oh, by the way, are you getting fired?

Chad: I am going to describe the painting, *Dempsey and Firpo* by George Bellows. Dempsey is knocking Firpo out, and the "ref" is counting. The crowd is going wild because Dempsey knocked Firpo out of the ring.

Aaron: Tell us how the audience feels about this fight, Brent. Are you really getting fired?

Chad: I think the guy that Firpo is falling on is afraid. The crowd is going wild.

Aaron: What have you noticed about this painting that makes it interesting, Brent? More interesting than you getting fired?

Chad: I like the way he gets every line in. All the men in the painting look very important. I like the muscular shape that he draws the body. No, I'm not getting fired. I am getting a new job with more money. Uh, a lot more money!

Aaron: O.K. That's all for now, here at the museum. Take it away at Control One, up there, down there, wherever you are, guys.

When examining this dialogue to identify some of the intellectual tasks, one might observe that these students have contrasted time frames of the past and present by asking a current celebrity to comment on a sports event from the past. Chad was very involved in this assignment; much more than had been observed previously during his production of visual art, whereas, Aaron, a serious student when making art, was more playful while conducting the interview. In this joint production, these two students have planned, collaborated in their writing, edited, and rehearsed their performance. The interview reveals a mixture of pretense and reality with which students at this age appear to be comfortable (and may prefer). Dyson (1987) has reported that primary students frequently monitor each other's writing and drawing for consistencies in logic between the real and pretend world.

The Use of Interpretive Response and Social Statement

In this approach, students may create an interview or short performance that narrates their work or an assigned work of art. Students may also take on the roles of art experts in creating their responses. A minimum of questions is used to structure the assignment. For example, the following assignment was designed for sixth graders to describe how their group visual narrative showed "justice through non-violence." Themes of injustice in the paintings of Jacob Lawrence were studied as background. Students were told that they could depict violence in their work as an example of "how not to be" or to show the evils of violence as other artists in history have done.

In another performance two sixth-grade boys jointly illustrated an ecological theme with the use of violence and wrote a rap tune about its superhero. They chanted this verse in typical rap tune fashion into the tape recorder:

> We'll tell you about a real cool Dude.
> Who wears Nike Airs.
> He's a fourteen-year old with facial hairs.
> His name is Bert Man, hacking up the town. (repeat)
> Our cartoon shows violence, but with environmental silence.
> Bert likes to prevent CFC contamination,
> By beating up the bad guys who give off CFC radiation.
> Bert Man, hacking up the town. (repeat)

In this piece, students joined in constructing the verse, inspiring each other in ways that brought out the other's strengths. Each student served as an interested audience during the creation of the piece and stretched the boundaries of the other student. Furthermore, the students initiated the addition of the theme of social awareness in addition to the one already defined in the assignment. These students, like many others, have become ecologically aware through school programs and have incorporated social themes into their lifeworlds. They not only appear to feel strongly about these issues, but seem to want to express their identity through the use of existing language and images attached to particular causes. Appropriately, the role of art response can allow for integration of those general goals with socio-aesthetic perspectives in the art curriculum.

Discussion

This chapter has described the activities of art students who have responded to what the teacher has to communicate by interpreting it within their peer culture. In the process of "reproducing their own culture," children may more firmly grasp, refine, and extend features of the adult world in the creation of their own worlds. Activities in the art classroom become more realistic when students deal more firmly with issues from the real world. As a result, the teacher's role of reinforcement and evaluation is more meaningful.

The joint effort related to the initiation, construction, and maintenance of interactive events and activities demands the active cooperation of the participants. Learning activities that incorporate cooperative learning with social interaction often result in students gaining understanding in an area in which they lack a firm cognitive grasp. Art criticism is an area in art education that may present vague and ambiguous situations for students.

To assess how the classroom activities fit into the developmental picture, the practical may be applied to the theoretical. The interpretive perspective (Corsaro, 1985, 1988) was implemented in allowing peers to creatively respond and extend the views of Piaget in two ways. First, the interpretive approach focused on the sources of disequilibrium in children's worlds (in this case the educational challenge) and attempted to evaluate the processes through which children create and share social order in their lifeworlds as

contributing to the theory of development. From this perspective, development is an interactive process which is situated in a social setting (which can be created in the classroom). Secondly, Corsaro points out that not only do children develop social skills and knowledge as the result of interactive experiences, they actually use their developing skills and knowledge to create and maintain social order in their lifeworlds.

However, in accordance with the views of Vygotsky, the interpretive perspective argues that these processes of dealing with problems are often themselves practical activities of children's lifeworlds, an example being peer culture activities integrated with art response. From the interpretive perspective, *socialization* in the world is not merely limited to the children's attainment of adult skills and knowledge, but is viewed as a result of their active production and movement through a series of peer cultures (Corsaro, 1985). In order for art students to acquire an understanding of the adult art world, whether as a consumer, participant, or informed observer, it is recommended that art programs be implemented which include social interaction activities and provide a focus on socially relevant issues that utilize and enrich those experiences within children's lifeworlds.

References

Bruner, J. (1962). *On knowing: essays for the left hand.* Cambridge, MA: Harvard University Press.
Bruner, J. (1986). *Actual minds, possible worlds.* Cambridge, MA: Harvard University Press.
Chapman, L. (1978). *Approaches to art education.* New York: Harcourt Brace Jovanovich.
Corsaro, W.A. (1985). *Friendship and peer culture in the early years.* Norwood, NJ: Ablex.
Corsaro, W.A. (1988). Routines in the peer culture of American and Italian nursery school children. *Sociology of Education, 61,* (1-14).
Denzin, N. (1977). *Childhood socialization.* San Francisco: Jossey-Bass.
DiPardo, A. & Freedman, S.W. (1988). Peer response groups in the writing classroom: theoretic foundations and new directions. *Review of Educational Research, 58* (2), 119-149.
Dyson, A.H. (1987). The value of "time off task": young children's spontaneous talk and deliberate text. *Harvard Educational Review, 57* (4), 396-420.
Ervin-Tripp, S. (1977). Wait for me roller skate! In S. Ervin-Tripp & C. Mitchell-Kernan (Eds.) *Child Discourse* (pp. 39-41). New York: Academic Press.

Feldman, E.B. (1970). *Becoming human through art*. Englewood Cliffs, NJ: Prentice-Hall.

Goodman, N. (1978). *Ways of worldmaking*. Indianapolis: Hackett.

Harre, R. (1986). The step to social constructionism. In M. Richards & P. Light (Eds.) *Children of social worlds: development in a social context*. Cambridge, MA: Harvard University Press.

Johnson, D.W. & Johnson, R.T. (1987). *Learning together and alone: Cooperative, competitive, and individualistic learning*. (2nd ed.) Englewood Cliffs, NJ: Prentice-Hall.

Mead, G.H. (1934). *Mind, self, and society*. Chicago: University of Chicago Press.

Mittler, G.A. (1988). *Art in focus*. Mission Hills, CA: Glencoe Publishing.

Swann, A.C. (1986). Child/adult interaction during art activities in a preschool setting: an achievement seeking response. *Arts and Learning Research, 4*, (73-79).

Piaget, J. (1968). *Six psychological studies*. New York: Vintage Press.

Vygotsky, L. (1978). *Mind in society*. Cambridge, MA: Harvard University Press.

Youniss, J. (1980). *Parents and peers in social development: a Sullivan-Piaget perspective*. Chicago: University of Chicago Press.

Using Children's Literature in the Art Curriculum

Florence M. Mitchell
Mercer University
Atlanta, Georgia

Virginia C. Nelms
International Business Machines
Educational Systems
Atlanta, Georgia

Children's literature offers a wealth of material that can assist art educators in teaching art in the early grades and can assist in meeting the goals of an art curriculum which includes content from the areas of art history, art criticism, aesthetics, and art production. Since most art educators have not taken courses in children's literature, they may be unaware of the potential resource of this field for the art curriculum. Children's literature is even more valuable when it is used by the art specialist to provide a focus for introducing art concepts to young children through a medium with which they are already familiar.

The following advantages are gained by the strategy of using children's literature, particularly picture books, in the art classroom:

• When the best examples from children's literature are chosen, the illustrations can be used as examples for art production by children.
• The techniques used in the illustrations are varied and are similar to those used by fine artists.
• The lives and works of artists, as well as concepts from art history, can be introduced to children through discussion of similarities between the illustrations from picture books and those from fine art.
• Similarities between the illustrations in picture books and fine art can be used to introduce artists and concepts from art history.
• Art production, art history, art criticism, and aesthetics can be interrelated with children's literature by selecting picture books whose styles and techniques are similar to those of fine artists.

The History of Children's Literature

It is generally accepted that literature which has been written especially for children began in the eighteenth century. By the late nineteenth century, the author-artists Kate Greenaway, Walter Crane, and Randolph Caldecott had introduced an artistic quality to children's books through the use of illustrations (Bader, 1976). As illustrations grew in importance, "the picture book," a book in which the pictures occupy a prominent place rather than merely illustrating the text, had evolved (Meigs, 1969).

The first illustrations for children's picture books were wood cuts. Although, Kate Greenaway's illustrations of the 1870's introduced new subtleties of color, she was still restricted to the wood cut technique and its inherent limitations. This restraint was a result of technical limitations in the printing trade (Bader, 1976). During the 1920's, picture books grew in importance as artists experimented with different techniques made available to them through the advancement of printing processes. By the 1930's, photo-offset lithography was used in the printing trade, and book artists could reproduce and print any technique they chose to use in their art (Meigs, 1969).

In 1938, the Caldecott Medal was established to recognize the illustrator of the best children's picture book published in the previous year (Meigs, 1969). By this time, the place of the picture book within children's literature was clearly established. The art of book illustration, as honored by this award, had changed considerably from the early illustrations of Caldecott and his contemporaries.

Today, artists working in the field of children's literature are free to use any medium, technique, or style they find creatively worthwhile. As a result, many illustrations reflect this creative freedom.

Patricia Cianciolo, author of *Illustrations in Children's Books* (1976), describes various styles of art and children's books whose illustrations are executed in a manner similar to traditional painting styles. Although Cianciolo recognizes the potential which these pictures have for teaching children to recognize stylistic difference in illustrations and involving children in critical discourse, she does not emphasize the association of the illustrator with fine art. Most

authors writing about children's literature fail to conclude that additional art learning, including art history and fine artists, could be related to the illustrations. These books might also function as introductory stimuli for children in their own art production. Anyone who has ever struggled with the problem of deciding which artist or what concepts of style to introduce to children can immediately appreciate the significance of tying art production and the introduction of art history to the use of illustrations in picture books.

Comparing Fine Art and Illustration

A distinction is often made between illustration and fine art despite similar techniques used in both. Fine art is seen to be derived from a purely personal need to express oneself, whereas illustration arises from the need to give visual dimensions to verbal communication. When writing and illustrating are done by the same author and artist, the illustrations and text are more likely to appear as a unified whole. Art functions as illustrations, and illustration as art, when it arises from a need for personal expression (Lorraine, 1963/64). While the distinction between art and illustration may appear insignificant, it is one which is recognized in the fields of art and design and has often limited the range of styles used in illustrations. Fortunately, many illustrations also have artistic merit.

In the picture book, where illustrations and text are of equal importance, it is considered vital to the impact of the book that the text and pictures support each other (Cianciolo, 1976). In the books chosen for the following discussion, the question of integration is diminished because the authors, Leo Lionni, Keats and Carle, are also artists whose illustrations are not merely produced in response to a story. These authors worked as artists before becoming writers, therefore their artistic backgrounds are reflected in the creative approach which is apparent in their illustrations.

Using Children's Literature in the Art Classroom

The books of author-artists Leo Lionni, Ezra Jack Keats, and Eric Carle were selected for review and discussion since each exemplifies the infusion of fine art techniques into children's literature. These authors are well known and respected in the field

189

of children's literature, and they all use collage for illustrations in their books. Association with these authors and their art is significant for the elementary grades student, since collage is a technique which is often taught in the elementary art classroom.

Although each of these artists uses a different collage technique, each of those used can be related historically to the evolution of collage and to a fine artist who works in a similar manner. A brief historical review of the specific collage technique used in the illustrations is presented immediately following the discussion of each book which is described in this chapter. A fine artist who also works in that technique is also identified.

There are many learning objectives that can be built upon these books which allow for the inclusion of material from the areas of art history, art criticism, aesthetics, and art production. In introducing these books, the teacher can also emphasize the role of the author-artists, thus giving children a broader grasp of what artists do and how they contribute to society. By focusing attention on who made the illustrations, what techniques were used, and why they were chosen, a starting point can be established from which the introduction of fine artists who have also used collage techniques can proceed. When presented within the context of the familiar, in this case children's literature, a child's art experiences and activities can be integrated to include knowledge of art and its production. Thus the goal of integration of knowledge about art and art history can be accomplished.

Examples of Collage from Selected Children's Books

The following three picture books will be used to provide examples of content and objectives for instruction which are based upon the illustrations which the artists have used to create the stories.

Alexander and the Wind-up Mouse by Leo Lionni

In *Alexander and the Wind-up Mouse*, a real mouse, Alexander, envies a wind-up mouse for the love that people show him until he discovers that the wind-up mouse is going to be discarded. To save the wind-up mouse, Alexander seeks the help of a magic

salamander. The salamander makes Alexander's wish come true when, through the use of a purple pebble,Willy, the wind-up mouse becomes real.

The Illustrations

In *Alexander and the Wind-up Mouse*, Lionni includes cut and torn papers,as well as fabrics in the collages. The animals and objects are silhouette shapes which have been made by cutting out or tearing separate body parts and putting them together to make complex shapes. Lionni selected and organized the different materials so that they add emotional impact to the collage. Some of the patterned fabrics are placed in a neat, straight up-and-down manner which gives the impression of order, while other material, such as newsprint, is made to suggest clutter in the way it has been cut and torn into small bits and then pasted down with the print going in different directions. In some of the illustrations, paper is crushed or wadded-up before being pasted down. Lionni's handing of the various materials indicates that he is aware of the contributions that organization and treatment of materials add to the interpretation of a collage.

History of Collage

The word, *collage*, is derived from the French word *colle,* meaning "to paste." The term was used to describe a new art form in which materials from everyday life were collected and pasted onto the surface of a painting. For centuries before this event, folk artists in many countries used materials such as butterfly wings, feathers, shells, and other objects to create works such as Valentine's Day cards and pictures. However, non-art materials were not commonly used in fine art paintings and sculptures until Pablo Picasso made the first art collage in 1912 (Seitz, 1961). It was then that the term, *collage,*was used to identify art that was made from common materials.

These early collages, which were predominantly made of different kinds of papers and other flat materials, such as bottle labels, cards, wallpaper, and newspaper, emphasized the contrast between materials from real life and the illusions created by the artist. Picasso is credited with saying, "We can make works of art

out of the contents of wastebaskets" (Barr, 1946). Picasso and other artists who use collage as an art form have stated that the value of art is not necessarily determined by the materials which are used in its construction. In addition to traditional painting media, waste paper and objects from everyday life can be used to construct fine art. Collage is no less an important art form because of the use of "found" objects or materials. Picasso chose collage to avoid the slick look of traditional painting (Seitz,1961). These early collages were called *paper collages* to distinguish them from collages made of other materials.

Objectives for Perceiving and Describing Art

• Describe how Lionni has made the two mice, such as the way some shapes have been cut and others torn; the way in which the tail, ears, and eyes have been cut out separately and added to basic body shapes to make a complex animal shape.
• List the feelings that the students associate with different materials. Identify materials used in the collages and the feelings which the students associate with those materials. Describe how those feelings become associated with the collage.
• Describe the differences in materials that are pasted flat and those that are crumpled before being pasted down. Discuss how these techniques affect the mood of the collage.

Objectives for Making Art

• Organize materials in a collage to suggest a mood through the orientation of the materials; horizontally and vertically to suggest calm and orderliness, haphazardly to suggest disorder.
• Make a collage which has a make-believe adventure of a favorite toy as its theme. Select textures which will express whether the toy is soft, hard, natural, or mechanical.
• Be able to manipulate materials by tearing, cutting or crumpling them to create a particular mood when appropriate.

Objectives for Making Critical Judgments

• Be able to discuss why an artist chooses collage over other techniques.

• Be able to associate emotional characteristics with the use of different materials and the ways in which they are manipulated, i.e. flat, crumpled, torn or cut, rough or smooth, and use these criteria in making judgments about the collage.

• Be able to identify a preference for one collage over others in a group of collages and give reasons which are related to some criteria listed in the objectives listed above for perceiving and describing art or based upon another artistically valid criteria.

Objectives for Art History

• After discussing the history of collage, define collage and describe its origin and development.

• Recall and describe why Picasso first used collage.

• Make a time line from 1900 to the present. Be able to correctly place the date of the first collage on this line along with other non-artworks. As other artists are studied, add significant information which is related to them to the timeline.

The Trip by Ezra Jack Keats

In *The Trip*, Keats uses characters from his earlier books. One of these characters, named Louie, moves to a new neighborhood where he feels lonely. Louie is able to take an imaginary trip back to his old neighborhood by constructing a diorama. There he is tricked by his friends. Upon waking from his imaginary trip, Louie puts on a costume and joins a group of children in his new neighborhood as they go trick or treating on Halloween.

The Illustrations

The initial illustrations in this story are painted. They depict Louie's first responses to his new neighborhood as well as well as illustrations showing Louie as he constructs his diorama, wakes up, and goes trick or treating. Keats uses the collage techniques to show Louie looking into his diorama and beginning his trip back in time, thereby making a visual distinction between what Louie imagines and what he actually experiences.

Keats uses a variety of materials, or mixed media, which include chalks, decorative and colored papers and fabrics, to illustrate many of his books. During Louie's imaginary trip, Keats introduces photographic images of himself and of children, as well a photograph of the Chrysler building in New York. These collages which include photographs can be considered photomontages. The use of photographic images takes Keats' work beyond the tradition of paper collages making his collages similar to those collages of Romare Bearden and other photomontage artists.

Keats repeats the same materials in several collages to give continuity to the story. The fabrics used for the cat's and Amy's costumes as well as the marbled paper used to create the sky are repeated in different illustrations.

History of Photomontage

Photomontage is the name given to a collage technique in which photographs or photographic images from magazines or other types of printed materials are used alone or in association with other materials. The term, photomontage, comes from the German word which means to assemble and was first used in Germany in the 1920's by artists wishing to make a social or political statement with their art (Ades, 1976).

This technique was also used by the fine artist Romare Bearden, a Black American, whose work is concerned with Black life in America. The figures of people shown in his collages have been made by cutting pictures of hands, heads, arms, and other body parts from magazines. These parts are then reassembled, using parts from several different bodies to make up the new figure. The resulting figures are often very distorted. Along with the photographic images, he used real fabrics and colored paper cut into silhouette shapes to finish out the collage.

Although Bearden and Picasso both made collages which contain similar materials, Bearden's reason for using collage was different from that of Picasso's. For Bearden, collage was a means to an end. The end that he was seeking was the communication of what it was like to be a Black person (Washington, n.d.).

Objectives for Perceiving and Describing Art

• List all of the different kinds of materials and media used in the illustrations in this book.
• Find the collages in this book that are photomontages.
• Identify and compare those illustrations in *The Trip* which are realistic with those that are more abstract. Identify examples of shading, correct proportion, and deep space as opposed to layered space and silhouetted shapes.

Objectives for Making Art

• Create a mixed media collage using materials and distortions similar to Bearden's photomontages. Use some special event in your life as the subject matter.
• Create a photomontage of a contemporary social issue using only photographic materials and printed words.
• Illustrate a story by using a series of collages which are created by a group of students. Repeat similar materials through out the sequences to provide continuity between the illustrations.

Objectives for Making Critical Judgments

• Select a photomontage by Bearden or Keats. Explain the difference between a collage and photomontage.
• Discuss the differences between the painted illustrations and the collage illustrations in *The Trip*. Identify the reasons why an artist would choose one medium or collage technique over another.
• Discuss the effect that is created in the photomontages of Romare Bearden when he constructs figures from different photographs of people, such as figures constructed using a head from one photograph, and arms and other parts from another.

Do You Want To Be My Friend? by Eric Carle

This story is about a lonely mouse who seeks is looking for a friend. This almost wordless book follows a mouse through numerous adventures before he finds another mouse who will be his friend.

The Illustrations

Eric Carle, besides writing and illustrating children's books, worked as a graphic and poster designer, and freelance illustrator. His childhood love of bright colors and broad brush work is clearly expressed in the illustrations in *Do You Want To Be My Friend?* (Commire, 1973).

In the illustrations for this book, Carle has developed patterns on paper with paint and then cut out simple silhouette shapes to make the figures, adding details with crayon or pencil. The end pages provide an example of how brush marks in paint can create random patterns and then cut into shapes without trying to make a realistic texture for the objects depicted. In some of the collages, Carle has also drawn details, such as whiskers.

Collages Made with Paper Cut-outs

Toward the end of his life, sick and unable to continue painting as he had done in the past, Henri Matisse began to use colored papers which he cut and pasted in his art. Matisse had his studio assistants cover sheets of paper with various bright, intense colors of paint in which the brush marks were allowed to show. These painted papers would then be set aside until needed (Elderfield, 1978). Because these papers were painted and then cut up, the resulting collages, in which they are used, are a blend of collage and painting. They were so different from other collages that they were called "paper cut-outs."

Although some collage artists tear their papers to gain a soft, fuzzy edge, Matisse cut all of his forms to emphasize the crispness of the edges of the shapes. Because of this technique, the over all impact of the work has a clarity that comes from forms that have hard, rigid edges; a characteristic of collage. The shapes which were created with his scissors are flat silhouette shapes, but their contours are so inviting that the viewer does not miss shading or detail. The illustrations appeal to one's imagination and are playful and happy.

Objectives for Perceiving and Describing Art

• Discuss how Carle could have made the textures in the paper.
• Describe the values and intensities of the colors used in Carle's illustrations as compared with those of Matisse's.
• Look at student collages and point out how they are alike and different from those of Matisse and Carle.

Objectives for Making Critical Judgments

• Select one collage of those made by the class which has textures that are similar to or different from those seen in Carle's illustrations. Explain why it was selected.
• Select a collage, describe the colors used, and tell how they make you feel.
• Select a collage from this book in which the patterns of the paper are similar to the animal represented, or are different from the animal represented. Explain how the pattern contributes to the collage.

Objectives for Making Art

• Make a series of painted papers with different textures and colors.
• Use these papers to make a mural illustrating a story. Plan the mural so that the story develops from left to right. If possible, look at Matisse's collage, *A Thousand and One Nights*, which is organized in this way.
• Plan and illustrate a fold book using paper cut-out collages. Show care in the selection and use of the patterns and colors in the collages making up the illustrations.

Conclusion

The books which have been discussed in this paper were selected because their authors have illustrated them by using various techniques associated with collage. There are many additional books, which have been illustrated with collage techniques, that could be substituted. Other artists and styles found in children's literature could also be chosen to teach additional concepts.

Cianciolo's book offers many styles and illustrators from which to choose. The only constraint would be to choose illustrations and fine art examples which are clear expressions of the concept under consideration. School and public libraries have many artistically exciting picture books from which to choose.

Drawing upon this already widely used technique, teachers may introduce children to the world of fine arts through collage, a familiar art form. Collages which emphasize the use of a variety of patterns and materials require the artist to respond sensitively to materials which are commonly found in the "waste basket" and the environment. Children should be encouraged to find and use different kinds of papers. Wallpaper books, wrapping and packing papers of all types offer potentially exciting materials, and exotic marbleized papers can be purchased or created by the children themselves.

When children work with scrap materials to create collages, they are using a long standing art technique which has historical significance. The teacher should place this seemingly simple technique in the artistic context in which it occurs. By associating the child's art production with an artist whom the child knows and enjoys through children's literature, the value of the child's work can be enhanced because the child, the illustrator, and the fine artist may all use this same technique. Placing emphasis on art and artists makes the activity more meaningful and opens the door to increased learning about art. The goals of a discipline-based art curriculum, "... making of art, the perception and description of art, the understanding of art in time and place and the justification of judgments" as stated by Eisner (1987, p. 24), can be met by using a form and format which can be readily perceived and accepted by children.

References

Ades, D. (1976). *Photomontage*. New York: Pantheon Books.
Bader, B. (1976). *American picture books from Noah's Ark to the Beast within.* New York: Macmillan Publishing Company.
Barr, A.H. (1946). *Picasso, Fifty Years of His Art*. Boston: Museum of Modern Art.
Carle, E. (1971). *Do you want to be my friend?* New York: Thomas Y. Crowell.

Cianciolo, P. (1976). *Illustrations in children's books*. Dubuque, IA: Wm. C. Brown Company Publishers.

Commire, A. (1973). *Something about the authors*, Vol. 4. Detroit, MI: Gale Research.

Enderfield, J. (1978). *The cut-outs of Henri Matisse*. NY: George Braziller.

Eisner, E.W. (1987). The role of discipline-based art education in American schools. *Art Education, 40* (5), 7-45.

Keats, E.J. (1978). *The trip*. New York: Greenwillow Books, Division of William Morrow Co., Inc.

Lionni, L. (1969). *Alexander and the wind-up mouse*. New York: Pantheon.

Lorraine, W. (1963-64). Introduction, The artist at work. *The Horn Book, 39-40,* 576-577.

Meigs, C. (1969). *A Critical History of Children's Literature, A Survey of Children's Books in English*. Revised edition. New York: Macmillan Publishing Co., Inc.

Seitz, W.C. (1961). *The art of assemblage*. New York: Graphic Society Ltd.

Washington, M.B. (n.d.). *Romare Bearden: The prevalence of ritual*. New York: Harry N. Abrams, Inc.

Evaluation of Student Progress in the Elementary Art Classroom

Carole Henry
University of Georgia

Basically, evaluation is, or should be, regarded as an educational medium, a resource for doing important things better (Eisner, 1987, p. 26).

Evaluation of art in the elementary grades is primarily focused on *formative* evaluation, that is, in-process evaluation. Formative evaluation is an on-going process taking place as instructional activities are implemented. For example, an assignment is given, and student work is monitored by the teacher to make sure that the objectives are being met. The teacher may decide to change teaching strategies if the instructional situation merits a different approach. If a decision is made to change instructional strategies, that decision is a direct result of the teacher evaluating the process of instruction as it occurs. *Summative* evaluation usually occurs after the instructional unit is complete and is useful in determining the success of the instructional strategies implemented (Champlin, 1989).

Assigning a grade to student work is one form of summative evaluation. Although many art educators have not recommended letter or numerical grades at the elementary level, Chapman (1985) cautions that grading, which she equates with measurement (Chapman, 1978), must conform to school policy. In a number of school systems, an indication of satisfactory or unsatisfactory achievement in art class is all that is required on term reports to parents. Many elementary art teachers faced with the assignment of providing art instruction to an entire student population, and often seeing these students only once a week, find this method of "grading" to be both philosophically valid and practical to implement. Other art teachers are developing alternate methods of evaluation that provide additional information about the goals of the art program and the child's progress to the parent.

Historically, evaluation and assessment have not been primary concerns in art education. Viktor Lowenfeld viewed evaluation as an indicator of the child's growth in art governed by the individual

child's creative experiences and level of psychological development. The art room was to be a sanctuary for the child, a place where there were not any right or wrong answers, and grades were not a factor (Day, 1985). Influenced by Lowenfeld, many art educators believed that art was subjective and that student artwork should not and could not be graded objectively (Jefferson, 1967). This belief, carried to its logical extension, left the art teacher without any guidelines for grading except subjective response. According to Fearing, Mayton and Brooks (1986, p. 20), "A possible reason art has been considered suspect as a serious area of instruction is the impression that evaluation of instructional progress is based on the subjective assessment of artworks by the art teacher." However, changes in art education philosophy during the last several decades have necessitated changes in curriculum and modes of evaluation. It is widely accepted today that clearly written objectives can help guide student progress and increase the likelihood of learning. Lansing and Richards (1981) propose that carefully formulated objectives can also address the subjective aspects of art such as imagination or emotional content.

In academic subject areas, teacher-generated tests are the primary means of assessing the degree to which students have mastered knowledge. These tests are generally used to determine student grades rather than to evaluate teaching. A failure to master knowledge tested is usually relegated to a failure on the part of the student. Additionally, teacher-generated tests tend to measure the lowest levels of intellectual skills; students are frequently asked to recall, to list, and to define. The emphasis in education today "is on the development of critical thinking, problem-solving, and independent thought — the capacity to critically analyze the ideas of others and to generate ideas of one's own" (Cross and Angelo, 1988, p. 15). Art educators actively involved in teaching know that education in the visual arts can make unique contributions in the development of critical thinking skills.

Educational psychologists have explored the cognitive domain for much of this century. In particular, Benjamin Bloom developed a taxonomy of cognitive abilities that is frequently cited in education literature. Bloom's taxonomy classifies intellectual activity along a continuum from the most simple to the most complex:

1.0 Knowledge Recalling specific facts or general concepts.
2.0 Comprehension Understanding and/or summarizing a concept

	or process.
3.0 Application	Using principles, ideas and theories in specific situations.
4.0 Analysis	Breaking down information into its basic components.
5.0 Synthesis	Putting together information to form a whole.
6.0 Evaluation	Making judgments about the value of material and methods for given purposes (Bloom, Hastings & Madaus, 1971, pp. 271-273).

Wilson (1971) analyzed prevailing art education philosophy and, building upon Bloom's taxonomy, developed test questions focused upon specific levels of intellectual activity. Wilson maintained that the majority of the outcomes of art education are ultimately testable, and that well-developed test questions may better ascertain progress in certain areas of art such as art criticism and art history.

Other research has indicated that meaningful learning occurs only when new knowledge is linked to knowledge the student already possesses. The teacher must help the child make intellectual connections between what the child knows and understands and new information. Ausubel prefaced an entire textbook on educational psychology by stating, "The most important single factor influencing learning is what the learner already knows. Ascertain this fact and teach him accordingly" (Ausubel, 1968, p. iv). This view of learning means that traditional testing may not always be the most valid means of assessment. Other forms of evaluation and measurement must also be considered (Cross and Angelo, 1988).

The elementary grades provide the foundation upon which future learning is structured. Abilities to classify and categorize, to analyze and synthesize, to question and discover are frequently addressed in the elementary curriculum. The elementary curriculum initially focuses on the child and extends through the child's immediate surroundings to the world community (Ellis, Mackey & Glenn, 1987). The child is part of a continuum constrained and shaped by the events of the past and is potentially able to impact upon the future. Through creating their own artworks and through looking at and talking about works of art through time, elementary school children can explore the emotions and concerns that other humans have shared (Feldman, 1973). With an agenda of such importance, it is mandatory that art teachers assess student work, the curriculum, and the program as a whole.

The current emphasis on art education that is disciplined-based has resulted in nationwide trends in curriculum development for elementary and secondary grades. The content areas of studio production, art history, art criticism, and aesthetics are appearing in various forms in art programs throughout the country (Getty, 1985). For example, the Georgia State Department of Education has adopted the Quality Core Curriculum in Art, a sequential K-12 curriculum consisting of four domains: 1) Visual Awareness, 2) Production of Artworks, 3) Artistic Heritage and 4) Aesthetics and Art Criticism (Georgia State Department of Education, 1988). Additionally, the state of Georgia has also produced resource guides for each grade level. These guides contain suggestions for lessons keyed to the state objectives in each of these four areas (Georgia State Department of Education, 1989). An important aspect of each lesson is the evaluation procedure.

According to Eisner (1987, p. 26), evaluation is the process "for improving the quality of curriculum, teaching, and learning," and is a primary professional responsibility for those educators implementing discipline-based instruction. Evaluation should address the content of the curriculum, the quality of the teaching and the degree to which the instructional objectives have been met. As such, evaluation is much more than a mere grade and functions as a source of feedback for both the teacher and the student.

Some elementary art teachers have developed means of evaluation that emphasize the growth and development of the child and provide feedback to the student and the parent concerning the child's progress. In particular, Allen Caucutt, the art teacher at Maple Dale Elementary School in Thiensville, Wisconsin, recommends the use of a checklist and observation comments to indicate achievement of performance objectives such as the completion of a task, the effective use of color, the incorporation of variety, etc. (Caucutt, 1989). This type of evaluation makes the child aware of the level of performance that is expected. The checklist also identifies the objectives that the child has achieved and indicates the objectives that the child still needs to master.

Gentile and Murnyack (1989) raise the question of evaluation in discipline-based education and, building upon the work of Bloom (Bloom, Hastings, & Madaus, 1971), Day (1985) and others, suggest specific ways in which each of the content areas can best be assessed. They maintain that there are certain skills which are

necessary and must be mastered before more complex tasks are attempted. For example, a student must be able to demonstrate knowledge of color mixing techniques before the student can be expected to successfully complete a watercolor painting. Gentile and Murnyack suggest grading such component skills in the simplest manner possible: Satisfactory or Unsatisfactory. They then propose numerical grading systems keyed to content area objectives for more complex assignments and recommend the following:

• *Grading Art Production:* Student artworks can be graded according to clearly established criteria which identify components of the assignments. A rating system for each of the components can then be used (perceives details, uses various tints and shades, demonstrates good craftsmanship, etc., [see also Henry, 1990]), and a total numerical grade can then be assigned.

• *Grading Art Criticism:* Critical thinking criteria can be incorporated in a rating system like that described above (uses appropriate vocabulary, formulates and justifies interpretation, supports judgment, etc.). Grading the critical performance in this manner could become too restrictive, and it is suggested that using Satisfactory or Unsatisfactory with written comments may be more appropriate.

• *Grading Art History:* Tests which assess both lower and higher levels of thinking (from basic factual recall through application, analysis, and synthesis [e.g. Bloom]) have application in assessing material presented focusing on the relationship between art and culture throughout history. In most instances, these tests would be teacher-generated and should be designed to address the most essential objectives of a particular instructional unit.

• *Grading Aesthetics:* Aesthetics (defined by Gentile and Murnyack as the study of "beauty, its components, and the criteria on which judgments are made" [p. 38]) overlaps with historical and cultural issues. Instructional objectives related to the cultural or the historical aspects of that which is considered art, can be assessed according to the recommendations under Grading Art History. Objectives related to the use of criteria to make critical judgments can be assessed according to the recommendations under Grading Art Criticism.

The underlying premise of these recommendations is that evaluation and assessment of student progress documents the mastering of basic art concepts and skills and, simultaneously, encourages excellence. Gentile and Murnyack have analyzed aspects of a discipline-based art education curriculum and formulated specific evaluation procedures. These procedures can be used as guidelines in evaluation and assessment and may be adapted to fit specific elementary curricular needs.

One word of caution is necessary. Discipline-based instruction need not and should not be arbitrary and separate; true art education occurs best when the disciplines overlap and intertwine making solid connections between the visual arts and the child's life. Effective art teachers teach from constantly evolving curriculums that incorporate art criticism, art history, aesthetics, and the making of art. Through examining possible methods of assessing each discipline individually, the particular aspects generic to that discipline can be identified and addressed in evaluation procedures.

A workable model for evaluation of student progress in the elementary grades can be structured incorporating the work of Gentile and Murnyack with that of others in the field. In order to do so, it must be accepted that elementary art education is primarily focused on the mastering of certain basic skills; that is, the basic skills necessary to: 1) make artistic products, 2) explore the relationship between art and culture throughout time, 3) look at and talk about works of art, and 4) discuss and question those characteristics that identify an object as a work of art. In the elementary grades, it may be sufficient to formally evaluate progress in each of these disciplines in terms of Satisfactory or Unsatisfactory rather than to incorporate a numerical system.

The elementary art teacher must plan instruction in each content area and formulate clear, easily understood objectives. Actual instruction can then transpire in a logical, sequential manner. The material must be presented in the simplest and clearest form. The teacher should then demonstrate or model the process. As the students work on assignments designed to solidify instruction, the teacher needs to circulate and monitor student work. The students should be encouraged to evaluate their own artwork in terms of the specified objectives. The teacher should also engage in in-process evaluation with the students thereby making success more likely and simultaneously extending student thinking. The teacher should also

evaluate the instructional strategies that have been used and make the necessary changes to make instruction more effective (see Hunter, 1982).

If the existing school policy requires that the art teacher merely indicate whether or not the child is making satisfactory progress, the art teacher can view the child's performance in each of the four component areas in very specific ways. For instance, does the child use basic techniques to successfully complete an art project? Can the child identify and discuss the contributions of specific artists? Can the child successfully venture and/or support an interpretation of a work of art? Does the child participate in discussions about art? These assessments can be made on the bases of informal classroom observation or through the use of more formal assessment methods (see Gaitskell and Hurwitz, 1982, pp. 500-504).

The teacher can also supplement the "grade" of Satisfactory or Unsatisfactory with a checklist identifying those objectives in which progress has been made as well as those in which progress is still needed. For example, the child may be making satisfactory progress overall and be quite good at following an assignment through to completion, but just beginning to discuss works of art in class. A checklist can provide information about the child's success with producing artwork and indicate a beginning level of participation in art criticism. A carefully designed checklist also documents the goals of instruction in the classroom for both the parent and the child. The specific objectives for each grade level should, of course, govern the items included, but a general format for the design of a checklist is presented below:

PROGRESS IN ART

Grade Level_____ Date_____
Reporting Quarter I II III IV (Circle one)
Student_____
Teacher_____
A check indicates a satisfactory beginning level for each skill. A blank indicates that the child needs to make improvements in that area.

Production of Artworks

___ Follows procedural approach to complete a task
___ Takes pride in work
___ Meets objectives of each assignment
___ Uses imagination
___ Demonstrates skill level appropriate for age
___ Perceives visual details
Teacher comment: _____

Art History

___ Identifies artists and works of art
___ Recognizes stylistic characteristics of art of various cultures
___ Recognizes functions of art throughout time
Teacher comment: _____

Art Criticism

___ Describes and identifies subject matter
___ Interprets works of art
___ Analyzes artistic elements of works of art
___ Supports judgments about works of art
Teacher comment: _____

Aesthetics

___ Makes and supports value judgments
___ Takes part in discussing the nature of art
___ Discusses value judgments of others
Teacher comment:_____

Other methods of assessing student progress can also help supplement the Satisfactory or Unsatisfactory rating. Citing Goodlad's research that indicates art teachers use a greater variety of

teaching methods than teachers of other subjects, Day (1985, pp. 238-239) suggests that it would be logical for art teachers to also use a greater variety of evaluation and assessment procedures. He then identifies eleven evaluation techniques which are appropriate for use within the context of art instruction and which may provide the framework for following adaptations to the elementary art classroom as described below:

•*Observation:* The teacher observes the students as they work on the assignment and provides feedback and further instruction as needed. For example, the student may have difficulty mixing a tint correctly or orally expressing an interpretation of a work of art.

•*Interview:* The teacher talks with the student individually or in a small group to determine areas in which further instruction is needed. For example, the teacher talks with a boy in the class who is having a problem manipulating clay and discovers that he does not know the technique for joining two pieces of clay. The teacher may want to know more about the students' negative reactions to a particular piece of contemporary art and uses questioning strategies with small groups to discover ways in which the students make aesthetic choices.

•*Discussion:* The teacher leads a discussion focusing on a particular technique or historical information and evaluates student responses to determine comprehension. For example, the teacher may initiate discussion of the procedures involved in using printmaking materials or of the societal functions of masks in Native American culture.

• *Performance*: The teacher instructs the students to perform a specific task. For example, the teacher gives the students the three primary colors and a sheet with three rectangular spaces. She instructs the students to mix the secondary colors and paint one in each rectangle. Or the teacher may, after discussing the characteristics of realism, give the students several postcard reproductions and ask the students to select the image that is the best example of that artistic style.

• *Checklist*: The checklist can be used as described in detail above or kept as an ongoing record of student participation and achievement. For example, the teacher checks off students who

participate in discussions of works of art or the exercises that the student has completed within an instructional unit.

• *Questionnaire*: The teacher formulates a series of questions that the students must answer correctly to demonstrate readiness before additional tasks are attempted. For example, the students may be required to successfully complete a questionnaire on the techniques and safety procedures recommended for using scissors before the students are allowed to proceed to a collage assignment. The students may be required to complete a questionnaire focusing on the use of color in a particular work of art before they are allowed to present an interpretation.

•*Test:* The teacher generates a short answer objective test focusing upon the most significant information presented in one or more instructional units. As discussed above, the teacher must take care to address the more complex levels of learning as well as the most basic. Test items should reflect the productive, historical, critical, and aesthetic aspects of the material covered in instruction.

•*Essay*: The teacher asks the students to write about a technical process, an artistic style, or a particular work of art. The very young child may be asked to give the response in an oral form; in that case, the use of a tape recorder would be helpful.

•*Visual Identification*: The teacher shows the students examples of a particular media, style, or an artist's work that they have studied in class. The students are asked to identify the work by characteristics that they have previously discussed. For example, first grade students are asked to identify portraits from a group of reproductions which also include examples of landscapes and still-life paintings.

•*Attitudinal Measurement*: The teacher develops a questionnaire focusing on the students' feelings about an instructional unit that has been completed. These responses can be used to evaluate individual student response to instruction or to evaluate the instructional procedures as a whole. For example, a teacher may design a series of questions to assess the students' attitudes toward discussions about aesthetics. Analysis of the responses could indicate the degree of understanding of aesthetic issues among the students as well as the students' attitudes toward the discussions.

•*Aesthetic Judgment*: As discussed above, art teachers are seeking other means of assessing student artwork than their own personal subjective response. Clearly written instructional objectives can provide more valid criteria. However, making informed judgments about works of art is an important component of art criticism. For example, a teacher may ask students to support their personal aesthetic judgments with visual information available to all.

These techniques can be used at different times and for different purposes. The most meaningful evaluation necessitates using evaluation procedures suitable for particular instructional approaches. Additionally, the evaluation procedures must be workable in the context of the elementary art classroom and should not detract from the instruction taking place. Ultimately, it is the art teacher who must decide which evaluation techniques can best assess student progress, instructional effectiveness, and curriculum validity.

References

Ausubel, D.P. (1968). *Educational psychology: A cognitive view.* Atlanta: Holt, Rinehart and Winston.

Bloom, B.S., Hastings, J.T., & Madaus, G.F. (1971). *Handbook on formative and summative evaluation of student learning.* New York: McGraw-Hill.

Caucutt, A. (1989). Grading elementary art. *NAEA Advisory.* Reston, VA: National Art Education Association, Winter, p. 2.

Champlin, K. (1989). *Evaluation for test design.* Unpublished manuscript.

Chapman, L.H. (1978). *Approaches to art in education.* Atlanta: Harcourt Brace Jovanovich.

Chapman, L.H. (1985). *Discover art.* Worcester, MA: Davis Publications.

Cross, K.P. & Angelo, T.A. (1988). *Classroom assessment techniques: A handbook for faculty* (Tech. Rep. No. 88-A-004.01988). Ann Arbor: The University of Michigan for the National Center for Research to Improve Postsecondary Teaching and Learning (NCRIPTAL).

Day, M.D. (1985). Evaluating student achievement in discipline-based art programs. *Studies in Art Education, 26* (4), 232-240.

Eisner, E.W. (1987). The role of discipline-based art education in America's schools. *Art Education, 40* (5), 6-45.

Ellis, A.K., Mackey, J.A., & Glenn, A.D. (1987). *The school curriculum.* Boston: Allyn and Bacon.

Feldman, E.B. (1973). The teacher as model critic. *Journal of aesthetic education, 7* (1), 50-57.

Fearing, K., Mayton, E.L., & Brooks, R. (1986). *The way of art: Inner vision/outer expression* (teacher's manual). Austin, TX: W.S. Benson and Company.

Gaitskell, C.D., Hurwitz, A., & Day, M. (1982). *Children and their art: Methods for the elementary school* (4th ed.). Atlanta: Harcourt Brace Jovanovich.

Gentile, J.R. and Murnyack, N.C. (1989). How shall students be graded in discipline-based art education? *Art Education, 42* (6), 33-41.

Georgia State Department of Education (1989).

Getty Center Report (1985). *Beyond creating: The place of art in America's schools.* Los Angeles: The Getty Center for Education in the Arts.

Hunter, M. (1982). *Mastery teaching.* El Segundo, CA: TIP Publications.

Henry, C. (1990). Grading student artwork: A plan for effective assessment. In B. Little (Ed.), *Secondary art education: An anthology of issues.* Reston, VA: National Art Education Association.

Jefferson, B. (1969). *Teaching art to children: Content and viewpoint.* Boston: Allyn and Bacon.

Lansing, K.M. & Richards, E.R. (1981). *The elementary teacher's art handbook.* New York: Holt, Rinehart, and Winston.

Quality core curriculum. (1988). Atlanta: Georgia State Department of Education.

Visual arts resource guides: Grades K-12 (1989). Atlanta: Georgia State Department of Education in cooperation with The University of Georgia.

Wilson, B.G. (1971). Evaluation of learning in art education. In B.S. Bloom, J.T. Hastings, & G.F. Madaus (Eds.), *Handbook on formative and summative evaluation of student learning* (pp. 499-558). New York: McGraw-Hill.